American Accents

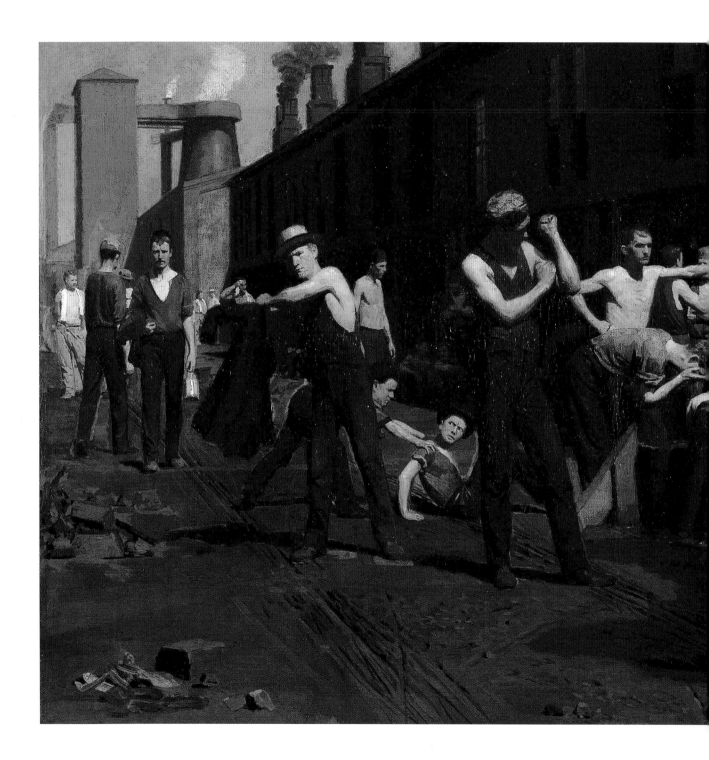

VISUAL CULTURE AS HISTORY
American Accents

Masterworks from the Fine Arts Museums of San Francisco

Daniell Cornell

FINE ARTS MUSEUMS
OF SAN FRANCISCO

Published on the occasion of the exhibition
American Accents: Visual Culture as History
organized by the
Fine Arts Museums of San Francisco
 California Palace of the Legion of Honor
 M. H. de Young Memorial Museum

1 July 2002 – 5 January 2003
Mobile Tri-Centennial, Alabama

11 October 2003 – 1 February 2004
Winterthur Museum Garden and Library,
Delaware

28 February – 30 May 2004
Charles M. Avampato Museum,
Charleston, West Virginia

This catalogue is published with the assistance of the Andrew W. Mellon Foundation Endowment for Publications.

All photographs are by Joseph McDonald, Fine Arts Museums of San Francisco, or, unless noted, courtesy of the lending institutions. Permission to produce other work has been granted for:

Cat. 81 © Estate of George Grosz/Licensed by VAGA, New York, N.Y.

Cat. 87 © Estate of Ben Shahn/Licensed by VAGA, New York, N.Y.

Figs. 14–15 © 2002 Artists Rights Society (ARS), New York/ADAGP, Paris/Estate of Marcel Duchamp

Fig. 25 © 2002 Estate of Pablo Picasso/ Artists Rights Society (ARS), New York

Front cover: Charles Demuth, *From the Garden of the Château*, 1921 (reworked 1925), cat. 74

Back cover: George Caleb Bingham, *Boatmen on the Missouri*, 1846, cat. 11

Frontispiece: Thomas Anshutz, *The Ironworkers' Noontime*, 1880, cat. 41

LIBRARY OF CONGRESS CATALOGING-IN-PUBLICATION DATA

Cornell, Daniell.
 Visual culture as history : American accents masterworks from the Fine Arts Museums of San Francisco / Daniell Cornell.
 p. cm.
Catalog of an itinerant exhibition.
Includes bibliographical references and index.
 ISBN 0-88401-104-6 (pbk. : alk. paper)
 1. Painting, American--Exhibitions. 2. Nationalism and art--United States--Exhibitions. 3. National characteristics in art--Exhibitions. 4. Painting--Califiornia--San Francisco--Exhibitions. 5. Fine Arts Museums of San Francisco--Exhibitions.
I. Fine Arts Museums of San Francisco.
II. Title.
ND205 .C583 2002
759.13'074'74946--dc21

2002006369

*Visual Culture as History:
American Accents, Masterworks from the
Fine Arts Museums of San Francisco*
was produced through the Publications Department of the Fine Arts Museums of San Francisco: Ann Heath Karlstrom, Director of Publications and Graphic Design, and Karen Kevorkian, Senior Editor

Designed by Robin Weiss Graphic Design
Printed by Regal Printing, with Overseas Printing Corporation, San Francisco

Printed and bound in Hong Kong

Foreword **6**
Harry S. Parker III

Preface **7**

American Accents: Visual Culture as History **8**
Daniell Cornell

Works in the Exhibition **114**

Biographies of the Artists **132**

Selected Bibliography of Visual Culture Studies **155**

Index **156**

Foreword

Continuing its history as one of the West Coast's premiere venues of fine art for over 100 years, a new M. H. de Young Memorial Museum is being constructed for the Fine Arts Museums of San Francisco to replace the building that was structurally compromised by the 1989 Loma Prieta earthquake. The internationally acclaimed Swiss architects Herzog and de Meuron, winners in 2001 of the Pritzker Architecture Prize, have designed an edifice that is not only a showcase for the museum's renowned permanent collections but is a work of art in itself. Scheduled to open in 2005, it will realize the dream of a world-class structure befitting the remarkable collections that the earthquake-damaged building had put at risk.

The construction of a new de Young Museum in Golden Gate Park provides a once-in-a-lifetime opportunity for one of the most significant survey collections of American art in the world to travel to other museums. Comprised of eighty-seven exemplary paintings at the heart of the museum's permanent collection, the exhibition features the masterworks that reflect the generous legacy of Mr. and Mrs. John D. Rockefeller 3rd. Initiated in 1979 and completed in 1993, their gift established the museum's ongoing commitment to acquiring an extraordinary survey of the highest quality paintings by the country's legendary artists, works that have become icons of our artistic tradition. We continue to be grateful for the Rockefellers' remarkable benevolence and their foresight regarding the importance of locating such a collection on the West Coast.

This exhibition and its accompanying book offer the first opportunity to assess what the completion of the Rockefeller gift and the acquisitions it has inspired have meant for the Fine Arts Museums of San Francisco. It also provides an occasion to consider paintings whose definitions as masterworks are expanded within a new context of cultural analysis, opening them to the kinds of rich insights based in cultural history that will characterize the installation of the completely reorganized American galleries of the new de Young. I am delighted that other regions of the country have a chance to experience this astonishing collection of paintings, which has been long known and loved by the people of San Francisco.

Many individuals have contributed to the success of this superb exhibition and book. Both reflect the cultural approach to visual studies of Daniell Cornell, Associate Curator of American Art and the exhibition's organizer. His lively and scholarly discussion of social, political, economic, and intellectual history focuses on the role of American artists themselves, not merely as reflectors but as shapers of the country's identity and values. In addition, I want to acknowledge the remarkable talents of our paintings conservators, whose preservation and preparation of the paintings have guaranteed an optimum viewing experience. Under the direction of Carl Grimm, Head Paintings Conservator, Patricia O'Regan, Tony Rockwell, and Charlotte Seifen have given considered attention and expert care to the paintings in the exhibition. The complicated logistics of preparing and transporting these treasures has

been capably handled by Therese Chen, Chief Registrar, and Steven Lockwood and Maria Reilly of her staff. Kathe Hodgson, Director of Exhibitions, has displayed undaunted persistence in securing the exhibition's venues and overseeing contractual arrangements. The book and exhibition design reflect the talent and skill of the team assembled by Ann Heath Karlstrom, Head of Publication and Design, especially the editorial dexterity and graceful proficiency of Karen Kevorkian and the elegant design of Robin Weiss and Juliana Pennington.

It gives me immense pleasure to present this well-informed and beautifully produced book as an accompaniment to the traveling exhibition and as a record of the remarkable permanent collection of American art that the Fine Arts Museums of San Francisco holds in trust for the people of the city. I invite its diverse citizenry to join with the staff of the de Young and the exhibition's museum partners across the country in this celebration of these marvelous masterworks and the cultural heritages that may be found in their painted histories.

HARRY S. PARKER III
Director of Museums
Fine Arts Museums of San Francisco

Preface

In the past, the splendid paintings represented here would have been exhibited and discussed exclusively as an art-historical survey of visual styles, artistic schools, conventional traditions, and prevailing influences. While such a presentation would certainly reflect the quality of the works under consideration, it would only tell half the story. The other half, emphasized in this analysis, is the story of how these paintings make visible the individual experiences, communal identities, and national dialogues that have shaped American history.

Since the earliest encounters between indigenous and European cultures, the notion of what is an American has been as varied as has been the peoples who have influenced each other. And America's artists provide one of the most important perspectives into that diversity. Consequently, this book and its exhibition provide a unique opportunity to observe how some of the country's keenest and most skillful observers have rendered the social, political, and cultural conditions of their times.

Such a complex project can only be a success with the collaborative talents and skills of many people who do not appear on the book's title page. My debt begins with the director of the Fine Arts Museums of San Francisco, Harry S. Parker, who expressed his confidence in me by supporting my conceptual approach. Steven A. Nash, Associate Director and Chief Curator, and Timothy Anglin Burgard, The Ednah Root Curator of American Art, endorsed that decision and lent their valuable expertise. Jane Glover, assistant in the American Art Study Center, was always ready to help with myriad details that threatened to overwhelm

me. Allison Pennell, Museum Librarian, was unending in her support of even my most elusive bibliographic requests.

Kathe Hodgson, Director of Exhibitions, and Krista Davis, Associate Curator of Exhibitions, have been tireless in presenting the exhibition and securing its venues. The Museums' conservation department staff — Carl Grimm, Tony Rockwell, Patricia O'Regan, Charlotte Seifen, and their interns Lisa Sardegna and Lance Moore — has worked tirelessly to restore the brilliance of the paintings, and Natasha Morovic gave her expert attention to the paintings' frames. Without their technical skills, the exhibition would loose its luster. Joseph McDonald newly photographed many of the paintings, insuring that this publication would have the highest quality images. Thanks, also, to Sue Grinols, whose work in photo services kept everyone on schedule and the transparencies in order. I also greatly appreciate their willingness — along with Karin Breuer, Curator, Anderson Graphic Arts Collection and Achenbach Foundation for Graphic Arts — to go the extra mile in helping with the additional figures in the text. An exhibition of such significant paintings would never get off the ground without help from Therese Chen, Director of Registration, and the professional and indispensable skills of her registrars, Steven Lockwood and Maria Reilly. Bill White and his staff of art handlers have negotiated the difficult demands of multiple sites and storage facilities with uncommon good will.

This publication is the direct result of the exceptional efforts and distinguished abilities of the Publications department under the direction of Ann Karlstrom. To say that it would

not have happened without Karen Kevorkian, Senior Editor, is more than a polite convention. Whatever grace, clarity, and economy exist in the prose is a reflection of her acuity. In many places, the finesse of the argument owes its shape to her intelligent probing. To create the elegance of the book's design, Robin Weiss remained inventive and flexible throughout its production. Juliana Pennington has provided the strong, sensitive design concept that showcases the artworks so well. I am also indebted to Robert Marc Savoie of Stanford University, who produced the biographies of artists. Thanks to Professor Wanda Corn for facilitating his internship. In the final stages, Emily K. Doman provided additional intern support that tied up crucial loose ends. Louise Chu's comprehensive knowledge and good will have added immeasurably to the book's usefulness through her intelligent indexing.

Finally, this book is the result of many conversations with people who share a love of art and historical analysis and who read early drafts of the text with interest and acumen. Chief among these are Timothy Burgard, Susan Donaldson, Terry Engebretsen, Carl Grimm, Patricia O'Regan, and Jeff Petrie. My most heartfelt thanks go to Rudy Rodriguez for the good grace with which he allowed many an evening's interruption, offering perceptive help with tact and intelligence when either my text or my spirit needed it.

DANIELL CORNELL
Associate Curator, American Art
Fine Arts Museums of San Francisco

American Accents VISUAL CULTURE AS HISTORY

*Description delineates the world, yes, but in doing so it
informs what's seen with ourselves, our ways of seeing.*

MARK DOTY, *Still Life with Oysters and Lemon*

PAINTING IN HISTORY/HISTORY IN PAINTING

This survey of American art bridges the linguistic and visual concepts
suggested by the terms "accents" and "masterworks." A linguistic
accent suggests something local, a speech pattern specific to a particu-
lar time and community. To speak with an accent conveys difference,
the identification of a speaker with some other place. But an accent
also calls attention to itself, creating associations with other related
but dissimilar groups. For instance, an American accent not only iden-
tifies its speaker with a region of the country, but also with American
English more generally.

In a related metaphoric usage, a visual accent injects a noticeable,
striking, or even startling emphasis into an otherwise unremarkable
context. Such an accent offers a paradox, by its insistent presence
revealing the surrounding environment of which it both is and is not
a part. Using the notion of accent to tell the story of American paint-
ing allows the diverse and varied experiences of individuals and
communities to emerge, while revealing the ways they make up a
larger national pattern. By paying attention to elements that accent
visual depictions, viewers can understand how different groups invest
in the stories told about their nation, and how these stories reflect the
groups' own defining concerns. In other words, the concept of accents
makes visible what is at stake, and for whom, in the broad visual lan-
guage that museums historically have used to make sense of the
development of American painting. These accents highlight the dis-
parate cultural contexts that often go unnoticed or are ignored in the
larger, more monolithic national narrative.

"Masterwork," on the other hand, is a term that aggressively elides
the notion of invested, local interests. In the Western tradition since
the eighteenth century, a masterwork implies something universal,
an expression that moves beyond a simple mastering of techniques to
encompass the creative power that has been called genius.[1] Although
the words genius and masterwork (or masterpiece) both existed
before the Enlightenment, the philosopher Immanuel Kant, in his
Critique of Judgment (1735) articulates the interrelated association
of their meanings in a way that accords with our modern use and

understanding. In previous usage, they represented opposing ideals— genius as based on inherent inspiration and instinct; masterwork on studied training and skill. Since Kant, a genius has been understood as someone whose very essence places him or her outside the rules and conventions of the normal cultural dictates that constrain most people.[2] Thus, the concept of masterwork as a narrative strategy for telling a grand, sweeping story of American painting ignores the interests assembled under the rubric of accents, articulating a vision that historically has given the museum its position as a cultural institution. There is, then, an inherent tension between the art museum's claims for the universal visual power of the masterwork and the particular, local experiences out of which the work is produced.

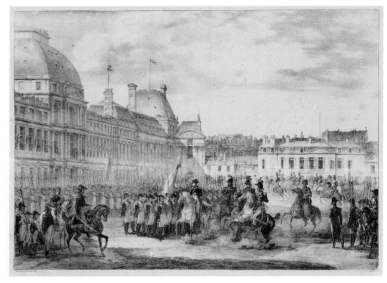

Fig. 1
Charles Etienne Pierre Motte (French, 1785–1836), *Napoleonic War Series III: Installation du Gouvernement Consulaire aux Tuileries*, ca. 1810–1820. Lithograph, 11 x 16 in. (28 x 40.5 cm). Fine Arts Museums of San Francisco, 1963.30.23297.

Arthur Danto, professor of philosophy at Columbia University, seeks to explore the current tension between the concept of a masterwork and the role of museums in contemporary culture. He explains that, ironically, the very idea of a masterwork as we now understand it emerged out of the conditions of a specific historical moment. In 1791, as an immediate consequence of the French Revolution, Bertrand Barère proposed that the Louvre, the palace of the recently beheaded royal family, be turned over to the people of France as a way to return to the public the treasures amassed there. The museum, then, emerged as an act of revolutionary appropriation, even pillage, in the ideological service of a new socio-political system.[3] As Napoleon's military strength grew in successive years, he merely took the political implications of this event to its logical conclusion when he began plundering the rest of Europe while establishing his empire.

Danto succinctly and somewhat wryly describes the conditions for a masterpiece at this juncture, by defining it as whatever artwork Napoleon thought worthy of stealing as a trophy and symbol of his conquest.[4] In this manner, the public art museum came into existence as the tangible evidence that Napolean's regime was one of the world's most powerful political authorities (fig. 1). As Danto points out, authority is still invested in museums and what they designate as masterworks. And because Napoleon's conquests were notable for their scale and ambition, those qualities became associated with the works in the Louvre, the first public treasure house, and continue to

Fig. 2
After Paolo Caliari Veronese (Italian, ca. 1528–1588), *Marriage of Cana*, 1562–1563. Engraving, 5⁵⁄₁₆ x 7¼ in. (13.2 x 18.4 cm). *Galerie du Musée Napoléon* (Paris: Filhol, 1814):9, pl. 601. Fine Arts Museums of San Francisco, 1964.166(9) .

tinge the expectations of museum visitors.[5] This is why, Danto maintains, no matter how superbly they are executed, small and modest works cannot lay claim to being masterworks, since they lack evidence of a momentous ambition equal to Napoleon's political aspirations. Thus, early political reality originated the later, rarefied definition of the masterwork as an object of creative artistic genius that can be easily identified, so the logic goes, by anyone possessing aesthetic perception rooted in a universal notion of taste.[6]

Danto's analysis, additionally, reflects a shift in art-historical studies during the past decade that seeks to understand works of art through a methodology that has been called *visual culture*.[7] This approach assumes that visual art is a language, and that there is no such thing as a transparent transcription of reality. Instead, all visual perceptions and experiences are communicated by culturally coded signs. The means of representation we employ and our interpretations of them are simultaneously shaped by and also shape the understanding of what we see. The visual-culture historian pays close attention to the shaping mechanisms that create meaning, believing that these mechanisms or vocabulary of vision embody the assumptions viewers use to understand what they are seeing in the first place. Visual-culture historians believe that *every* cultural form relies on its own mediating language, with which the viewer must aggressively engage in order to make sense out of a specific cultural experience.[8] The masterwork is one such cultural discourse, organizing the viewing

expectations of museum visitors around the political promises of Napoleon and the French Revolution, which delivered the aesthetic treasures of the King's palace to public citizens, but retained the language of aristocratic privilege and grandeur that still inflects art works exhibited in a museum setting (fig. 2).[9]

Histories of American painting traditionally rely on discussions of how the country's artists have created masterworks by adapting the classical genres of myth, history, landscape, figure, portrait, and still life to the special circumstances of the nation. However, without an official salon, American artists were not as bound as European painters to follow the rigid categories of painting genres authorized by the art institutions of their countries.[10] Even when working within the regulatory parameters of authorizing institutions such as New York's National Academy of Design, American artists (and their patrons) were often freer to consider the subject matter that interested them and to transcribe it in the ways that seemed most appropriate, rather than attempting to fit the content of their paintings into preordained formulas.

This is not to say that the best European artists merely rehearsed the conventions dictated by previous traditions or that American artists ignored European influences.[11] However, American artists were less constrained by the rules and regulations that discouraged the blending of genres and the hybridizing of conventions in pursuit of subject matter. Therefore, the juxtapositions of genres and conventions in American painting offer an especially congenial opportunity to uncover the way in which meaning is mediated in the visual arts. In addition, organizing the study of paintings according to broad cultural themes highlights the ways that strategies of mediation are suited to different occasions. Such an analysis sets up a dialogue between an official, master narrative of national life and the more individual and local stories of actual life as it is experienced by specific people. *American Accents* takes up the three thematic domains of family, community, and nation that have particularly focused American artistic interests and operated as sites of cultural negotiation.

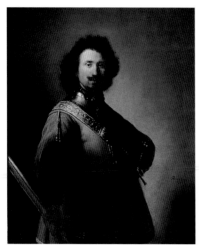

Fig. 3
Rembrandt Harmensz. van Rijn (Dutch, 1606–1669), *Portrait of Joris de Caulerij*, 1632. Oil on canvas transferred to panel, 40½ x 33⅜ in. (102.9 x 84.3 cm). Roscoe and Margaret Oakes Collection, Fine Arts Museums of San Francisco, 66.31.

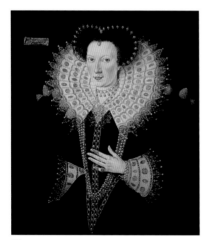

Fig. 4
Anonymous (English, ca. 16th century), *Portrait of a Lady*, ca. 1590. Oil on panel, 33½ x 29½ in. (85.1 x 74.9 cm). Mildred Anna Williams Collection, Fine Arts Museums of San Francisco, 1954.75

Cat. 1
ATTRIBUTED TO THE FREAKE-GIBBS
PAINTER
The Mason Children: David, Joanna, and Abigail, 1670

PRIVATE VIEWS/PUBLIC VALUES The notion of family has served throughout American history as the most private symbolic realm in which the social values of the larger nation could be staged. In particular, it supports a view of society based on the twin poles of harmony and independence. The relations between the generations, especially, offered potent metaphors for these values, embodying the principles that the founders deployed in their ideological struggle with England, the "mother country." In 1760, Benjamin Franklin argued that the continuing health of the English nation was directly contingent on encouraging independence among the colonies, writing that "the growth of the children tends to increase the growth of the mother."[12] In this way he ingeniously inverted the logic of dependence and independence that usually defined the relations of colonies and their parent nations, wresting control of the debate away from the mother country. As a byproduct, this rhetoric also aligned moral virtue with youth, a legacy that continues to play itself out in contemporary America. However, the most important symbolic role of the family was to provide an apparently timeless space that could continually evolve in response to the shape of public life. Ideologically, the seemingly universal experience of family provided metaphors that echoed and thus legitimized whatever controls were needed to guarantee the ever-changing national consensus regarding social, political, and economic relations.

The earliest painting presented here speaks directly to the theme of families, using childhood as a visual metaphor to construct an ideological picture of the assumptions underlying life in seventeenth-century New England. *The Mason Children: David, Joanna, and Abigail* (1670) is attributed to the Freake-Gibbs Painter (cat. 1). The details and even the actual name of this artist, one of the nation's earliest in the deployment of a western aesthetic tradition, are not known. His name is derived from the fact that a recognizable style can be seen in the frequently painted portraits of these important colonial families.[13] Although the children are rendered in a style much less realistic than the high baroque of European old masters just prior to this time (Rembrandt died in 1669) (fig. 3), they are far removed from the naïve, untutored images created by the itinerant sign painters known as limners. Rather, they reflect the previous era's Tudor period in England, which ushered in a style of painting that could be described as "neomedieval" (fig. 4).[14] In opposition to the plasticity of form and animated naturalism of Italian, Flemish, and Dutch depictions, the English strove to create a more iconic flatness and linearity of form that was reminiscent of a pre-Renaissance visual vocabulary. As in this portrait of the Mason children, the emphasis was on surface decoration, color, and silhouette.

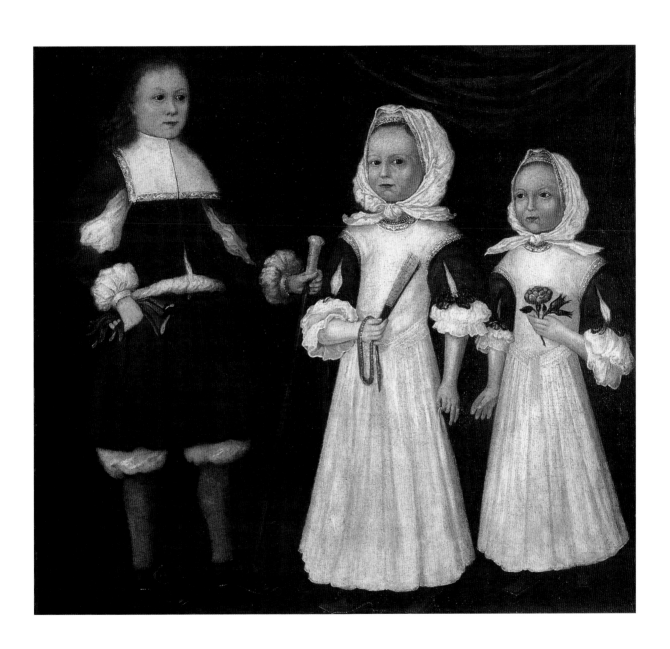

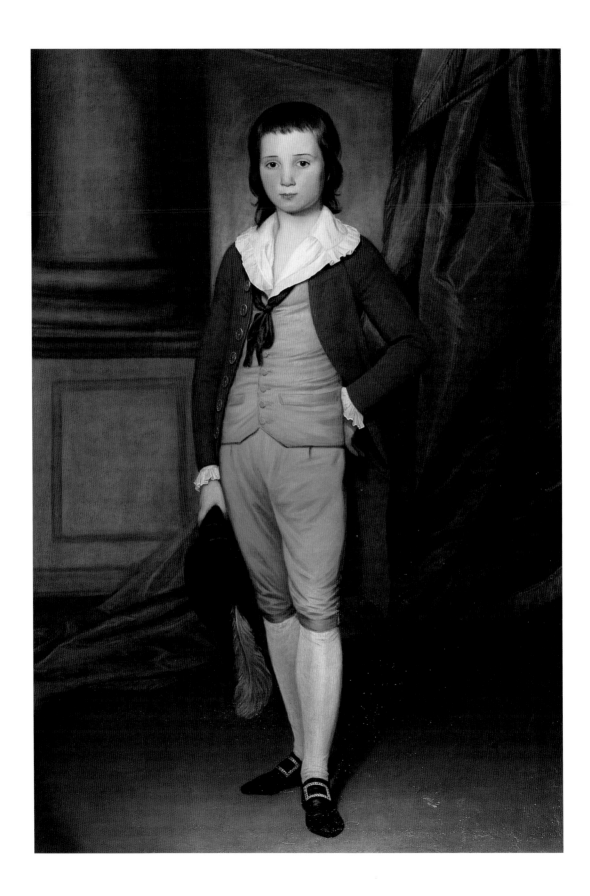

The Mason Children are indeed icons more than personalities. Signs of the family's wealth collapse the symbols of their class with their likenesses, encouraging viewers to perceive these children as emblematic. Eight-year old David holds a silver-headed walking stick in his right hand and a pair of gentleman's gloves in his left, indicators of the power and position he is destined to inherit. Joanna's necklace, ribbon, and fan suggest the accoutrements that will be necessary for a woman of prominent social standing. The youngest, Abigail, holds a rose, an emblem of rich symbolic meaning associated with feminine innocence and love but also with the piety and moral passion, which would align her upper-class status with religious institutions. The children's effects, represented in their costumes and accessories, create a setting for their faces, rendering them more like jeweled icons than actual personalities. Indeed, within the New England context of Puritan values, children were considered the "jewels" in the heavenly crowns of their parents and evidence of spiritual blessing. The richly decorated details of their clothing does suggest something of the wealth of the family, but more importantly, it sets up a visual impression of the elaborately patterned system of gender, social status, and spirituality that gives meaning to these young lives. The visual flatness achieved by the artist parallels the emblematic flatness of their iconic status. As with other icons, such flatness points to the deeper reality of a transcendent world to which the surface only refers. In this way, *The Mason Children* is a visual mediation in paint that mirrors the assumptions of the family's world by requiring viewers to rely on outward signs as conveyers of intangible truths.

An entirely different visual strategy is at work in Joseph Wright's childhood portrait of *John Coats Browne* (ca. 1784) approximately one hundred years later (cat. 5). As the first American artist to be admitted to London's Royal Academy Schools in 1775, Wright demonstrates little resistance to the European conventions of his day.[15] His early entrance into London's most prestigious art circles at the age of nineteen was largely the result of his influential mother, Patience Lovell Wright, a successful wax modeler.[16] A colorful character, Patience Wright was not only a very accomplished artist but she also used her position and connections in London society to act as an American spy during the Revolution. After Wright's study in London, his mother also used her influence to secure his entrance into French society, where his acquaintance with Benjamin Franklin gave him the credentials to take up society portraiture on his return to Philadelphia in 1783.

The neoclassical tradition of Wright's portrait offers a definition of childhood that is rooted in the Grand Manner. Popular in both London and Paris, grand-manner portraits usually displayed life-sized,

Cat. 5
JOSEPH WRIGHT
John Coats Browne, ca. 1784

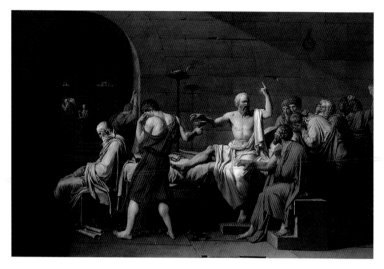

Fig. 5
Jacques-Louis David (French, 1748-1825), *The Death of Socrates*, 1787. Oil on canvas, 51 x 77¼ in. (129.5 x 196.2 cm). The Metropolitan Museum of Art, New York, Catharine Lorillard Wolfe Collection, Wolfe Fund, 1931, 31.45. © 1995 The Metropolitan Museum of Art.

full-length likenesses that stressed recognizable traits. They emphasized the subject's face as the carrier of a readable, albeit ideal, personality, which is the hallmark of portraiture in general. The rest of the portrait borrowed postures, gestures, settings, and accessories from three sources: Roman sculpture, Italian Renaissance painting, and the baroque English court portraiture of Peter Paul Rubens and Anthony van Dyck. It deploys these conventions to create metaphoric visual forms that link the symbolic props of intellectual and cultural history to the indicators of social and political status.

The elite citizens of the newly formed United States morally justified revolution by associating their new government with the Roman republic, which they argued was ethically superior to the European monarchy that more closely was represented by the decadent and despotic period of the Roman empire. Such a comparison aligned Roman republican virtue with the necessity of an independent American government, an understanding embodied in the most popular play of the period, Joseph Addison's *Cato*, with its classical setting and hero who perishes for opposing the rule of a tyrannical Roman emperor. The play's resonance with the ideals of Enlightenment political theory made it the perfect vehicle for the rhetorical connections that colonialists were seeking as a way to describe the moral dangers in their continuing subordinate relationship with England.[17]

Wright's firsthand encounter with the works of Jacques-Louis David, the official painter of the French Revolution, provided him with a visual model that conveyed similar associations (fig. 5).[18] To the right of young master Browne is a classical column, suggesting Roman antiquity. On his left, an expanse of luxurious silk drapery falls from above as if it were a theatrical curtain that is being drawn back by a golden cord to reveal the historical realities behind the boy's elite position in society. In fact, as an ironworker, Browne's father worked in a trade that offered an ideal symbol to link the American republic to ancient Rome, known as the empire of iron. The economic opportunities that derive from the skills of a pragmatic and industrious occupation points to the notion of meritocracy that was advocated by Thomas Jefferson; the industrial material of iron was itself the hallmark of Rome's engineering skill and military might. Such conjoining of symbols creates the metaphoric associations of meaning that conflate

sitter with setting and which typify grand-manner portraiture.

In England during the 1870s, Sir Joshua Reynolds, who was head of the Royal Academy, and Thomas Gainsborough were the undisputed masters of grand-manner portraiture. It seems clear that Joseph Wright saw Gainsborough's famous portrait of the youth *Jonathan Buttal*, popularly known as "The Blue Boy" (ca. 1770) (fig. 6), while studying there and used it some fifteen years later as the model for his own portrait of John Coates Browne.[19] In both paintings an adolescent boy stands in nearly identical poses: left arm akimbo, right foot forward, left foot at right angle, and a large plumed hat in his right hand. Called a "swagger," such a pose suitably represents the visual tone of grand-manner portraiture, conveying a sense of showiness and ostentation tempered by the suggestion of an amusing and entertaining consciousness (cat. 2, *Works*).[20]

Jonathan Buttal was also the son of an ironworker. However, Gainsborough set his young subject in nature, drawing more from baroque conventions than from those of classical antiquity. This tradition allowed Gainsborough to develop a highly colorist style based in sketchy brushstrokes and also lent itself to rendering the ceaselessly changing aspect of the natural world. At the same time, the constancy of nature's eternal laws reassuringly reminded of basic stability underlying the actual and painted fluctuations of the landscape. By incorporating his sitters into this schema, Gainsborough created a metaphor that acknowledged the transitory character of social position and outward appearances but simultaneously inferred that such external conditions were sustained by the elemental and more permanent forces of history. It was a visual mediation perfectly suited to Enlightenment philosophy, with its focus on individualism and its commitment to rational order and certainty in the face of social and political change.

Although Wright could not have expected most of his viewers to know Gainsborough's portrait of Jonathan Buttal, he could have expected them to know and understand the mediating conventions of grand-manner portraiture that it embodied. The two paintings also reflect the changing social conditions that would have allowed the son of an ironworker in both England and the United States to be represented through imagery previously used to portray aristocratic sitters. However, the change in setting is telling. While wanting to communicate the nobility conveyed by the conventions that Gainsborough adopted from baroque portraiture, Wright would have wanted to distance his own sitter from the aristocratic associations of that tradition.[21] The dramatically sweeping drapery in Wright's painting functions to create a sense of movement and grandeur that

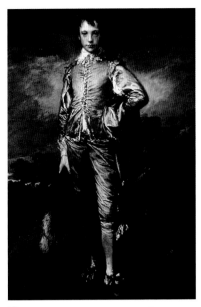

Fig. 6
Thomas Gainsborough (English, 1727–1788), *Jonathan Buttal (The Blue Boy)*, ca. 1770. Oil on canvas, 70 x 48 in. (155 x 122 cm). Huntington Library, Art Collections and Botanical Gardens, San Marino, California.

Fig. 7
Anthony van Dyck (Dutch, 1599–1641),
*Marie Claire de Croy, Duchesse d'Havré,
and Child* (detail), 1634. Oil on canvas,
82¼ x 48⅞ in. (208.9 x 124 cm). Roscoe
and Margaret Oakes Collection, Fine
Arts Museums of San Francisco, 58.43.

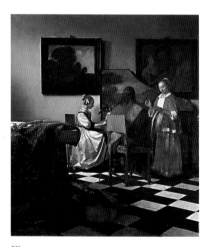

Fig. 8
Johannes Vermeer (Dutch, 1632–1675),
The Concert, ca. 1658–1660. Oil on
canvas, 27¼ x 24¾ in. (69.2 x 63 cm).
©Isabella Stewart Gardner Museum,
Boston, P21w27.

Cat. 32
Eastman Johnson
The Brown Family, 1869

is similar to what Gainsborough achieves through the tossing trees
and tempestuous skies of the English countryside. However, the
indoor setting, with its neoclassical props, provided a link to France
and republican political ideology in place of England and its land-
based political structures of monarchy.

Wright also transforms the sensuous fabric of Gainsborough's
bourgeois sitter, eliminating the pretentiously aristocratic, seven-
teenth-century costume and replacing it with Browne's more sober
clothing. Wright reserves his depiction of elegant material for use as a
theatrical backdrop. In place of the arrogance that the newly liberated
colonists associated with a young British aristocrat, Wright represents
the self-confidence of an independent young individual. In this,
Browne's portrait visually embodies the exuberant freedom of the new
nation, turning his image into a double metaphor. The portrait associ-
ates a virtuous new political system with a newly emerging moral
citizenry, and at the same time it declares youthful self-confidence to
be the guarantor of a vital and independent nation (cat. 3, *Works*).

Eastman Johnson created a different kind of childhood image
entirely in his group portrait of *The Brown Family* (1869) (cat. 32). In
place of the formal poses and gestures of grand-manner portraiture,
Johnson arranges his sitters within the furnishings of the Brown's
family parlor. This type of portrait, known as a "conversation piece,"
was especially popular during America's prosperous years following
the Civil War.[22] The conversation piece is something of a hybrid, com-
bining English portraiture and Dutch genre paintings. The English
had already appropriated seventeenth-century Dutch and Flemish tra-
ditions for such portraits in the eighteenth century. Gainsborough was
known for presenting his sitters in what was called "van Dyck dress"
(fig. 7), portraying them in dramatic clothing that had the sumptuous
look and feel of the fancy dress worn by van Dyck's aristocratic sit-
ters.[23] Also, from the seventeenth-century scenes of the everyday
that were the hallmark of Dutch bourgeois life in Holland (fig. 8), the
conversation piece borrows an emphasis on informal events and com-
monplace interactions. As a result, the theatrical elements shift from
individual poses and gestures to an emphasis on group narratives.
In place of a pictorial vision grounded in the heroic, the conversation
portrait elevates the middle-class ethic of sensibility and benevolence.
Moreover, as in seventeenth-century Dutch life, those narratives often
celebrated the placid and tranquil joys of domestic bliss that are the
foundations of a smooth-running bourgeois society.[24]

The Brown Family was painted in the early years that became
known in American history as the Gilded Age. Mark Twain and
Charles Dudley Warner's satiric lampoon of the times by the same

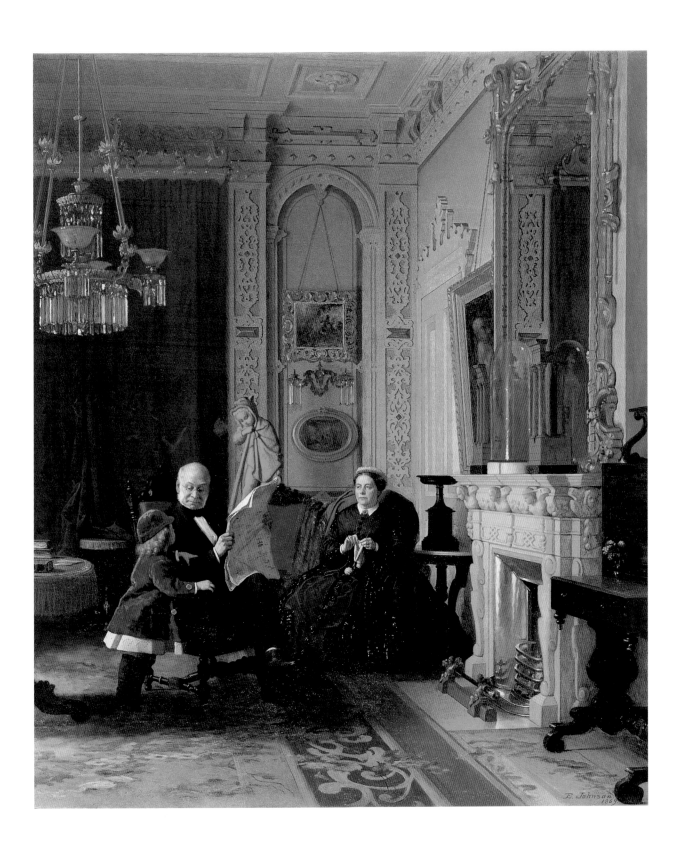

name was published in 1873, but the sensibility extends from the time of this portrait until the end of the century. During this period, Americans seemed anxious to put behind them the tensions of the first part of the century that had led to the devastating events of the Civil War (cat. 29, *Works*). They also were eager to celebrate the fashionable new wealth that the industrial revolution was creating in the United States.

Johnson's portrait of the Browns in their parlor continues the hybridity of the conversation piece but gives it an American Gilded Age slant. The informal and commonplace quality of Dutch genre painting is communicated in the narrative elements of the work. The scene represents the young son and the parents of John Crosby Brown, who commissioned the portrait. John Brown's child has initiated a moment of attention from his grandparents, James and Eliza, who pause in their pursuits to pay attention to his interruption. James Brown, dressed in formal attire and still holding the newspaper that he has been reading moments before, looks down as his grandson tugs on his arm. Eliza Marie Coe Brown, James's second wife, is shown seated, wearing a richly brocaded dress and looking up in the middle of a knitting stitch. Both seem to be indulging an interruption from the child, who is dressed for outdoors rather than for the stuffy confines of this grand parlor.

The affable expressions of the three participants in this domestic scene of interruption and expectation create its narrative situation and mark it as a commonplace moment, the hallmark of the conversation-piece portrait. The quotidian quality of the event reinforces the supposed naturalness of the depiction and creates a feeling that everything is as it should be.[25] The activities of reading and knitting further suggest the industry that authorizes the prosperity, which the parlor's decor is meant to exhibit. At the same time, these are activities meant to indicate the gendered ordering of society that was considered necessary for such tranquil social harmony: Eliza pursues an activity within the home for the home, which is her proper sphere, and James reads about the world outside the home, linking him to the world of business and commerce that is his proper domain.[26] Both worlds are joined in their attention to the child, symbol of the legacy such roles insure.

Ironically, nothing about the parlor itself supports the assumptions behind this narrative about the importance of the commonplace in establishing social order. The parlor, built in 1846 and designed in the height of fashion for that time, had been transformed from the Greek-revival style popular earlier in the century to its presently pictured French Renaissance-revival style by the famous French cabinet

maker Léon Marcotte.[27] In a manner similar to Wright's translation of the fancy dress of van Dyck into the large, sweeping curtain behind *John Coats Browne*—his Americanized "blue boy"—Johnson displaces the register of sumptuous display and luxurious materiality into the room and its furnishing. In fact, critics of the painting in 1869 were quick to point out that the room, for all its sumptuousness, represented the excesses of taste from a period predating the Gilded Age. A critic for the *New-York Daily Tribune* wrote:

> *Is it possible that an artist could have invented or chosen this dreadful room? We cannot believe that Mr. Johnson would do either. . . . What conscience has been expended on the chandelier. It looks as if made up of the artist's crystallized tears of vexation at having to waste his time over the tasteless thing. What quiet skill has given us the mantelpiece, though it must have hung like a millstone round his neck in the doing. And how skillfully he has wrought the whole discordant upholstery mess into a harmony which, while it allows nothing to escape, makes it easy to forget all the incongruous detail.[28]*

However, the very fact that the decor is out of date and yet still opulent gives the sitters in the painting an air of elitist noblesse oblige. Nevertheless, the impression of entitlement that it creates is set firmly within an American ethic of prosperity rather than the aristocratic ethic of birth associated with European wealth. The painting insinuates that the senior Browns have earned their luxury by the force of character and therefore have not just the right but almost a moral duty to enjoy the fruits of their labor and middle-class respectability.

The realistic painterly techniques that Johnson uses to depict this family morality play also derive from seventeenth-century baroque models. The virtuosity of realist methods with their attention to detailed rendering was ideally suited to portraying the commercial values of the rising Dutch merchant classes, and that same spirit equally served the newly prosperous economy of America's Gilded Age.[29] Johnson has used this realist vocabulary to turn the ordinariness of this scene into an elaborate display for the eyes of the painting's viewers. Everything in the painting feels designed to heighten the sense of contrast. The color scheme itself is a study in the opposition set up by red and green hues. The monumental scale of the mantle, towering overmantle and mirror, oriental carpet, draperies, and chandelier contrast with the more intimate scale of the cozy fire, floral bouquet, and books and letters on the table. The cavernous ceilings contrast with the cramp and clutter from the overwrought ornamentation of nearly every surface. And, most curious of all, the windowless interior is infused with a strong sense of light. The painting itself

becomes a metaphor for the strange conflations of a cultural sensibility that painted the everyday virtues of bourgeois morality with the brush of prosperity and consumption.

Although nineteenth-century American artists are justifiably known for their commitment to the realist tradition and the virtuosity with which they advanced its painterly style, they were also aware of the new avant-garde methods of painting, especially the techniques of the Impressionists, who were challenging academic conventions in Europe. Foremost among those was John Singer Sargent, who lived primarily as an expatriate, first in Paris from 1874 to 1886, years that coincided with the eight major Impressionist exhibitions.[30] After visits to England in 1881, 1884, and 1885, he moved to London permanently in 1886 where he lived until his death in 1925 (cat. 71, *Works*).

When Sargent painted Albert and Edith Vickers in *A Dinner Table at Night* (1884) (cat. 45), he wedded the informal portraiture of the conversation piece to the techniques of Impressionism and created a mood that is strikingly at odds with the family harmony suggested by Eastman Johnson in his portrait of the Brown family. Although the domestic setting of the Vickers's dinning room is much more intimate than the Brown's extravagant parlor, the psychological spaces are deeper and wider in keeping with the modern impressionist sensibility. In place of the usual narrative interactions that characterize the conversation-piece portrait, Mrs. Vickers (Lady Gibbs) occupies the center of the painting and looks directly at the viewer. Her husband sits to her left, his profile barely included in the scene and marginalized, quite literally, at the right edge of the painting. In place of the family harmony that Johnson established by the interaction between the Browns and their grandchild, Sargent creates a narrative of anxiety and disaffection.[31]

As a form of pictorial representation, impressionist effects are meant to offer an even more fleeting expression of the everyday moment than the realism derived from seventeenth-century Dutch genre scenes. It is most often related to the cut of the frame, canted angles, spontaneous moments, and light effects associated with the captured images of photography (cat. 55, *Works*). During the 1880s especially, photography gained in popularity as a fine art rather than a recording practice. Artists in all media experimented with its novel vocabulary for rendering pictorial space. As a photograph might, Sargent's portrait also implicates the viewer in the scene. The angle of the table positions the spectator as a third person at this elegant dinner party—whom Edith Vickers seeks to engage in an effort to animate her fashionable yet possibly tiresome life.[32]

Also, as in a photographic setup, Sargent's use of strongly

Cat. 45
JOHN SINGER SARGENT
A Dinner Table at Night (The Glass of Claret), 1884

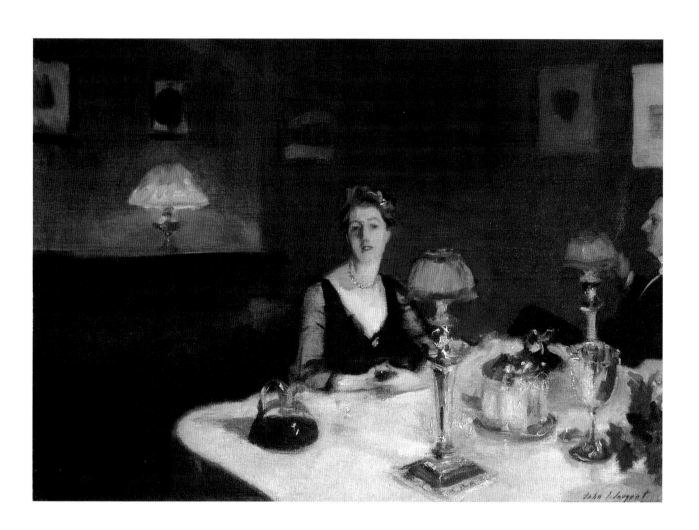

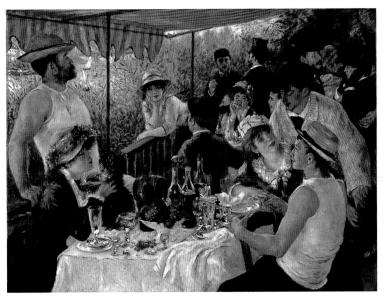

Fig. 9
Pierre-Auguste Renoir (French, 1841–1919), *The Luncheon of the Boating Party*, 1880-1881. Oil on canvas, 51¼ x 69⅛ in. (130.2 x 175.6 cm). The Phillips Collection, Washington, D.C., 1637.

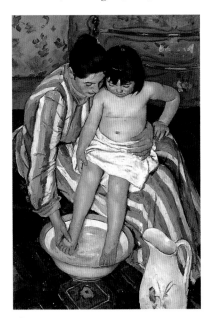

Fig. 10
Mary Cassatt (American, 1844–1926), *The Child's Bath*, 1893. Oil on canvas, 39½ x 26 in. (100.3 x 66 cm). The Robert A. Waller Fund, The Art Institute of Chicago, ©The Art Institute of Chicago. All rights reserved, 1910.2.

contrasting tonalities suggests that the scene is lit from three different sources, which creates its light and dark effects and produces the shadows playing across Mrs. Vickers's face. As a consequence, the same painterly highlights that register on her face also infuse the silver and crystal on the table with spectacular brilliance, giving them a visual presence as powerful as that of the human actors in the scene. Because the tableware occupies the pictorial space as significantly as Mrs. Vickers—an effect also fostered by the flatness of spatial illusion inherent to the vocabulary of Impressionism—

Edith and Albert Vickers are separated by their opulence rather than comfortably surrounded by it. Sargent aligns Mrs. Vickers with her accessories, and both, in turn, are accessories to Mr. Vickers, who is nearly excluded from the scene. The couple's estrangement is made even more complete by the unsettling register of the painting's angry red palette.

Another expatriate, Mary Cassatt, was as much a part of the Impressionists' circle in Paris as any American artist. In fact, she was the only American artist (at the invitation of Edgar Degas in 1877) to participate in any of the eight exhibitions specifically organized by the group.[33] Although living abroad from 1877 until her death in 1926, Cassatt was a tireless champion among her American friends of the so-called "new painting" of contemporary avant-garde artists in France, especially Manet, Courbet, and Degas. These artists, in their different ways, advocated styles of painting directly opposed to the conventions of academic realism that dominated the juries of the official French salon.

The French Impressionists are known primarily for their vivid and colorful celebrations of the achievements and pleasures of nineteenth-century bourgeois life (fig. 9). They delighted especially in the cultivated leisure activities of opera, theater, ballet, reading, outdoor boating, garden parties, and horseracing that had previously been diversions enjoyed by the wealthy and that the new industrial economy was now making available to an emerging middle class. Cassatt became especially interested in the role of mothers in this new social order, and is usually associated with her many depictions of a mother and child at home. Cassatt's portrait, *Mrs. Robert S. Cassatt, The Artist's Mother* (ca. 1889) (cat. 49), pursues this theme to adulthood, the

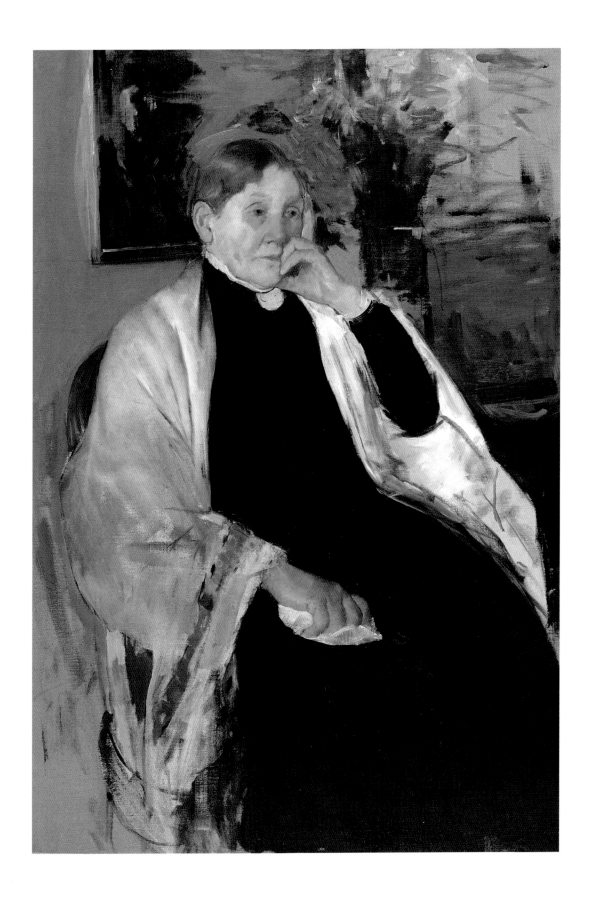

Cat. 49
MARY CASSATT
Mrs. Robert S. Cassatt, the Artist's Mother
(Katherine Kelso Johnston Cassatt),
ca. 1889
Page 25

mother represented by the painting's subject and the apparently absent child present in the work's artistic handling.

Just as Sargent uses the vocabulary of Impressionism to express the interior lives of Mr. and Mrs. Vickers, Cassatt relies on it to draw the viewer into the psychological character of her mother (cat. 56, 58, 59, *Works*). However, Cassatt's portrait conveys a very different sensibility than the enervated marriage depicted by Sargent. In spite of her obvious age, Katherine Cassatt's gaze is clear and commanding. She appears to be comfortably lost in her own thoughts. Unlike Mrs. Vickers, she has no reason to look to the viewer to relieve her condition. Katherine's face is rendered in meticulous detail with a delicate brush and lifelike modeling that suggest depth and dimension of character. On the other hand, the highly visible and sketchy brushstrokes of colorful paint that define the background wall, bouquet, painting, chair, and shawl contrast with the more realistic depiction of the face and amplify the artist's description of her subject, conveying the vitality and vigorous intelligence of a strong woman. Also characteristic of the "new painting" by nineteenth-century, avant-garde French artists, Cassatt's work organizes the spatial relations according to the psychological impressions created by the abstract arrangement of form and color, rather than the illusionistic perceptions of a three-dimensional space. The large area of the canvas that is given over to Katherine's black dress further flattens the image and tilts her toward the picture plane; yet simultaneously the same black mass operates as a visual weight that anchors her within the scene.

The hands, too, are painted with the solidity and attention to realistic detail that Cassatt used for her mother's face. As an artist, Cassatt would have a special interest in hands, and in many of her portraits of mothers and children it is the tender and capable hands of the mother attending to her child that give the impression of a loving bond. In this way the hands in Cassatt's intimate scenarios become a symbol of the familial bond between generations. The role of hands in this painting becomes especially poignant because Cassatt's own artistry lies in her manual skill (fig. 10). In depicting the strength of Katherine's hands, Cassatt metaphorically addresses the talent passed to her from her own mother. As a metaphor, these hands suggest that women of creative talent have the capacity to bring culture and intelligence to the bourgeois family and to shape it according to the strengths of their gender.

The force of the conventions of decorum and taste may clearly be witnessed in John Singer Sargent's glittering, lifesized society portrait *Caroline de Bassano, Marquise d'Espeuilles* (1884) (cat. 44). Sargent's painting of the marquise is designed to register her position in society

Cat. 44
JOHN SINGER SARGENT
Caroline de Bassano, Marquise
d'Espeuilles, 1884

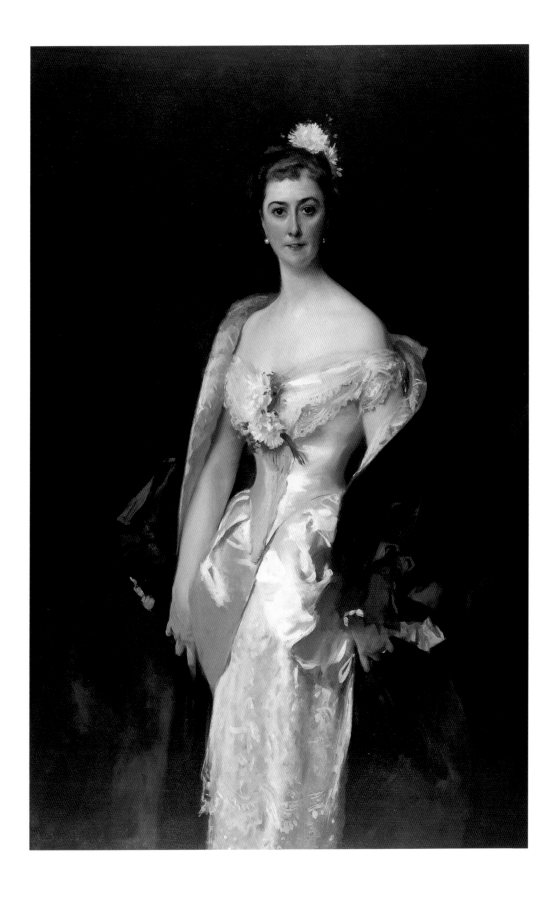

as a titled aristocrat. However, in place of the imposing setting usually referenced in grand-manner portraiture, Sargent isolates the marquise in a space meant to render her beauty as timeless. The weight of her status and position registered by her expression is reiterated by the opulence of her clothing and accessories. She stands in regal display, her dark satin wrap neither on nor off but rather exposing the full expanse of her pale shoulders and accentuating a long, graceful arm and slender neck. The figure of the marquise emerges almost seamlessly from the wrap and background, nearly equal to their opaque tonality, as if she needed no other prop than the sheer force of her personality.

The marquise's face is a fully realized likeness, rendered in the realist technique of smooth, imperceptible brushstrokes that create a sharply focused image. In contrast, Sargent depicts her gown with the broad, visible brushstrokes of Impressionism, a bravura display of painted surface. Sargent's highly textured use of paint evokes sensuality that the viewer translates into the textures of costly fabrics. Interestingly, flowers rather than jewelry set off her décolletage and head, as if the marquise herself were the jewel that crowns this ensemble. Her unadorned shoulders heighten the viewer's experience of bare flesh.

In contrast to Victorian attitudes of sexual purity as the basis of domestic bliss, which dominated American understandings of women at this time, Sargent uses the tactile sensuality of his painted surface to represent a life of seductive appeal. Sargent discloses the sexual allure encoded in the conventions of the society portrait by emphasizing the extravagances of satin and lace, exotic flowers, and the woman's bold gaze. Erotic metaphor links wealth and female sexuality by representing the marquise as an exquisite physical object. However, in spite of the provocative possibilities she conjures, it is her tightly set mouth, pinched expression, and the wintry, ivory hues of skin color and dress that remind viewers of the social boundaries she represents by rendering her presence cool and untouchably grand.

Robert Henri and his followers engaged their viewers in a very different image of the family than the portraiture of American artists who based their depictions on social norms of decorum and taste. Henri studied in Philadelphia and Paris during the 1890s and his early paintings reflect the tensions of realism and Impressionism that those cities represented and that Sargent explored to such eloquent effect.[34] When Henri moved permanently to New York City in 1900, he began working in a manner that would lead him to champion a group of emerging avant-garde artists there who had been rejected by the

National Academy of Design, known for its preference for impressionist and academically derived painting. These artists, who became known as "The Eight" (after the number of artists represented in a 1908 New York exhibition), created a visual vocabulary that reflected their commitment to the gritty, real-life portrayals of urban life (cat. 63, 72, 66, 68, *Works*).[35] Such subject matter has also earned the members of this group the popular name of the Ashcan School.[36] *O in Black with Scarf* (1910) (cat. 69) is a portrait of Marjorie Organ Henri, the artist's young wife of less than two years. O, as Henri called her, was a highly successful cartoonist for the *New York Journal*, and her caricatures of New York personalities appeared regularly in the *New York World*.[37] Marjorie Organ's work as a cartoonist probably recommended her to Henri, whose own paintings were strongly influenced by the affinities between a realist vocabulary and illustration.

Henri's portrait of Organ is consistent with his search as a member of the Ashcan School for a vocabulary that would allow him to represent a more commonly lived experience rather than that of a society preoccupied with decorum. In fact, Henri's depiction of Organ visually argues with the conventions of society portraiture as well as the assumptions about the kinds of family experience that would be communicated in a portrait such as Sargent's painting of the marquise.[38] Organ also stands isolated against a dark ground, her neck and face crowning the length of an elegant gown. The poses of the two women are strikingly similar in their regal formality and direct, confrontational gazes. Yet the sexual register could not be more different. In place of the cool, extravagant elegance and privilege represented by Sargent's traditional woman of society, Henri's vocabulary of psychological realism represents Organ as the self-possessed, assured, and liberated woman that was the feminist ideal of the day.

At the end of the nineteenth century, progressive women in Europe and America participated in what became known as the Reform Dress Movement. The constraining manipulations of the female body through bustles, whalebone corsets, and tight lacings were condemned both medically for their abuse of women's biological functions and socially for the restrictions they placed on women's freedom of movement.[39] In place of the hour-glass silhouette that limited a woman's activities to the drawing room, the ideal figure of the new woman displayed "the more flexible serpentine curvature of the modern body."[40] Such reforms in dress reflect a shift from clothing as a sign of class or an indicator of vocation to a more expressive measure of personality. Organ's slightly turned pose emphasises the more natural shape of her body, yielding the desired serpentine curves that were the hallmark

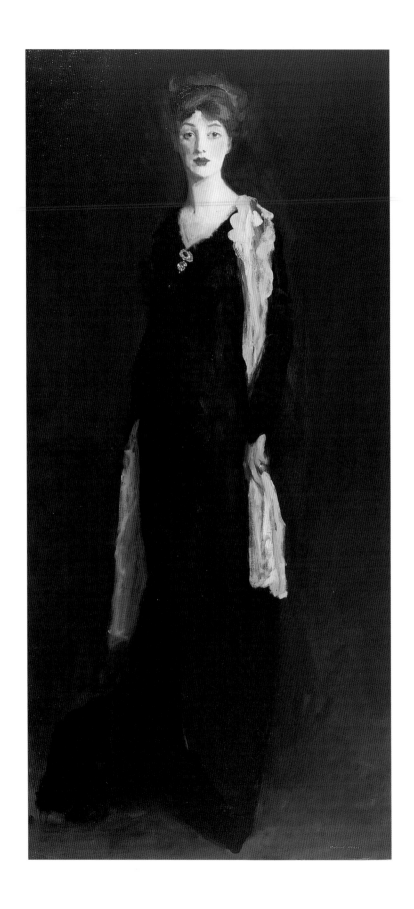

of this new, independent woman. The loose sketchy brushwork creates a sense of painterly movement that further reinforces the ideal of physical movement and liberation. As a member of the Ashcan School, Henri's independence from decorous painting conventions is the perfect foil for his remarkable portrait of Organ as a modern and culturally empowered woman of the twentieth century who is free from social conventions, befitting her status as his intellectual and artistic equal.

While Henri's painting is infused with the look of an artist deeply in love with Organ as an image of the emancipated, modern woman, his homage to her beauty is also encoded with the registers of a darker sexuality that the symbolists found in Freudian models of desire. However, he has replaced the menacing image of the femme fatale (cat. 38, *Works*), which the symbolists had used to designate the power of that sexuality, with a more open though no less insistent sensuality.[41] The warm tones of the dark background and the coupling of Organ's black dress with her flaming auburn hair and red pouting mouth point to assumptions about the role of sublimated sexual drives that dominated the new discipline of psychology and its discourse of forbidden pleasures and temptation.[42] She stares directly at the viewer, confident in her alluring beauty and the definition of a sexual identity that she controls. In the language of sexual politics, she disallows the mastering gaze that psychoanalytic models associate with male viewers and their visual prerogatives, asserting her own look and claiming the erotic power of her body and its image.[43]

Although it might seem surprising that Henri would represent his beloved wife in such overtly sexual terms, his image is consistent with the Ashcan School's determination to replace impressionist paintings, "which to them seemed superficial and decorative, with pictures that were intended to have a direct and strong effect."[44] Henri's portrait masterfully delineates the double register of pleasure and apprehension implicit in the psychoanalytic model of desire. By attending to each half of Organ's face, the viewer can clearly see how Henri collapses these two separate sensibilities: he paints the left half of her face according to ideal conventions of objectified feminine beauty whereas he presents its right half as a penetrating and calculating gaze. On the left he portrays the lovely image of an ingenue; on the right the more resolute personality beneath her surface appearance. Consistent with the new psychology and the realities of modern life that were the subject matter of Henri and his followers, her beauty is explicitly not naturalized as innocent, naïve, or dependent. Rather, Henri's portrait goes beyond superficial appearances, capturing the strong, internal social and psychological forces underlying the impact that Organ's fully embodied spirit has on his life.

Cat. 69
ROBERT HENRI
*O in Black with Scarf
(Marjorie Organ Henri)*, 1910

This series of portraits suggests how artists used specific visual vocabularies to portray family associations in a way that reinforced or contradicted the social beliefs of their times. Artists communicated not just images but social values through strategies of representation. That process begins early with the iconic flatness employed by the Freake-Gibbs Painter, whose painting reflects the typologies of a social order tied to family roles determined by religious doctrine. It continues throughout American history, extending to artists working within realist traditions of description, as evidenced by Robert Henri, whose paintings reflect his age's new studies in psychology and the changing roles of women created by the advent of modern urban life. Artists did not merely depict family life in America; they actively participated in its invention by their visual inscriptions based in the social, political, economic, and philosophical assumptions that formed the contexts of their lives and work.

PERSONAL CALLINGS/COMMUNAL CONNECTIONS

This essay has proceeded through a chronological survey of paintings to discover changing historical attitudes about individuals and families that are revealed by the visual mediations used in depicting them. It has focused on the portrait as a site of cultural negotiation, where values, from the public realm contend with private experiences and shape meaning. We now turn to a larger social unit, the community, examining the relationship of individuals to it by making a parallel survey from the colonial to the modern period. The relationship between family and community life lies at the heart of American cultural values because the communities in which people work and play hinge the private family lives of individuals to the public sphere. Even work accomplished in the home, the space of the individual and family, usually anticipates the public realm of commerce. And from the opposite pole, the landscape, which includes both rural and city sites, is the public arena where much of the work and play that people do takes place.

A group of sociologists working under Robert Bellah conducted a ten-year field-research project that sought to assess "what resources Americans have for making sense of their lives, how they think about themselves and their society, and how their ideas relate to their actions."[45] They found that from the colonial period to the present work has remained "typically the most significant link between private and public life."[46] They further point out that, from its earliest practice among colonial settlers, the practice of work has been invested with the religious notion of a "calling" in spite of how "difficult and often elusive" such a vision might be.[47] *Calling* is the belief that one's moral and ethical life is most fully realized when work is suited to one's place in a divine plan for the universe. "A calling links a person to the larger community, a whole in which the calling of each is a contribution to the good of all Work in the sense of the calling can never be merely private."[48]

Even in our contemporary and more secularized American society, the concept of an individual's calling that was articulated so clearly by the Puritans motivates the understanding of most people about their work. This perception remains in spite of the changing realities of the workplace that have replaced the idea of a calling with the twin concepts of professionalism and career that tie individuals to their own goals rather than the shared goals of the community. Paintings have been one of the primary carriers of calling and its powerful vision of work as artists used visual strategies to represent it within the moral and ethical categories of community.

Charles Willson Peale's painting of *Mordecai Gist* (ca. 1774) (cat. 4)

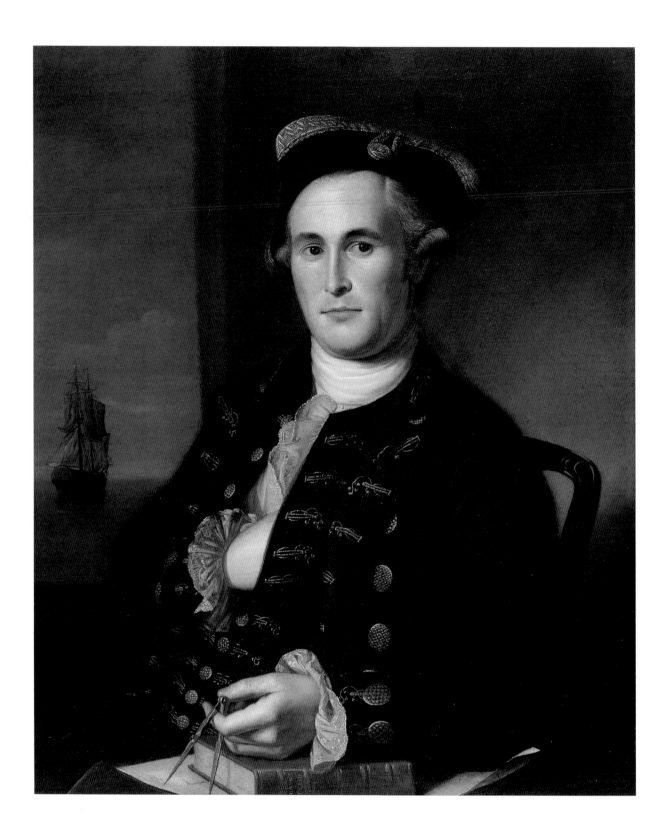

is related to the English portrait conventions of Sir Joshua Reynolds and the London Academy, where he studied under the American expatriate painter Benjamin West (cat. 9, *Works*).[49] However, in place of the links to social and political status typically referenced in grand-manner portraits, Peale has represented Gist through a collection of symbols that associate him with visual references to his mercantile calling as a member of Baltimore's entrepreneurial elite. Peale has loaded the painting with the signs of Gist's commercial venture: compass, map, and a book of Euclid's *Geometry*. His hand rests on the book and holds the compass with an easy elegance that is delicately drawn, suggesting a comfortable acquaintance with handling these tools. The painting emphasizes the psychological aspects of Gist's likeness that are registered in his expression by drawing the viewer's attention to his face, its luminous tones standing out from the midst of a canvas organized as an arrangement of brown hues. Consistent with the notion of his calling, Gist's direct, assured gaze and self-confident pose reinforce the viewer's sense that the man represented by this face is exactly who he was meant to be because he is comfortably engaged in precisely the activities that are suited to a larger purpose. The jaunty angle of his fashionable, three-cornered hat reinforces a personality that is slightly playful yet sensibly sincere as befits a dashing, thirty-one year old colonial businessman.

Although seated indoors at his writing desk, Gist is fulfilling his community calling, which is indicated by his ship that draws the viewer's eyes out the window into the harbor and the larger world of commerce where his tools have their practical uses. Gist's vessel sailing into a rosy light links his own fortunes to those of the community by turning it into the ship of state, a popular metaphor for the nation. The elegance of Gist's hat, coat, and vest with their ornate buttons and abundant embroidery provide a rich, decorative pattern. The visually elaborate display of reflective gold provides bright accents that not so subtly align Gist with wealth without the negative associations of an ostentatious setting, attesting to the success of both merchant and the country his business serves. In this manner, the painting explores a relationship between decoration and function on several levels at once, tracing the effects of paint on the material surface of the canvas, underscoring the optical splendor of Gist's attire, and providing a metaphoric understanding of the role of wealth in his calling.

Of course, work has its cultural flip side in leisure, whether it be the active participation of play (cat. 27), relaxed pursuit of ease (cat. 47, 50), or passive appreciation of entertainment (cat. 68, all in *Works*). As cultural critic Raymond Williams has explained, the very notion of leisure is inexplicably tied to work. The word leisure developed in the

Cat. 4
CHARLES WILLSON PEALE
Mordecai Gist, ca. 1774

fourteenth century from the Latin *licere*, which means "to permit," and was meant to designate both an opportunity and free time.[50] Beginning in the seventeenth century with the advent of paid employment under mercantilism, and even more emphatically under capitalism in the nineteenth century, work increasingly became a social relationship defined by the reciprocal roles between an individual and another person or group who controlled the means of production. This relationship divided the space of an individual's life into productive time spent working for someone else and free time spent in his or her own pursuit of leisure. Because the United States experienced its most explosive growth and expansion (especially geographically and economically) during the nineteenth century, the newly emerging capitalist structures dramatically shaped the ideological understanding of work and leisure for most people in the nation.

Perhaps no painting in the American collection at the M.H. de Young Museum better illustrates the relationship between work and leisure than George Caleb Bingham's *Boatmen on the Missouri* (1846) (cat. 11). If machines can be said to be the heart that powered the industrial revolution, major river systems were the arteries that sustained its life. In the United States, the Missouri River provided one of the country's significant conduits, not only connecting the western frontier established by the Louisiana Purchase in 1803 to the eastern seaboard, but also, as a tributary of the Mississippi, connecting the north to the south. By allowing ships to sail upstream, Robert Fulton's invention of a practical steamboat in 1807 was perfectly timed to make a reality of navigating the Missouri and Mississippi rivers deep into the territories of the Louisiana Purchase (cat. 17, *Works*). By 1830 nearly 200 steamboats were operating on the Mississippi River alone.[51] Bingham's painting of the steamship signals the importance of this technology for life on the western frontier of the United States. It moves off into the distance, upriver to the right of the river boatmen, providing the context of labor against which the boatmen's relaxed poses may be read.

Bingham was one of the first American artists from the western frontier to make a name for himself as an artist of prominent reputation. Although born in Virginia, his family moved to Franklin, Missouri, when he was eight years old and only a year before the infamous Compromise of 1820, which was to bring Missouri into the Union as a slave state. With few opportunities to study art in the western territories, Bingham was largely self-taught, earning a living first in portrait commissions.[52] After trips to New York and Philadelphia in 1838, followed by four years in Washington, D.C., from 1840 to 1844, Bingham returned to Missouri where he began

Cat. 11
GEORGE CALEB BINGHAM
Boatmen on the Missouri, 1846

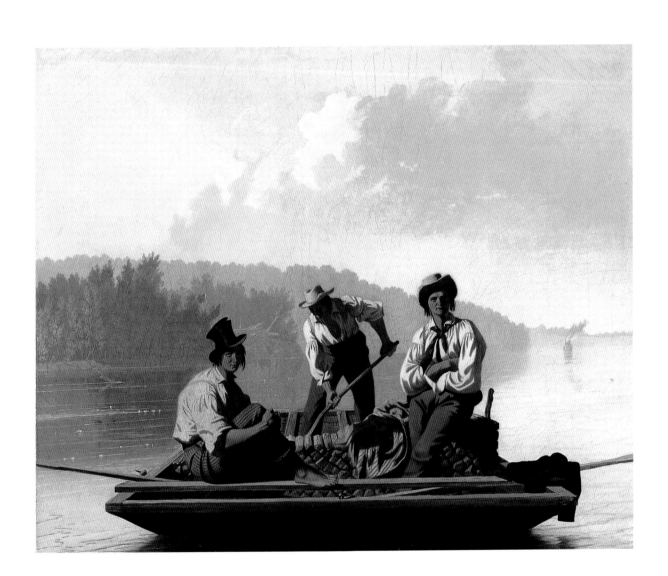

painting the western genre scenes for which he is so justly known. Even at the time he was praised for his paintings of river life and the politically populist scenes that characterized community gatherings in the western states (cat. 14, *Works*). Not merely an observer of political life, Bingham was elected to a seat in the Missouri legislature in 1848. In both his political career and his artistic output, Bingham celebrated the spirit of resolute independence and self-reliant ingenuity that gave mythic dimension to the notion of American individualism. It was an ideology that united people as different as frontier settlers and transcendental philosophers. Later, Mark Twain, one of America's most beloved writers, covered the same ideological terrain in *The Adventures of Huckleberry Finn* (1885) and other books as a way to explore the complex tensions left unresolved after the Civil War.

In *Boatmen on the Missouri* Bingham dramatically depicted leisure against the backdrop of work. Two of the figures do nothing but stare at the viewer, the third figure attending to an unseen task in the rear of the shallow boat. With its raised oars and relaxed poses, the carefully organized image creates an impression of suspended action that is reinforced by its visual vocabulary of classical balance and smooth, uninterrupted surfaces. Although the boat is depicted in motion, and a visible current belies the placidly reflective surface of the water, the flatboat and its occupants appear to be hanging in a timeless moment as they take their tranquil ease. The workers's unhurried repose suggests the rhythms of work and leisure that are a function of the natural life of the river itself, an impression that is at odds with actual conditions that would have inspired the painting. Boatmen working the rivers of the west such as those that Bingham depicts here were widely regarded as boisterous and vulgar scamps, whose violent antics made them powerful antiheroes and disrupters of communal harmony.[53] Moreover, by 1846 when Bingham painted this view of placid work, steamboats such as the one in the background largely had replaced the manual labor of the flatboat. By focusing on the outdated river boatmen instead of the steamboat, Bingham downplays both the commercial realities of the west and the actual lives of those who lived outside the controls and restraints of a stable social order.

Although based on actual river boatmen from a previous era, Bingham's painting, thus, turns to leisure from work in order to suspend its viewers in a nostalgic moment from a recent past that never was. Several critics have commented on the heroicizing effect of this strategy and its contribution to the belief that the American frontier was a guarantor of independence, self-reliance, and natural abilities tested by strenuous conditions (cat. 15, *Works*).[54] However, the visual language of Bingham's painting is even more telling then his subject

matter. The realist conventions of traditional genre scenes depict ordinary events in order to elevate them as exceptional moments of transcendent meaning. *Boatmen on the Missouri* appears to capture common laborers whose cycles of work and leisure are tied to the natural ebb and flow of the river, but its visual language transforms the actual historical conditions into a mythic reality.

Just as the painting suspends its viewers mentally between actual and mythic conditions, it also suspends them visually by organizing the scene according to the opposing languages of classical and romantic representation. The riverboat and its figurative grouping display classicism's linear emphasis on tightly controlled description and flat, geometric design that turns the river into a pastoral idyll. By contrast, romanticism's painterly qualities of atmospheric light and diagonal movement turn the riverscape into a picture of sublime action through its reflected triangles of sky, land, and water, which cause the eye to roam throughout the scene. This visual organization implies that the ordered design and clarity of classicism have the ability to domesticate the adventurous and visionary restlessness of romanticism. However, far from depicting the historical conditions of a region, Bingham's work actually displaces this national debate over classical and romantic ideals onto the experience of viewing his painting.[55] *Boatmen on the Missouri* offers a highly orchestrated visual argument for the frontier as a place where the perfect balance between work and leisure is as inevitable as the seemingly natural conditions of life on the river itself. Bingham's painting, thus, serves America's mid-century ideology of Manifest Destiny, a romantic belief that the United States was a country destined by natural forces and the character of its people to subdue the land from the Atlantic to the Pacific coasts.

The industrial revolution of the 1820s to the 1840s had changed the means of production significantly, and with them the social arrangements between labor and capital that defined American communities. In 1867 Karl Marx published *Das Capital*, his groundbreaking and now famous treatise on the relations between production and economic value.[56] In it he outlined the ways in which the entrepreneurial ideology that supported the notion of calling had given way to the bourgeois ideology of wage labor that fueled the modern world, or modernity, as it was usually called.[57] In Marx's adversarial explanation of bourgeois ideology, "the only activity that really means anything to its members is making money, accumulating capital, piling up surplus value; all their enterprises are merely a means to this end, in themselves of no more than transient and intermediary interest."[58] In place of the interdependence of individual work and community goals that the notion of calling encouraged, bourgeois

capitalism divided the community into classes according to proletarian workers and bourgeois owners and consumers. Not surprisingly, responses to these effects of modernity on American lives and communities were both positive and negative, depending on whether one emphasized the progress brought by industrialization or the dislocations it fostered. Visual artists contributed to both responses, often expressing an ambivalence that suspends viewers between these positive and negative poles.

In his painting of 1846, Bingham created an anachronistic picture that nostalgically hearkened back a generation earlier to the country's preindustrial era (cat. 16, *Works*). Thirty years later, when Thomas Eakins painted *The Courtship* (ca. 1878) (cat. 37), such nostalgia had become unambiguously reactionary. Although Eakins trained in Europe, as director of the Pennsylvania Academy of the Fine Arts he remained committed to the concept of an artistic tradition native to America: "If America is to produce great painters and if young art students wish to assume a place in the history of their country, their first desire should be to remain in America, to peer deeper into the heart of American life."[59] However, the America that Eakins had in mind was more the result of a poetic nostalgia than the industrially driven reality of his own age, as the vision of preindustrial work in this painting makes clear. The vision of work in this painting is drawn from a preindustrial period. Arguably Eakins is the American artist who most championed the conventions of realism with its allegiance to representations of the external world based on impartial observation and an attention to detail that supports the appearance of objectivity (cat 57, 61, *Works*). Yet as this painting demonstrates, that vocabulary could be used to create highly imaginary scenes.

In place of any references to industrialism, Eakins represents work as a handmade craft, divided by gender roles, and isolated from the world of social commerce. The use of "courtship" for the title of the work also retreats into the private and personal categories of family from the more public and communal sphere that working represented in the Gilded Age. Although Eakins has isolated this depiction of work within the confines of an indistinctly articulated room, the clothing and the type of spinning wheel clearly locate the period in the colonial era. Eakins was not out of step with his time in this interest in the colonial past. As a native of Philadelphia, the site of the 1876 Centennial Exhibition, Eakins was inspired by the colonial revival that the exhibition stimulated, which spread its influence throughout the decorative arts, fine arts, and architecture.

A certain irony is implicit in the very notion of the Philadelphia Centennial, which celebrated the past for its commitment to a

Cat. 37
THOMAS EAKINS
The Courtship, ca. 1878

progressive future, an irony that may be seen in Eakins's painting and his choice of subject matter. Spinning, itself, is a metaphor for narrative and history. The turning of raw materials into thread has been a staple of imagery for the turning of events into stories since classical antiquity. It underlies the personification of history as Clio, one of the female muses who presided over song and prompted memory.[60] An entire constellation of tropes has evolved based in this metaphoric symbol: we look for the central thread of a story, talk about weaving events into a recognizable pattern, and even spinning a good yarn. These tropes all share an understanding of the importance of the individual details in constructing an interconnected totality. To loose a single stitch is to risk unraveling the whole. A similar understanding underlies the assumptions that support the conventions of realist representation. It is in the precision of the details that the illusionary force of realism carries its ideological authority. For this reason, no matter how painterly—in other words, with what degree of visible brushstroke an artist paints—the success of a realist painting is judged by the way in which its details are incorporated into a convincingly unified composition.

In *The Courtship*, much of the image is rendered through obvious brushstrokes that call attention to this work as the product of painting. The space of the walls and the floor, especially, evinces an obvious delight in the various effects that can be used to depict a single surface. Eakins scumbles, hatches, daubs, and smudges the paint. He uses short, long, stubbed, and flowing brushstrokes. He paints the canvas with gestures that include spreading, scratching, streaking, rubbing, smoothing, and even drawing. These are the lessons he learned from Velázquez, Ribera, and the other great Spanish baroque realists (fig. 11). In particular, the young suitor, at rest and gazing uninterruptedly at the object of his affection, is composed through the variety of painterly effects that Eakins clearly enjoys. In terms of the narrative implied in the painting, this strategy aligns the viewer with the suitor's gaze and the privilege of looking that both the scene and the painted surface encourage as a natural activity. In this alignment, the gender roles are significant: the male figure, who embodies (literally in his painterly form) the work of the artist, gazes directly at the female figure, whose attention is diverted to her own work of spinning. Through this combination of narrative and painterly effects, Eakins establishes a hierarchy of gazes that move the viewer's look from artist's activity, to male suitor, to female

Fig. 11
Diego Velázquez (Spanish, 1599-1660), *Maria Teresa (1638–1683), Infanta of Spain*, 1651–1652. Oil on canvas, 13½ x 15¾ in. (34.3 x 40 cm). The Metropolitan Museum of Art, New York, The Jules Bache Collection, 1949, 49.7.43. © 1989 The Metropolitan Museum of Art. Photo by Malcolm Varon.

worker, to spinning wheel. Attendant to that movement is an increased attention to detail.

It is in the details that Eakins worked the hardest to create the believability of the scene in order to convince viewers of his antiindustrial ideology. In place of the painterly effects used to render the male suitor, Eakins effaces the evidence of his brushstrokes in the depiction of the female figure. The boy's face is shadowed and indistinct, whereas the young woman's features are completed with care and eloquently modeled to give the impression of smooth and supple skin. Her left arm is shapely in its classically drawn proportion, showing evidence of the anatomical structure that supports her activity. As viewers of the painting follow her attention on spinning, they are made to notice that the spinning wheel is depicted with all the specificity necessary to identify its working parts. One could build a working model based on the evidence provided in this image. The only missing part would be the spokes of the wheel, ironically rendered invisible by the activity of spinning.

The painting's emphasis on the act of spinning identifies the young woman in this scene with the preindustrial work of the home and the gender roles determined by the colonial family this courtship anticipates. The painting, therefore, is organized in both its narrative gazes and details to transform the young woman and her spinning wheel into a metaphor for narrative and history, representing a social scheme suited to preindustrial values. Eakins's nostalgic genre scene idealizes this relation and fixes it in an earlier historical moment through the logic of a realist vocabulary that makes it seem not only factual but the way things should be. Its values are at odds with the mechanized and accelerated change of natural resources into cultural objects, which is at the heart of industrialization. It should come as no surprise that the revolving wheel at the center of this painting serves as a symbolic critique of the revolution in social structures that were the result of industrialization.

The view of industrialism in Thomas Anshutz's *The Ironworkers' Noontime* (1880) (cat. 41) could hardly be more different from the sensibility expressed by Eakins's painting, in spite of the fact that the works were completed within two years of each other in the same city. The first fully realized painting of an industrial subject in American art, Anshutz's painting is structured through mixed visual codes that signal the conditions of modernity that had been brought about by the industrial revolution.[61] By his subject matter Anshutz anticipates the Ashcan School artists, many of whom he mentored at the Pennsylvania Academy of the Fine Arts when he took over the directorship from Thomas Eakins.[62] Because Anshutz was their teacher,

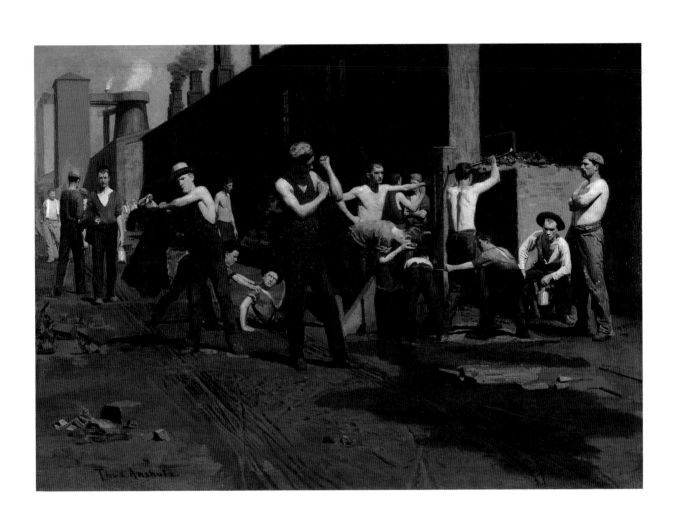

Fig. 12
Barthel Beham, (German, 1502–1540),
The Rape of Helen (frieze design), 16th
century. Engraving, .9 x 4.5 in. (2.4 x
11.6 cm). Achenbach Foundation for
Graphic Arts, Fine Arts Museums of
San Francisco, 1963.30.320.

and the artists of the Ashcan School the first to record the rough-and-tumble life as lived by immigrant and working classes in the city, it is tempting to interpret this painting in light of its less than ideal portrayal of urban life among the poorer classes.[63] The fact that Anshutz was close to the socialist movement adds support to this interpretation.[64] However, socialism was aligned with the concept of industrial progress as closely as capitalism, and Anshutz uses a realist vocabulary to pay tribute to these urban workers. But in order to create such a celebration in his painting, Anshutz, as did Eakins, hearkens back to the relationship between individuals and machines from a previous generation.

The painting depicts workers from an iron foundry that manufactured nails in Wheeling, West Virginia, a town where Anshutz spent much of his childhood.[65] In fact, the kind of foundry depicted here is much more typical of one from Anshutz's childhood during the middle of the century than one from 1880 when he painted this scene. However, Anshutz resists the sentimentality of the nostalgic perspective that usually accompanies a place associated with early memories. He avoids the familiar strategy of using romantic tropes of progress to applaud economic modernity by glossing over its disturbing effects on the land and the social organization of class in America.

And yet, the work remains celebratory in spite of its apparent commitment to unvarnished realism. It depicts heroic male workers, many of whom are stripped to the waist in order to show off their muscular bodies, through a vocabulary rooted in academic life drawing. The depiction of anatomical detail creates the illusion of an objective and naturalistic scene and yet the classically posed bodies invest the workers with heroic perfection. The display of multiple poses as these men stretch and bend resonates with the idealized, youthful athletes represented in Greek and Roman sculpture, as if they were spread across a commemorative frieze (fig. 12).[66] The resulting monumentality of forms belies the modest scale of the 17 by 23-inch painting and gives it the presence of a work with the much larger size of a traditional history painting. Anshutz's idealist visual language contrasts dramatically with the more gestural marks, turbulent bodies, and emotive

Cat. 41
THOMAS POLLOCK ANSHUTZ
The Ironworkers' Noontime, 1880

goals of the Ashcan School painters, whose realism was directed toward social criticism.

The nostalgia that motivates Anshutz's depiction is for a kind of work that was already passing away because of the increasing mechanism of industry. These men are "puddlers," the highly skilled laborers who produced the sheets of metal that can be cut into nails. The temperatures must be calculated exactly or the sheets will not be soft enough to punch out the nails or hard enough to make them durable. Further, the melted metal must be poured with precision and dexterity into the molds to insure an even quality in the material. Such exacting work demanded strength, agility, and endurance, qualities associated with a rugged manliness not needed by professional men whose jobs were largely confined to pencil and paper. In this way, Anshutz was participating in the Victorian period's perceived need to reinvigorate masculinity, especially bourgeois masculinity, which many believed to be threatened. Images of working class virility were an antidote to the feminizing influences on society, "not only by the proliferation of ladies' magazines and the genteel decorative arts, but also by the increased demand for mental rather than physical labor among the middle and upper classes."[67] By recalling the bodies and labor of workers from his childhood, Anshutz not only expresses his nostalgia for an earlier relationship between labor and industry, but also for a clearer and more traditional definition of masculinity.

But if the ironworkers themselves reflect nostalgia for an earlier, seemingly less complicated social order of masculinity and labor, the canvas is organized to reflect the social fabric of the period. The painting is divided between two competing spatial terrains. As discussed previously, the ironworkers themselves are displayed across a shallow foreground plane. On the other hand, the foundry is represented in a way that gives viewers a feeling of deep space. It appears to stretch from the foreground into the background as far as can be seen by means of a sharply angled perspective that vanishes almost exactly at the left-hand edge of the painting. This arrangement gives the painting a strongly dynamic movement that contrasts with the more static presentation of the workers. The sense of movement is reinforced by a visual pun: the boxlike buildings topped by smokestacks create the impression of a railroad train, and a set of parallel ruts, which extend from the foreground toward the same vanishing point, create a visual rhyme that recalls railroad tracks.

Such associations would have had widespread cultural resonance in the immediate wake of the nation's worst and most violent railroad strike of 1877.[68] The most potent symbol of industrialization at the time was the railroad. On the one hand, it was a sign of material

progress when showcased at the 1876 Philadelphia Centennial Exhibition and also of growth, as the newly completed transcontinental railroad testified. On the other hand, the high visibility of organized labor and the union activity accompanying the railroads spoke of a growing threat to those who feared that the industry would be used by political radicals to attack capitalism and its bourgeois supporters. Especially telling for Anshutz's painting was the support by the city's ironworkers for the striking railroad workers in Pittsburgh during the 1877 strike. Within such a context, the huge shadow in the immediate foreground turns the individual workers into an ominous dark mass that contrasts with their heroic poses.

As the nineteenth century advanced and the American landscape increasingly evinced the signs of industrialism, urban planners began to consider ways to integrate work and leisure more seamlessly into the life of communities. A belief in the ameliorating effects of nature inspired Frederick Law Olmsted's interest in urban parks, which he is credited with initiating in America when he and the young English architect Calvert Vaux won the competition for the design of New York's Central Park in 1858. Together they produced "Greensward," a new concept in city planning that integrated a rural space for play and leisure in the middle of New York's growing urban setting (fig. 13).[69] The concept brilliantly created intertwining paths to accommodate without collision pedestrians, horseback riders, and carriages. Places to stroll and meditate were sheltered from meadows and more active play by quiet dells and dramatic rock formations. Formal promenades and gardens alternated with wilder areas of informal lakes, woods, and thickets.

The result was a separation of functions and aesthetic purposes that was intended to promote democratic goals by providing a natural setting where all classes and interests would intermingle to mutual benefit.[70] Implicit in this concept was a commitment to the transcendental belief in the civilizing effects of human experiences in the realm of nature. "Nature had the power to touch and rearrange the souls and minds of all human beings, insisted Olmsted, and thus the authority to remind all citizens of equality."[71] In this way, his vision of Central Park was for a space that would provide the moral ground of community even in the large-scaled metropolis of New York with its wealthy industrialists, entrepreneurial capitalists, and growingly diverse immigrant populations. It reinforced his "long-held commitment to the concept that a park should bring together people of all classes and interests, thus promoting democratic ideals."[72]

By the turn of the century, when William Glackens painted *May Day, Central Park* (ca. 1905) (cat. 63), the vision of Olmsted and Vaux

Fig. 13
Otto Wackernagel (American, 1880–?), *Central Park South, New York*, 19th–20th century. Etching, 13.7 x 10.6 in. (35.2 x 27.1 cm). Achenbach Foundation for Graphic Arts, Fine Arts Museums of San Francisco, 1963.30.24477.

for a rural park within an urban center had become one of the corner-
stones of the Progressive movement. The newly rising middle-class
bourgeoisie, who composed the ranks of the Progressives, translated
the earlier values and related moral reforms of the transcendentalists
into a program of social uplift on behalf of the urban working classes.
Although moralistic in intention, Progressive activists were secular in
their rhetoric and more likely to rely on science and government
rather than religious institutions for their reforms.[73]

A key component of this Progressive program was the City
Beautiful movement, which called for a combination of beaux-arts
style buildings and public parks organized according to classical
principles of order, dignity, and harmony. City Beautiful proponents
believed that the external expression of these principles would con-
tribute directly to their internalization among the city's inhabitants,
leading to urban communities characterized by moral and civic virtues.
Although the City Beautiful movement was derived from a combina-
tion of earlier notions, the first explicit attempt to create an entire
urban center according to the principles of the City Beautiful move-
ment was the 1901 plan for Washington, D.C.[74] A central tenet of the
movement remained the urban pleasure park based on the design that
Olmsted and Vaux used for their Greensward plan of New York's
Central Park. In fact, beginning in the 1870s, Central Park became the
model for nearly every major urban development plan in America.[75]

As an illustrator for both the *New York World* and *McClure's
Magazine*, Glackens used his considerable skills to portray upper- and
middle-class New Yorkers enjoying the pursuit of leisure provided by
the rural retreat in the midst of the nation's most densely populated
city.[76] He joined his fellow Ashcan School artists in a visual language
that combined the descriptive legibility of realism with the expres-
sionist bravura of Impressionism in order to capture the fleeting
perceptions of urban life. However, unlike his fellow Ashcan artists,
Glackens was less interested in the social and political ferment that
characterized New York during the Progressive period.[77] In this he
more closely resembled his nineteenth-century French counterparts
in the avant-garde, Edouard Manet, Berthe Morisot, Edgar Degas,
and other Impressionists who took their inspiration from the commu-
nities of leisure that formed around the emerging bourgeois urban
classes (cat. 66, 70, *Works*).[78] Nevertheless, it is Glackens's hybrid
vocabulary that renders his paintings such a successful portrayal of
this May Day scene. From the language of Impressionism Glackens
took his broad, vigorous brush strokes with their evocation of vital
energy and the spontaneous moment that Progressives found in the
modern city. Yet he eschews the lighter palette of Impressionism in

Cat. 63
WILLIAM J. GLACKENS
May Day, Central Park, ca. 1905

favor of the darker tones of realism, which define the park and its mass of teaming children as solid and substantial.

Moreover, no matter how genteel the families of these well-dressed children, Glackens deploys a wealth of specific details to capture the rowdiness of their rough-and-tumble play. Although Glackens organizes his composition to create a single effect, he actually builds his painting out of an aggregate of individual moments. He offers viewers the highly particular narrative elements that are drawn from the incidental language of realist illustration. In the foreground on the far left a nanny struggles with her squirming young charge. Behind her an older girl in a blue dress stands isolated from the crowd, fixing her hair. Next to her, a young boy beats a drum. In the center, a couple of boys wrestle girls to the ground while their female friends watch, some passively and others with gestures that indicate pleading or anxiety. Another girl busies herself in solitary play with a bright red ball that she has tossed into the air. Two boys are climbing the central tree where the maypole leans with its bright ribbons that rhyme the festive holiday clothing of the children. Any number of children of both sexes can be seen playing tag or sprawled about the ground. Some are merely conversing. A pair of adolescents old enough to suggest the possibility of a romantic couple at the center of the crowd seem overwhelmed by the sheer exuberance of the chaotic play around them. In other words, far from being an undifferentiated mass, Glackens has taken care to present a visual catalogue of individual children and adolescents at play.

However, while the children represent the individual types that are characteristic of journalist illustrations, the impression of the scene is that of a single, dynamic summation. Above the children in the top half of the painting, Glackens creates a similar effect in the trees and foliage. Although different types of vegetation are clearly represented, the emphasis in the painting is on its highly gestural brush strokes, the greenery rendered in deliberate marks of obviously forceful impasto. A celebration of paint echoes the celebration of the scene's merrymaking. This doubling is reinforced by the large central tree and the maypole that mediate between the two halves of the painting both anecdotally and visually. In fact, the energetic handling of paint in the greenery deepens the viewer's impression of activity in the children below. Through this visual language that combines realist incident and impressionist movement, Glackens expresses the Progressive movement's ambivalence over the growing dominance of urban life and the kinds of communities it fostered.

Glackens depicts the bourgeoisie at play during May Day in Central Park, but at the time in America the first of May was also celebrated

among the working classes as an international labor holiday. The period of Glackens's painting was especially significant for the nearly forty percent of all Americans who were living in poverty.[79] In the summer of 1905, thirty-four American labor organizations met in Chicago for what was called a Continental Congress of the Working Class. The result was the formation of the Industrial Workers of the World (IWW), a radical union of unions that was nicknamed the Wobblies for its explicit commitment to toppling the class-based ownership of the means of production underlying industrial capitalism.[80]

Glackens presents those very ownership classes through the rowdy and rambunctious antics of a crowd of children. In this way he slyly evokes the chaotic lives of the laboring masses, the potential threat of disorder just below the surface that they represented, and the hopes of city planners in the civilizing role of urban parks. The painting operates as a metaphor for progressive reform, linking the park and leisure to the social communities that lived in dynamic tension within the city. This metaphor is given force by brush strokes that translate the language of progressivism, with its emphasis on the values of aggressiveness, strength, and vitality, into a visual vocabulary of painterly gestures that mark the canvas in similar terms. It offers the promise of the twentieth-century city as a visionary place that combines action and beauty, work and leisure, and ultimately affirms both the individual and the community within the social organization of industrial capitalism.

During the forty years from the railroad strikes of 1877 to World War I, the character of labor and industrialism changed so dramatically that an ideological retreat into a pre-industrial past such as Eakins proposed could no longer be sustained. The early years of the twentieth century, especially, were a time of optimism that was fueled by a sense of progress based in scientific and technological advancement. In 1880 at Menlo Park, New Jersey, Thomas A. Edison demonstrated the application of electricity to the power dynamo, which would initiate an explosion in industrial production.[81] In a famous account of the 1900 Paris Exposition, the American intellectual historian Henry Adams was so astonished by his experience of the dynamo that he declared it was the symbol of an entirely new historical age, writing that "he found himself lying in the Gallery of Machines at the Great Exposition of 1900, his historical neck broken by the sudden irruption of forces totally new."[82]

The applications of electrical power for new industrial work were rapid, increasing from under two percent in 1889 to thirty percent by 1914.[83] Advances in metallurgy also had a profound effect on industry and the rapidly changing face of work in America. From 1900 to 1920,

the production of iron and steel tripled, allowing for buildings that could reach previously unthinkable heights.[84] Together, steel and electricity created the conditions for a new kind of building, the skyscraper. These new buildings were made possible by the supple strength of steel that supported their graceful heights and the powerful electrical elevators that were necessary for their soaring towers to be functional work spaces.

Charles Demuth's painting, *From the Garden of the Château* (1921) (cat. 74), used a new visual language to celebrate these powerful conditions. Americans had been introduced to the visual shocks of modern avant-garde painting in Europe through the Armory Show in 1913.[85] The abstract movements of the School of Paris—notably symbolist, fauvist, cubist, orphist, synchronist, and dadaist—generated hostile responses among the general public and more traditionally minded artists and critics as well. Marcel Duchamp's *Nude Descending a Staircase No. 2* (1912) (fig. 14) and his readymades (fig. 15) were singled out for special ridicule.[86] However, it was in the 1920s that a number of American artists developed their own approaches to modern representation in the language of Precisionism.[87] Although not a self-conscious group, these artists shared a common interest in urban and industrial themes, which they rendered in a manner that synthesized the principles of avant-garde abstraction and America's longstanding interest in realism (cat. 77, 78, 84, *Works*). They were, however, shown and promoted as a group by several New York galleries, most notably Alfred Stieglitz's gallery 291, The Daniel Gallery, The Bourgeois Galleries, and The Downtown Gallery.[88]

Fig. 14
Marcel Duchamp (French, 1877–1968), *Nude Descending a Staircase No. 2*, 1912. Oil on canvas, 57½ x 35 in. (146 x 89 cm). The Louise and Walter Arensberg Collection, Philadelphia Museum of Art, 1950-134-59.

Fig. 15
Marcel Duchamp (French, 1877–1968), *Fountain*, 1917/1964. Assisted readymade: porcelain urinal, 14.4 x 19.2 x 24.4 in. (36 x 48 x 61 cm). The Vera, Silvia, and Arturo Schwarz Collection of Dada and Surrealist Art, The Israel Museum, Jerusalem.

Cat. 74
CHARLES DEMUTH
From the Garden of the Château, 1921 (reworked 1925)

Demuth's painting depicts the view out his second-floor studio in his family's Lancaster, Pennsylvania, home.[89] Although the buildings themselves present an unremarkable view, Demuth uses the conventions of precisionist painting in order to turn them into a radiant ovation to industrial innovation and progress. The scene depicts a laundry, emblematic of the new uses for electrical power in the modern city. The bright, blue-toned electrical insulators on the side of the building in the immediate foreground, and repeated on the telephone pole in the background, signal the dynamic character of the site. They connect the forceful visual lines that radiate throughout the painting to the energy of urban life that electricity makes possible.

Demuth organizes the pictorial arrangement of forms according to the breakdown in spatial planes that characterizes Cubism's emphasis on multiplicity and simultaneity. Although his precisionist language does not shatter forms into the riotous facets of Cubism's many perspectives, it does reduce them to flattened, simple, geometric shapes that share a single plane. In this way it participates in Modernism's rejection of Renaissance assumptions: the picture plane no longer serves as a window through which the viewer appears to look at an illusionistic scene of three-dimensional depth created by linear and atmospheric perspective. In place of this illusionistic depiction, Precisionism represents the visual tensions of the shapes themselves and presents them as a metaphor for the rational organization that is meant to reflect the order and logic of human culture.

It may seem odd in the wake of World War I to applaud order and logic. But for most Americans, the war, which was perceived as a European-based imperial civil war, did not destroy their faith in progress but only made the necessity of creating a bond between technology and democracy seem more urgent.[90] In keeping with this belief, Demuth's painting honors the modern machine age, implying rather than depicting the people who inhabit it. Although the image is devoid of individuals, the active presence of human intentionality may be seen in the reduction of an actual place into the flat, precise, ordered space that represents an intellectual construction. This mental work is made visible through the organization of lines that simultaneously define the shapes and reference the explosion of electrical forces that constitute the urban scene.

The lines emanate from every edge of these shapes, extending across the canvas in an intricate web of intersecting trajectories that echo and correspond metaphorically to the literal electrical power lines depicted in the painting. As one art historian has noted, these lines "carve the sky into slices" in a way that creates a pulsating and luminous series of overlapping modulations of color.[91] Through his

precisionist vocabulary Demuth uses the force of electricity to link the human sphere of urban architecture with the natural space of the sky. The result is a depiction that captures the defining tensions within the modern industrial conditions of work: dynamic movement versus stable engineering; transparent light versus solid, geometric color; rationally ordered space versus random pattern; human thought versus bodily absence; abstraction versus figuration; and work versus contemplation. It is a familiar American vision that confidently acclaims, as the painting's title implies, a belief in the compatibility of the machine and the garden.

During his inaugural speech in March 1929, Herbert Hoover, the new president of the United States, stated with breathtaking optimism that "The almost unbelievable magic of industry during the truly incredible decade just past has been so continuously amazing as to lead the mere inexpert bystander to be ready for almost anything in the field of material achievement."[92] However, this optimistic vision of work as an arena where industrial technology and human endeavor confidently meet in a mutually supportive relation was cut short by a worldwide depression, which hit the United States with devastating effects after the New York stock market crashed in October 1929. Millions of American workers lost their jobs and breadlines swelled.[93] As social and political conditions became more acute for the average worker, artists returned to a visual language rooted in the vocabulary of realism.

Reginald Marsh was one of a group of artists who were known as social realists for their portrayals of the everyday conditions of average Americans (cat. 79, 83, *Works*) . Social realists often sympathized with a progressive critique of American industrial interests, which they saw as exploitative of labor in the pursuit of corporate profits.[94] Many of them worked as illustrators for populist newspapers and magazines that promoted socialist and liberal solutions to America's economic depression and its social dislocations.[95] Marsh and his fellow social realists in general were reaching back to the traditions of the Ashcan School painters that preceded the avant-garde experiments in abstraction during America's progressive boom years at the beginning of the twentieth century. Just as the Ashcan artists before them, social realists took their inspiration from the urban working classes, seeking a visual vocabulary that would portray the vitality and dignity of the communities they formed in America's cities (cat. 81, *Works*). As first a student and subsequently a teacher at the Art Students' League in New York City, Marsh developed his realist vocabulary from studying Renaissance and baroque masters.[96] However, he applied their pictorial language to depictions of the proletariat who were experiencing

hard times during the depression. Marsh was self-conscious about the need for a social realist vocabulary derived from premodern artists. He stated: "I believe that if we follow the great masters and paint from our own experience, we shall contribute valuably."[97]

Reginald Marsh's *The Limited* (1931) (cat. 80) is rendered in tempera, a medium well suited to Marsh's classically trained drawing skills and commitment to realism.[98] However, his social realist vocabulary goes beyond the language of realism and its allegiance to detailed observation of the external world through an objective viewpoint. Social realists informed this earlier definition of realism with their own progressively committed point of view based in the language of the document. In general, documents are meant to provide evidence of tangible experience, a role particularly suited to the writings of progressive and socialist reformers who desired to create convincing depictions of noble workers who were struggling under the constraints of an industrial capitalism that was insensitive to their social conditions. The descriptive vocabulary of the document accomplishes its purpose by convincing the viewer of a specific viewpoint through the clarity and precision with which it presents apparently verifiable facts and narrative illustration.[99]

At first glance, *The Limited* appears to celebrate industrial progress through the language of social realism even more surely than does Demuth's quieter, precisionist painting of an urban laundry. A train races diagonally into the foreground at an angle that enhances the impression of speed. A cloud of smoke from its engine dominates the entire sky with its billowing sign of harnessed power. Aligned with the left edge of the paintings, a row of electrical poles recedes toward the same vanishing point as the train, linking the grand romance of the railroad to twentieth-century technology. Everything in the painting appears to be rushing almost vertiginously into the future. It is only upon close inspection that the viewer becomes aware of the three men in the bottom left-hand corner who are passively watching the train as it cuts a strong perspectival wedge across the canvas. "Limited" is a transportation term that refers to the express trains, which skip local stops. Appropriately, these workers watch as the most potent symbol of industrialization speeds into a future that literally is passing them by. The pointed narrative scene renders the impact of industrial capitalism on the working community through a highly charged political vision: in place of the heroic laborers depicted in Anshutz's *The Ironworkers' Noontime*, Marsh's painting depicts a technological society that has no interest in the working class and local communities.

Cat. 80
REGINALD MARSH
The Limited, 1931

Although also aligned with leftist politics, Aaron Douglas turned to a different visual vocabulary than the documentary mode that characterizes social realism. During the 1920s, African Americans created a thriving culture of jazz, theater, literature, and visual art in New York City's Harlem district. Known as the Harlem Renaissance, this artistic explosion created a cultural community of African Americans who set about celebrating the opportunities of modern urban life in a language that drew inspiration from their common heritages as people of African descent. In 1925 Alain Locke edited *The New Negro: An Interpretation*, an anthology of writings by African Americans that largely defined the general public's understanding of the movement. Douglas provided illustrations for the anthology, establishing the visual conventions that defined its blend of modern optimism and stylized abstraction. Even during the 1930s, Douglas continued to believe in the promise of industrial and technological progress to create unlimited possibilities when coupled with modern cultural forms.

Aspiration (1936) (cat. 82) is part of a four-part mural cycle that Douglas created for the "Hall of Negro Life" at the 1936 Texas Centennial Exposition in Dallas.[100] The cycle reflects the optimism among African Americans that lingered well after the halcyon days of the Harlem Renaissance in New York City during the 1920s.[101] Although sited in New York City's Harlem district, this cultural gathering of African influences and traditions promoted an awareness of the multiple nations bound together by the transatlantic experiences of diaspora and the middle passage.[102] But as Douglas's painting makes clear, African tribalism was not the handmaiden of European decadence, in spite of declarations by Western avant-garde artists. These European-trained artists had developed a modernist vocabulary through their racialized negrophilia, which reduced African traditions to the exotically sensuous and instinctively immediate.[103]

In contrast, Douglas organizes his visual image of African heritage according to a highly rationalized, decorative scheme that emphasizes geometric restraint and deliberate knowledge. The fettered hands reach up in a gesture that links them together literally and figuratively within the common community of labor that was constituted by the experience of slavery. Consistent with the ideology of the Harlem Renaissance, Douglas aligns these hands with a tiered platform, suggesting that this untrained but vernacularly self-taught community provides the foundation on which an invigorated and modern African American triumvirate of skilled labor stands. The three monumental figures emblematically represent the transformation from the forced labor of chattel to a community of modern workers inspired by leaders

Cat. 82
AARON DOUGLAS
Aspiration, 1936

trained in literature, science, and engineering, as symbolized by the book, beaker, and globe beside the figure with compass and right angle. As a further celebration of African heritage, Douglas uses the pictorial conventions of Egyptian figurative representations that combine frontal and profile images.[104] In this way he inflects the flattened, abstract language of avant-garde modernism with a visual vocabulary that links Egypt to Africa. Presented no longer as the precursor of Greek and Roman conventions, Douglas situates Egyptian art within an African rather than a European cultural trajectory.

However, the clearest expression of optimism regarding the modern industrial economy is indicated by Douglas's soaring utopian vision in the distance of a brightly lit factory and towering skyscrapers. Notably, by the focus of their attention, the three monumental African figures point the viewer toward this secularized version of the Puritan's "city on a hill," an appropriation of the religious millennial ideology that supported their notion of a calling.[105] This complex vision of work and community defined by the shared heritage of slavery is held together visually by an interlocking pattern of expanding five-pointed stars and concentric circles, important elements within avant-garde vocabularies of symbolist abstraction as well as leftist political imagery. The utopian promises of the modern industrial city combine with the history of African heritage and reverses the racial exoticism on which the European language of avant-garde abstraction was based. In the midst of the depression Douglas offered a vision of hope through his image of African Americans who had transformed their own history of oppressive slave labor to create a supportive community united in the promise of a heavenly city.

INDIVIDUAL MEANINGS/SHARED GOALS The realms of family and community define fields of interaction that most individuals experience directly. By contrast, the concept of nation defines a public realm that requires an engagement more philosophical and psychological than tangible and corporeal. Because of the range of communities that comprise it, the nation is a concept that practically guarantees the contest of many interests and beliefs. As a result, individuals experience their relation to the cultural forms of the nation through the communities that claim their personal loyalties. However, these loyalties are given added force by symbolic forms, which constitute the ideological ground of national identity and authorize its existence. In some ways, the rhetoric of the American Revolution reinforced this more diverse notion of nation by insisting on the moral superiority of egalitarian and pluralistic values over and against what was viewed as a European commitment to hierarchy and conformity.[106] Defining their own political futures at the same time as the concept 0000of nation acquired its modern political character, North American settlers struggled to define the relation between personal and public life in terms of a national identity. That struggle, not surprisingly, engaged the affections of painters seeking to give visual expression to the values and beliefs of the families and communities that asserted their own allegiances.

The essay returns a final time to the colonial period in order to rehearse the country's history, this account tracing the engagement of painters with the concept of nation, the third and largest domain of individual affiliation. The earliest question for those concerned with the emerging vocabulary of American cultural forms was whether to claim the mantle of Europe's western progression or create an indigenous language. These opposing ideas, which defined the visual vocabulary at the founding of the United States of America, continue to influence current national debates over the role of western traditions in a multicultural society. During the late eighteenth century that debate would not have employed the contemporary language of multiculturalism. However, among the English-speaking settlers who revolted against the colonial rule of England's monarch, George III, who had come to the throne in 1760, the question of the proper cultural relationship between Europe and the United States did key the discourse of tradition to the language of heritage. The resulting discourse, which is also central to multiculturalism, relies on the vocabulary of legacy, legitimacy, inheritance, and generational conflict, but is inflected with a more radical sensibility.

As we have seen in the section on family, America's most accomplished eighteenth-century painters often borrowed European

Fig. 16
Benjamin West (English, 1738–1820),
Death on a Pale Horse, 1796. Oil on
canvas, 23½ x 50½ in. (59.7 x 128.3 cm).
Founders Society Purchase, Robert H.
Tannahill Foundation Fund.
Photograph © 1985 The Detroit
Institute of Arts, 79.33.

painting's tradition of the Grand Manner that used symbolic props as indicators of social and political status. In such painting, status was associated with the neoclassical influences of the European academies and their hierarchical ordering of painting into the salon-based categories of history, portrait, still life, genre, and landscape.[107] Within this classification system, the highest form of expression to which an artist could aspire was history painting, which was drawn from literary sources and included mythological subjects. American artists who desired to be acknowledged on a world stage understood the importance of creating large-scaled historical paintings. At the Paris Salon of 1802, the French greatly honored American expatriate Benjamin West, who had become president of London's Royal Academy after Sir Joshua Reynolds, explicitly for his reputation as a painter of historical subjects. His own entry to the Salon, *Death on a Pale Horse* (fig. 16), was admired by Napoleon Bonaparte, and West was invited to join the cortege as the general continued to tour the rest of the exhibition.[108]

However, it was not the expatriate West, or any of the other Americans associated with London's Royal Academy, who was the first artist to exhibit at one of the Paris Salons. In 1800 John Vanderlyn gained that distinction with his self portrait of the same year.[109] In his self portrait Vanderlyn adopts both fashion and techniques from the French tradition, signaling his desire as an American artist to be a legitimate heir to its visual language. That desire was given its greatest encouragement at the Paris Salon of 1808 where his *Caius Marius Amid the Ruins of Carthage* (1807) (cat. 7) won a gold medal.[110] Vanderlyn was himself decidedly continental in his European tastes, preferring the painting traditions of France and Italy to those of England. American attitudes toward France shifted considerably from the end of the eighteenth century to the beginning of the nineteenth, as the excesses of the French Revolution came to embody (often literally in political caricatures) the fears of conservative Americans rather than their democratic ideals. West's association with London's

Cat. 7
John Vanderlyn
Caius Marius Amid the Ruins of Carthage,
1807

Royal Academy had been a factor in the choice of England as the usual European destination for aspiring American painters. By contrast, anti-British, republican politician Aaron Burr's patronage of Vanderlyn's studies in the Parisian atelier of François-André Vincent made Vanderlyn sympathetic to the heritage of France and its traditions.

The atelier tradition that dominated French artistic training guaranteed that Vanderlyn would spend time drawing from live, nude models, which is evident in the keen sculptural lines, close attention to anatomy, and smooth surface of his monumental portrait of Caius Marius. In addition, the French tradition, which had developed to support the moral values of the Revolution, offered him a vocabulary of psychological depiction that was rooted in the human body and its gestures, providing Vanderlyn with a way to create powerful messages and present them in the language of aesthetic ideals. Drawing inspiration from Plutarch's *Lives*, Vanderlyn uses the literary narrative to dramatize his own understanding of the relationship between individual character and political fortune.

Marius had been a military leader and member of the Roman consul who fell from power during the political turbulence of the Roman republic during the second century B.C.E. Fleeing to Carthage in North Africa in hopes of gathering an army that would conquer Rome, his life was threatened and he was denied asylum. Using the symbolic vocabulary of French history painting, Vanderlyn paints the famous general seated as a military hero, yet defeated in his ambitions. The ruins of Carthage mirror Marius's own ruin and suggest that in failing to recognize a noble leader, the city is itself doomed to fall. In protoromantic fashion, the ruins of the city are symbols both of its decay and former grandeur. The jackal running across the rubble is an emblem of the Egyptian god Anubis, who presides over tombs and weighs the heart of the deceased in the scales of justice. However, by transforming the animal into a fox, Vanderlyn connects the moral meaning of this tableau to an American subject.

All these associations suggest that Vanderlyn may have meant for the painting to be an allegorical portrait of his patron Aaron Burr. A well-respected New York politician, Burr's fortunes were reversed after becoming vice president under Thomas Jefferson in 1800. Having earned the enmity of Alexander Hamilton, his rival in New York politics, Burr became a legal refugee when he fatally wounded Hamilton in a duel. Frustrated at his ineffectual role under Jefferson, Burr conspired in an impossibly grandiose scheme. With an Irish expatriate named Harman Blennerhassett and the governor of the recently acquired Louisiana Territory, James Wilkinson, Burr attempted to take over the land west of the Mississippi, secede from

the United States, use his new power base to invade Mexico, and set himself up as head of a new political empire.[111] The ill-conceived plot was discovered, and although acquitted in a trial for treason, Burr's fortunes never recovered. He died isolated and embittered. Burr and Marius shared parallels of virtuous character, public service, overweening hubris, and investment in eventually self-destroying schemes. They were well-suited to the French tradition of history painting in its use of classical scenarios to reference contemporary events.

However, despite the effectiveness of the setting in conveying a narrative to viewers, it is the physicality of Caius Marius's body that commands attention. More than a symbolic icon, his body metaphorically articulates the power of the individual relative to the power of the nation. Specifically, Marius reinforces an image of independent, confident, virile, and active masculinity, despite his obviously defeated circumstances. In this way his body displays characteristics appropriate to both his gender and the nation he represents as one of its political and military leaders. Sitting in a relaxed yet upright, erect posture, firmly grasping the scabbard of his sword, Marius gazes intensely forward, though not at the viewer. Meditative rather than direct, his look is intellectually concentrated. Some critics have suggested that the image indicates a brooding Marius plotting his revenge.[112] Contradicting the deep psychological trouble legible in his face, the open drapery and towering placement of his torso in the immediate foreground emphasize Marius's firm, well-defined, muscular male form as an ideal of honest resolve. In fact, the cloak and tunic have fallen away to reveal his bare upper torso and a large, strong leg, exposing his powerful physique in a manner that suggests the heroic athlete of classical Greece and Rome with a register of sexual potency as aesthetic ideal.

This image of the masculine ideal was part of a highly coded visual vocabulary that defined men and women according to the gendered assumptions inherent in European cultures in the nineteenth century. Vanderlyn's painting draws on the tradition of the nude figure in European art that participated in this language of gender. This way of seeing uses a system of related oppositions to encode male and female bodies with cultural norms associated with that visual difference. In contemporary critical discussions this difference has been explained as a function of spectatorship, or the relationship between the painted image and the viewer. Most simply, men and women are positioned respectively as active and passive, a dynamic mirrored in social, political, and cultural relations that make these roles appear natural (cat. 59, *Works*). Art historians interested in gender attempt to disentangle this condition of visual display by identifying cultural ways of seeing rather than accepting difference as a natural fact.[113]

Through a visual language of gendered identity, Vanderlyn establishes the vocabulary of idealized masculinity as a metaphor for a regenerated body politic. The founding of the United States of America near the end of the eighteenth century coincided with republican political theory and its rejection of the courtly assumptions of aristocracy in favor of a society organized around the profitable exchanges of middle-class Capitalism. Having overthrown their colonial status by depicting the English monarchy as a government based in a superficial and ineffectual aristocracy, the founders needed a new visual language of power to redefine the moral authority of the nation. Vanderlyn's painting uses its gendered vocabulary as a visual argument for the means by which the new nation might claim a European cultural language for its own. The highly gendered masculinity of Caius Marius is as much a metaphor for the conditions of a prosperous capitalist nation as a virtuous republican one. However, Vanderlyn's appropriation of this European model did not meet with the acclaim for which he hoped. In spite of its gold medal at the Paris Salon, no market existed for his painting when he returned to the United States.[114] It would not be the heroic body of antiquity that would capture the imagination of Americans as they developed an indigenous language to give visual shape to their understanding of national experience.

Thomas Cole's monumental painting *Prometheus Bound* (1847) (cat. 13) illustrates the direction that American artists would take in their quests for a visual vocabulary to express the philosophical and psychological experience of living in a new and expanding nation. Cole's painting follows the model of traditional history painting by taking its subject from a literary source, but Cole focused his painting on the grand mountainous setting rather than the heroic figure of Prometheus. Reversing Vanderlyn's strategy of emphasizing the figure, Cole appropriates the conventions of the nude in European history painting and thus locates moral meaning for American art in the language of landscape rather than the classical body. In his Greek tragedy, *Prometheus Unbound*, Aeschylus narrates the story of the Titan Prometheus, who defied the wishes of Jupiter by bringing the gift of fire to aid human civilization. According to the mythological account, Jupiter in his anger had Prometheus chained to a rock on Mount Caucasus in Scythia, where he was exposed to all the extremes of temperature and the elements. Even more gruesomely, he was condemned to have his liver devoured by a vulture each day, only to have it renewed and then devoured again. Because of the risk taken by Prometheus in defying the gods on behalf of humanity, his story was

Cat. 13
THOMAS COLE
Prometheus Bound, 1847

a favorite of literary and visual artists, especially the romantics, who valued the virtues of independence, rebellion, and uncompromising sacrifice.

In spite of the opportunities that Prometheus afforded the artist as a heroic figure, Cole did not emphasize the moral meaning usually encoded in the ideal classical body. In contrast to Vanderlyn, who set up an encounter between the spectator and the figure of Caius Marius, Cole staged his spectacle as an encounter between the viewer and a monumental and vertiginous panorama. Although Cole prepared a sketch of Prometheus, he seems almost indifferent to the anatomy of this nude. X-ray analysis suggests that the figure was painted only once, without being worked up in the neoclassical manner of lifelike modeling.[115] Prometheus is represented as a nude to indicate that Cole's aspirations for this work fell within the sphere of history painting, the highest category of judging at the European salons. However, the figure is a mere cipher, its slightly awkward handling in contrast to the bravura treatment of Cole's landscape, the true subject of his painting. Even the vulture beginning its ascent in the foreground is painted with more finesse than the figure of Prometheus. Cole's visual strategy is to shift the work's focus to the landscape, the lowest category of painting in the Salon, while still claiming the grand aspirations and noble quality of history painting.[116]

Cole's gambit was consistent with the emerging sensibility of romanticism, which emphasized the ethical value of powerful emotional experiences. In the language of romanticism, the natural world and art were twin routes to moral understanding. Both were capable of leading those who contemplated them into a heightened state of awareness, even transcendence, through an emphasis on the sublime. For this reason, the combining of nature and art in landscape painting gave it a new and elevated significance. The English philosopher Edmund Burke in his *Philosophical Inquiry into the Origins of Our Ideas of the Sublime and Beautiful* (1757), defines the sublime as an experience of emotional excitement that suspends its spectator in a state of terror and dread.[117] This effect is antithetical to an experience of the beautiful, which Burke identified with the classical traditions. According to Burke's theory, beauty composes the soul by creating an emotional feeling of order, balance, and harmony, which reassures its perceiver and inevitably leads to passivity and moral complacency. The sublime, on the other hand, unsettles the soul by creating impressions of chaos, disparity, and anxiety. It moves those who experience it to action by initiating a sense of heightened awareness that leads to a change in consciousness.

Within the economy of the sublime, the psychological state of terror was believed to be the most extreme emotion available to human beings, and thus it became the most highly prized route to this desired state of heightened awareness. As a corollary, pain was viewed as one of the most effective agents of the sublime because its anticipation creates fear or dread, which then heightens a person's physical sensation of terror. In Prometheus, Cole created a picture of pain. The notion of the sublime provided a theory of human psychology that supported the turn away from the inherited weight of European traditions in American art toward exactly the kind of encounter with unfamiliar terrain that the vast continent seemed to offer to the people of the new nation (cat. 51, *Works*).

Cole's painting directly engages its viewers with an experience of the sublime. Its monumental scale overwhelms the eye and makes it impossible to take in the entire image all at once. The setting itself is a landscape of momentous proportions, signaled by the diminutive size of the vulture in the lower foreground and the ice-covered, craggy peaks that sweep into the distance. A deep chasm opens at the bottom right of the painting, positioning the viewer over its plunging abyss. The mountains are painted as if they were roiling waves about to crash over the spectator, with Prometheus chained to the leading edge of the nearest crest. The strong diagonal organization of the scene and the apparent rushing movement of the landscape from right to left create a sense of the terrible force of nature that the romantics believed was the precondition of the sublime.

At the same time, an inverse triangular space occupies most of the upper portion of the painting, recording a vast and empty sky that stretches far into the distant night. At the lower left edge of the work, the rising sun signals daybreak and provides the opportunity for Cole to create the subtle tonalities and luminous light that conveys the painting's transcendental effect. The position of Prometheus as a crucified figure at the apex of the central peak links Christian assumptions to a transcendentalist understanding of nature as the source of moral values.[118] The deep stillness and quiet luminosity of the sky contrasts dramatically with the terrain and its tempestuous resonances. Jupiter, a lone star, emphasizes the expansive emptiness. The spectator thus remains suspended between these two emotional extremes represented by the calm of the empty sky and the turmoil of the jutting ridges.

A further oddity adds to the physical uncertainty of the viewing position. Because he is a human figure, Prometheus establishes a sense of scale that gives the impression he is near the viewer, which is supported by the detail in the rock outcropping on which he hangs.

However, on closer inspection of the trees at the base of the cliff, it becomes obvious that the distance is much further than the scale of the figure would suggest. The logic of the conundrum is easily explained by the realization that although Prometheus has a human form, as a Titan his body would be much larger. The vulture in the lower foreground more accurately determines the human scale. Nevertheless the spectator is made to feel the dislocation in this landscape by the shifting impressions of scale and with it the emotional excitement caused by the anxiety of sublime perceptions. In reproduction this sensibility is only available as a logical problem because the entire image can be accommodated in a single glance. Its visual effect relies on the painting's large scale, which creates the condition of a scene that is apprehended through a series of disconnected sights that never quite resolve into an integrated whole.

Cole's painting literalizes its metaphoric intentions. *Prometheus Bound* not only visibly demonstrates the visual vocabulary of the sublime but enacts the conditions of the sublime as a physical experience. In the language of Edmund Burke, the painting demonstrates the moral possibilities of terror, not merely the anxiety of a tragic story but the disarming spectacle of visual chaos. For American settlers facing the prospect of a wild and uncharted continent, Cole's historical landscape captured their own dread and excitement before the heroic challenge that the new territories represented. There was no need to look back toward Europe in order to borrow the moral metaphors of antiquity when the very landscape of the nation offered an opportunity to experience an entirely new mode of vision. In Cole's hands, the vocabulary of the sublime became a metaphor for the experience of a nation that would take its inspiration from the awesome power of the natural world at its most impossibly spectacular.

Of course, even as Cole was portraying the American wilderness as the site of sublime experience, it was disappearing under the advancing twin technological circumstances of industrialization and urbanization. Cole is considered the founder of the Hudson River School of painting, so called because its adherents followed the vocabulary of visual effects that by their recognizable scenic details had made Cole's landscapes of the Hudson River valley such rich evocations of place (cat. 10, 21, 22, *Works*). Cole's immediate successor as the leader of the Hudson River School was Asher B. Durand, who had begun his career as an engraver. Durand was not only the most accomplished but also the most famous engraver in America as a result of his much reproduced print, taken from John Trumbull's *Signing of the Declaration of Independence* (1822).

Durand's success with Trumbull's national historic subject led

Luman Reed to commission portraits of the first seven presidents from him.[119] Reed, a wealthy grocery wholesaler, typified America's newly emerging merchant-patrons, whose confidence in their role as self-reliant entrepreneurs seemed to mirror the assurance of an emerging independent nation. In this way, historic subject, patron, and painterly school came together, constituting America as a new and modern nation through the language of nature. Within this representational language, bucolic landscape scenes offered an ideal— and predominantly idealized – vocabulary of place that associated the beauty of the natural world with an identifiable American topography (cat. 24, 25, 30, 31, 33, 34, *Works*). Durand made this association explicit when he wrote: "Go not abroad then in search of material for the exercise of your pencil, while the virgin charms of our native land have claims on our deepest affections."[120]

Durand's appeal to "the charms of our native land" was not only a rejection of European traditions in favor of a more indigenous American subject matter. It was also an appeal to the philosophy of natural law that had supported the American Revolution and established the political principles of the new nation. Natural law emerged as a concept that grew out of the philosophical writings of John Locke and the political commentaries of William Blackstone during the end of the eighteenth century, becoming the foundation of western political discourse in Europe and America during the nineteenth century.[121] Its most basic tenet is that the laws of God are not delivered by decree in abstract principles, either in sacred texts or by a divinely appointed authority, but are manifest in the created order and therefore evident to all people through common-sense observation of the natural world. As a secondary corollary, the regulating principle of natural law was the true and substantial happiness of each individual.

A Frenchman living in America during the revolutionary era, Hector St. John de Crèvecoeur identified the regulation of a happy and just society with the proper understanding of natural law.[122] His *Letters From an American Farmer* (1782) were vigorously embraced by the founders of the new nation as support for a democratic society based on the observations of an individual whose life was intimately connected to the natural realm and its instructive order. According to Crèvecoeur, farmers possessed an ideal perspective because their livelihood placed them in a "middle landscape," between the artifice of urban society and the honest truths manifest in the natural landscape. Although not everyone in the country could be a farmer, the conditions of America seemed to guarantee that an experience of the land was readily available to all. Tragically, it also paved the way for the

perception that indigenous people and cultures would need to make way for agricultural settlers who could transform the wildness of nature into that middle landscape, thus guaranteeing the experience of nature that natural-law theory required. It was this emphasis on an individual's encounter with the landscape as a foundation for the moral and ethical life that established the language through which Americans would understand their participation in the life of the nation. Ironically, as industrialism increased the nation's strength, it created urban centers that diminished the possibilities for an actual experience in the landscape. Individuals increasingly found that their most significant encounters with the landscape were through painting.

In *A River Landscape* (1858) (cat. 20), we can see Durand's visual strategy for creating such an encounter. The scene is presented to the viewer as if walking along the bank of a gently flowing river. The large elm trees in the foreground, which dominate the right half of the painting, are indigenous to the Hudson River valley. Although the composition is derived from the seventeenth-century French landscape painter Claude Lorrain (fig. 17), the faithfully rendered vegetation and geology of the area announce that this is an American site.[123] Durand's painting relies on the conventions of the pastoral and its visual language of peace and harmony that the humanizing influence of civilization introduces into the wildness of nature. In the middle distance, cows meander through the trees and down to the river for a refreshing drink, much as viewers of this painted scene come to it for the mental refreshment its pleasing view offers.

Characteristic of the pastoral mode, several secondary paths provide viewers with a narrative entrance into the picture's imaginative possibilities and lead the eye through Crèvecoeur's ideal middle landscape, its apparently natural condition underscored by its central position in the painted scene between the detailed foreground and the indistinct background. Visually, the cows lead the eye from the prominent display of elm trees to the contrasting open vista and spacious sky that comprise the left half of the painting. This movement sets up a series of balanced spatial oppositions: near and far, compressed and open, dark and light, sharply focused and hazily atmospheric.

Fig. 17
Claude Lorrain (French, 1600–1682), *View of Tivoli at Sunset*, 1642-1644. Oil on canvas, 39½ x 53½ in. (100.5 x 136 cm). Gift of Samuel H. Kress Foundation, Fine Arts Museums of San Francisco, 61.44.31.

Cat. 20
ASHER BROWN DURAND
A River Landscape, 1858

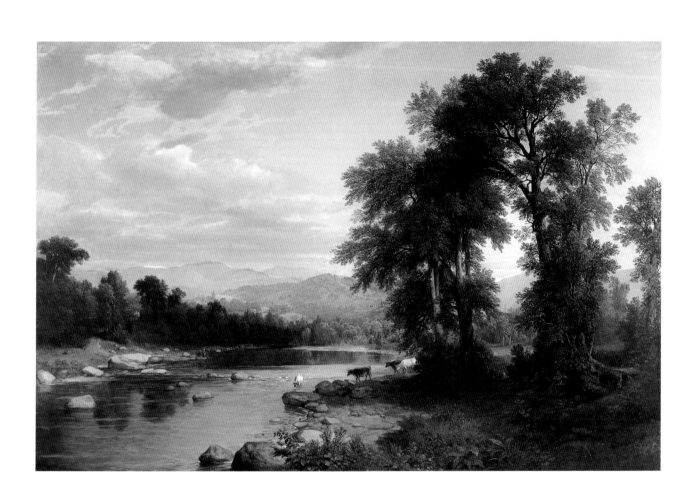

The stream and diagonal line of trees on the left pull one's eye toward the placid pool at the center of the painting, as do the hills that lead the eye back from the distant mountains to the middle ground. The still, reflecting pool becomes a literal and figurative image of the painting's visual focus. The overall effect suggests the poetry of contemplative tranquility and repose rather than sublime anxiety and exhilaration that was evident in Thomas Cole's *Prometheus Bound*.

Durand's painting thus does not merely depict the pastoral ideal, but turns the middle ground into a metaphor for interpretation itself by positioning viewers both narratively and visually in its harmonious balance. It reinforces a philosophical belief in the concept of the natural world as a repository of common-sense laws that resonate with the moral and ethical values of the middle class. His pastoral scene thus creates an identifiably American site that literally and symbolically enacts the ameliorating role of rural traditions and values as the guarantee of democracy in the national life. In nineteenth-century America, this vision provided the center for cultural debates over the fate of the wilderness, linking individual experiences of the landscape to a national consensus of the need to extend the force of western civilization across the entire continent.

The counterpart to Durand's middle-landscape vision in the Hudson River School is exemplified in Frederic Church's *Twilight* (1858) (cat. 19). Although painted the same year and by artists equally influenced by Thomas Cole, each work relies on very different visual vocabularies. Church was interested in Cole's use of the sublime in order to invest the landscape with symbolic and figurative meaning. In fact, Church had Cole's *Prometheus Bound* in his studio while he was working on *Twilight*.[124] Although Cole's painting depicts dawn rather than twilight, both works share the virtuoso effects of intense, glowing colors and rich, tonal modulations. In a letter, Church referred to Cole's rendering of sunrise "the finest morning effect I ever saw painted."[125] In spite of Cole's importance to the entire Hudson River School group, Church was the only student he ever accepted, suggesting that Cole probably recognized their shared passion for the language of the sublime in landscape.[126] He would go on to paint some of the grandest and most awe-inspiring landscape canvases, not only of national American sites such as Niagara Falls but also of the exotic natural wonders of South America and the Middle East, where he traveled extensively.[127] In a sense his works are as much a reflection of his exploring spirit as they are expressions of an artistic vision.

The language of exploration relies on a vocabulary of natural adversity, the heroic, and personal conquest. It also encourages an understanding of nature as wilderness and the foil to civilization.

Cat. 19
FREDERIC EDWIN CHURCH
Twilight, 1858

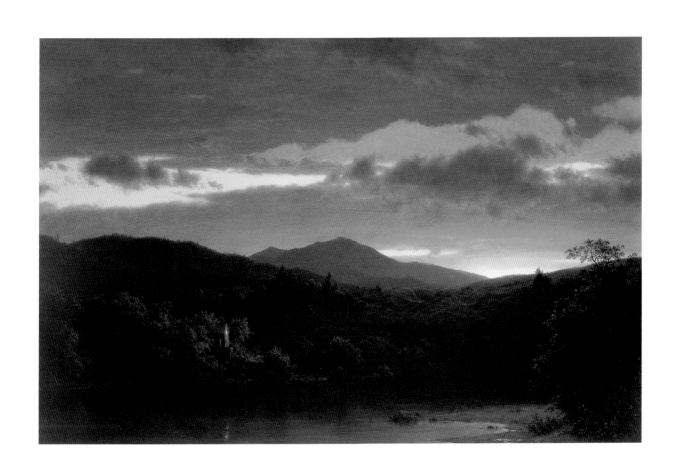

Such a construct of nature lies at the opposite pole from the pastoral notion of landscape that Durand embraced in his Hudson River School paintings. To be sure, the atmospheric effects and the lone dwelling with its reflecting window create a poetic mood in keeping with the contemplative tone of the middle landscape. However, in place of the pastoral's focus on harmonious calm, *Twilight* seems to present dusk as a more foreboding prospect. The light on the window and the surface of the pond reflect the light that disappears over the horizon, acting as a final echo before darkness envelops the scene. The encroaching darkness heightens the solitary character of the cabin and emphasizes its vulnerability within the wilderness context. It seems likely that Church's twilight reflects the increasingly ominous sectional divisions that will erupt into the Civil War two years later.

Church's vision of nature depends less on the topography of the Hudson River valley than on the flamboyant spectacle of its ever-changing, cloud-filled skies.[128] It places his understanding of America's wilderness much closer to the sublime effects of natural forces in Cole's grand symbolic allegories than to the benign conditions that American citizens associated with the industrial progress of urbanization. In place of a natural paradise that reflects a divinely ordained harmony between individuals and the landscape, Church's painting interjects the philosophical vocabulary of the sublime to shift the psychological effect on his viewers away from a pastoral experience toward an uncertain and ambiguous encounter.[129] The painting provides a visual symbol of an individual's encounters with the nation as a landscape to be explored and conquered. Implicit in conquering the wilderness is the individual's heroic exhilaration at negotiating forces of grandiose and majestic power. For the empires of monarchy it substitutes the dominion of nature, transforming the symbol of national identity from the sovereign's authority into the nation's terrain.

As an ideological corollary, the use of landscape as a setting for heroic nationalism sanctioned the conquest of all territories that could be so depicted. It would lead artists of the Hudson River School to exotic locations throughout North and South America in search of ever more extraordinarily sublime scenes that could be understood in terms of the symbolic vocabulary of a national will to exploration and natural conquest. Terrain as diverse as Ecuador in Church's lushly light-drenched *Rainy Season in the Tropics* (1866) (fig. 18), William Morris Hunt's mysteriously luminous *Governor's Creek, Florida* (1874) William Bradford's starkly serene *Scene in the Arctic* (ca. 1880), and Thomas Moran's majestically spacious *Grand Canyon of the Yellowstone, Wyoming* (1906) (cat. 35, 40, 64, *Works*), attest to the distances to which such national ambitions could lead.[130] They provide the visual

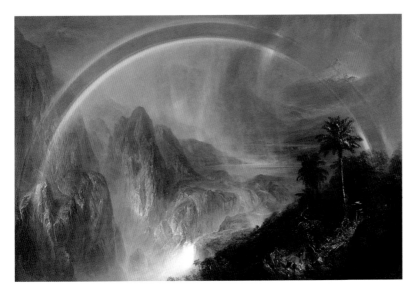

Fig. 18
Frederic Church (American, 1826–1900), *Rainy Season in the Tropics*, 1866. Oil on canvas, 56¼ x 84¼ in. (142.9 x 214 cm). Mildred Anna Williams Collection, Fine Arts Museums of San Francisco, 1970.9.

evidence that helps to explain the expansion of the United States into Mexico, Russia, Cuba, Hawaii, the Philippines, and Panama in the second half of the nineteenth century.

Not surprisingly, the American foreign policy known as the Monroe Doctrine was established in 1822 as Thomas Cole was first defining the Hudson River School of painting. English politicians, who hoped to bring the United States into an alliance that would resist expansion in the Americas undertaken by competing European powers, proposed a policy statement limiting rival territorial claims in the Western Hemisphere. However, American President James Monroe seized the opportunity to declare unilaterally all of the Americas, both North and South, under the protection of the United States from interference by any European nation, including England. The Monroe Doctrine firmly established the American nation as a sovereign identity, completing a chain of political events that had begun with the Declaration of Independence in 1776. The visual power of a national landscape that extended throughout the Americas thus was matched by the linguistic power of a national doctrine that claimed all of the Americas (and the Atlantic and Pacific islands) as integral to American identity.

However, at the same time that the Monroe Doctrine was aiding in the creation of a political rhetoric of national unity, the debate over slavery was creating an increasingly rancorous sectionalism that would severely test the philosophical and psychological ties between individuals and national identity. The roots of the conflict were based in the competition between states whose economies relied on slave labor in the South and states in the North whose economies were based on wage labor. In order to keep a political balance between these two regions, a number of political compromises were negotiated.

One of the most famous agreements that has a direct bearing on these sectional tensions was the Missouri Compromise of 1820, which had the pragmatic effect of establishing the principle of a national Senate that was evenly divided between Northern and Southern states. Because every state has two senators, such a division was meant to guarantee that states where slavery was legal would be balanced in legislative matters by states where it was outlawed. The most immediate practical result meant that Maine would be admitted as a free state to allow the admission of Missouri as a slave state.

The Missouri Compromise also established what has become known as the "Mason-Dixon line," the 36° 30' latitude in the western territories that determined whether future states would be slaveholding or free. Although these provisions appeared to settle the question of how the nation would accommodate the sectional disagreements over the issue of slavery, they actually articulated symbolic principles that elucidated and intensified sectional interests. Thus, in the years between 1820 and 1860, individual Americans found themselves participating in an understanding of place that on the one hand drew them together through national pride in the natural landscape and on the other tore them apart through regional opposition over the role of African Americans in the country.

The tensions that grew out of this and the other fragile political agreements over such sectional interests exploded in 1861 as civil war. In its four years the American Civil War claimed over 600,000 lives, which represented a staggering two percent of the national population, the largest number of casualties in any American war.[131] The impact of such losses was more palpable than the philosophical constructs of ideology implicit in the natural landscape and its symbolic language, whether the middle ground of pastoral or the aroused sensations of the sublime. The language of warfare, in general, translates private concerns into public issues in order to mobilize a collective national sentiment. In the case of the American Civil War, the North and the South made claims for their respective understandings that were rooted in the language of earlier national aspirations.

In calling itself the "Union," Northern states appealed to an ideology of the country as a single body and rehearsed the vocabulary of equality and solidarity that had supported the American Revolution and the centralized principles of the federalists embodied in the United States Constitution. By contrast, in their use of "Confederacy," Southern states appealed to an ideology of the country as a voluntary aggregate based in the pre-Constitutional Articles of Confederation with its attendant vocabulary of alliance and separation. In this way, Southerners claimed for themselves the individualism that had come

to be associated with America through transcendentalism, which had originated, ironically, in the Northeast. In the minds of the American people, the Civil War thus was not only about territorial control, but also as importantly about defining the relation between personal and public life at the national level.

We have seen how depictions of the relation between personal and public life in art shifted in the second quarter of the nineteenth century from the grand designs and allegorical narratives of history painting to the monumental and symbolic scenes of landscape. During this period, the invention of photography in 1839 initiated another change in the public's perception of historical representation. The camera's seemingly unmediated image promised to capture the world and record it with unvarnished realism. Photographers such as Matthew Brady and Timothy O'Sullivan (fig. 19) used the new medium as a documentary tool, famously sending back images of carnage and destruction after Civil War battles. That they often rearranged the fallen bodies in order to create a more powerful scene did not lessen the public's faith in the objectivity of their photographs as incontestable visual proof.[132]

As a result, the language of descriptive truth became associated with the vocabulary of the photograph and its incidental and spontaneous scenes rather than the elaborately organized tableaus of prominent historical events. When Winslow Homer sketched his observations of the Civil War for *Harper's Weekly*, he borrowed this photographic vocabulary in order to lend authenticity to his visual reportage.[133] And in fact, when Homer exhibited his painting *The Bright Side* (1865) (cat. 26), he not only received immediate critical acclaim, but also was pronounced "the best chronicler of the war" by *The New-York Daily Tribune*.[134] Homer confirmed this impression of his work as an accurate transcription of the truth by asserting that he had actually witnessed this precise scene.[135]

The Bright Side is rendered in a vocabulary of direct visual accounting that emphasizes the role of observation by its stress on the ordinary and prosaic. The photographic feeling of the painting is not only due to its realistic techniques that create a precise, clear image. The cropping, most notably of the top and sides of the tent

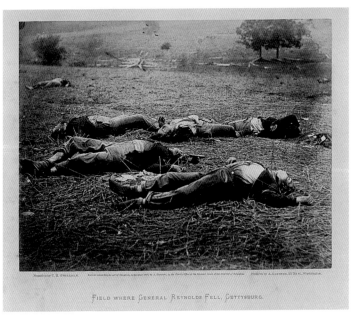

Fig. 19
Timothy H. O'Sullivan (American, 1840–1882), *Field Where General Reynolds Fell, Gettysburg*, 1863. Silver print from collodion negative, 6⅞ x 9 in. (17/5 x 22.8 cm). *Gardner's Photographic Sketch Book of the War*, 1866, pl. 37. Gift of the Graphic Arts Council, Achenbach Foundation for Graphic Arts, Fine Arts Museums of San Francisco, 1990.3.1.

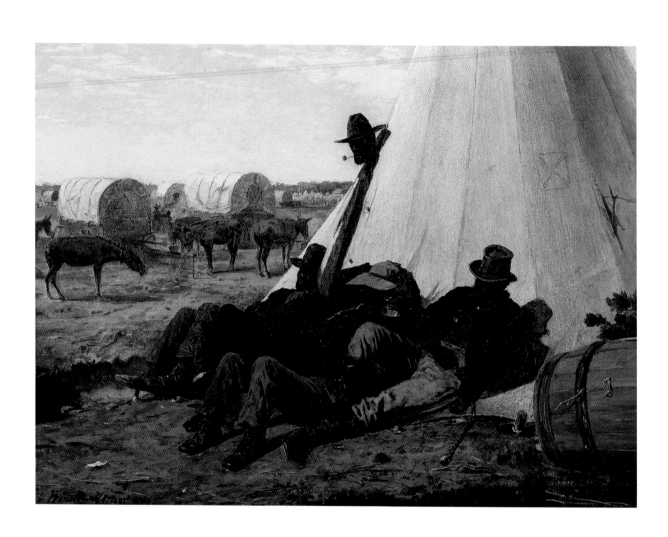

and the barrel in the foreground, create the impression that we are looking at a slice of actual life, which extends beyond the edge of the image. Additionally, the small scale (only 12¾ by 17 inches) approximates the size of a glass-plate photograph and demands that viewers come close to the painting, which thereby increases the feeling of intimacy. The direct gaze toward the viewer of the man whose head appears to have poked out of the tent just at this moment also contributes to the informality of the scene and suggests the immediacy of a captured moment that is typical of the photographic image.

However, within the context of the Civil War, such truth claims for the image of a group of black army teamsters carry a potent resonance. The painting bears witness to the historical facts of the war as a contest over the role of African Americans in the national life. As muleteers, these soldiers occupy a circumscribed position within the Union army that reflects the question of their role in the larger society. In the racialized language of nineteenth-century America, the claim for equal status by those of African decent always called forth an uneasy compromise, even among those of European descent who were opposed to slavery. Homer's teamsters are support soldiers, engaged in the unglamorous task of transporting the army's supplies and managing the notoriously unruly mules on which their job depended.

Mules are sterile crosses between donkeys and horses, bred to stand hard use and the abuses of combat better than horses. Well-known and often satirized characteristics of crossbred mules include their lazy, stubborn, and ornery temperaments.[136] During the 1860s in both the North and the South racist stereotyping often made African Americans the butt of low jokes and humorous narratives, a circumstance on which Homer relies to create comical associations for this scene in spite of the seriousness of the Civil War context. Homer's image carefully negotiates contemporary attitudes toward African Americans, who are shown to participate in the national struggle, though relegated to a position that would not threaten the cultural hegemony of white Americans. Although clearly not slaves, these men are still acting as support for the largely white northern troops. In this way, Homer presents these men as hybrids, implying that they occupy an intermediate position, like the mules in their charge who are stranded halfway between the noble horse and beastly donkey.

Contemporary viewers would have understood the implications of this comparison without being troubled by its racism because the painting's informal photographic vocabulary militates against questioning the stereotypes represented. On a more positive note, that same vocabulary also would have contributed dignity to the scene by emphasizing the individualism of each man in this group. The five

Cat. 26
WINSLOW HOMER
The Bright Side, 1865

Fig. 20
Jean-Léon Gérôme (French, 1824–1904),
The Bath, ca. 1880–1885. Oil on canvas,
29 x 23½ in. (73.7 x 59.7 cm). Mildred
Anna Williams Collection, Fine Arts
Museums of San Francisco, 1961.29.

soldiers are represented as unique individuals, not only through the superficial element of personal style evinced by the differences in their clothing, especially the hats, but also by the unique manner in which each one slouches to rest. In this respect, the painting typifies other works in which Homer's narrative and illustrative depictions of humorous vignettes humanize the soldiering life.[137]

The most significant result of this photographic language for artistic representation is the transformation that it realizes in the genre of history painting. *The Bright Side* was one of two Civil War paintings by Homer that was exhibited in the American section of the 1867 Universal Exposition in Paris, where French artists such as Gustave Courbet and Edouard Manet also were reinventing the language of history painting through the vocabularies of realism and photography.[138] Homer's painting was received in this light, drawing praise from European critics, although the most frequent comparisons were with Jean-Léon Gérôme (fig. 20) (cat. 28, *Works*).[139] The Civil War provided the perfect opportunity for Homer to test this new language for history painting. The nature of the war was a turning point in military combat, the first truly modern contest deploying industrially produced weapons and attacking land, supplies, and infrastructures in addition to troops.[140] As a result, the war did not lend itself to the portraits of military leaders in the midst of heroic battles, which previously characterized the vocabulary of history paintings. Rather, it moved the register of historical representation from symbolic myth to metaphoric document, which is also a move from grand narrative to everyday incident.

In place of a narrative of the Civil War that is told from the official perspective of those who hold national power, Homer's painting presents the war from the point of view of those with the least power in the nation. The grand designs of traditional, large-scaled history paintings, such as Vanderlyn's *Caius Marius* (cat. 7), link the fate of the nation to particular persons, events, or systems through classicizing tropes that reinforce the role of social elites at historical moments of public consequence (also contrast cat. 43, 86, *Works*).[141] In the case of *The Bright Side*, the fate of the nation is linked to a much quieter event. Homer presents his viewers with an ordinary moment that anyone should be allowed to enjoy: taking a respite from hard work and basking in the glow of the sun's warmth. The boldly direct gaze at the viewer of the man looking out of the tent reinforces the basic right of such a break. He does not call on his fellow workers to scramble

to their feet but returns the viewer's uninvited look with confidence.

Thus the painting offers itself as a trope of the social order that is at stake in the Civil War. It asks the viewer to consider whether or not the United States of America will be a nation where everyone living within its borders can assume the common privilege of resting undisturbed in the sunshine. For the hard-working muleteers, taking a rest on the bright side of the tent is literally the bright side of their job. It is also figuratively the bright side of the war because the freedom of their momentary time in the sun is exactly what is at stake in the conflict. This is history painting that is attentive to whose individual histories are being considered and what purpose is being served by the truths of national life represented in the work.

Although Americans of European heritage were divided over the role of African American individuals in the nation's life during the mid-nineteenth century, they shared a considerable consensus on the role of American Indians. Beginning with President Andrew Jackson's policies in 1830, the fate of native peoples was tied directly to the theory of a "vanishing race" that validated the conquest of their land as a necessary and supposedly humane gesture. In May 1830, Jackson signed into law "an act to provide for an exchange of lands with the Indians residing in any of the States or Territories and for their removal West of the river Mississippi."[142] The most infamous result of this legislation was the removal of the entire Cherokee Nation from its legal territories, primarily in Georgia, to lands west of the Mississippi in October 1838. The forced march and high mortality of whole Cherokee families along what become known as The Trail of Tears was only partially about the United States of America appropriating land that had been guaranteed to the Cherokees by earlier treaty arrangements.[143] It was also about the vision of what kinds of families and which communities could participate in the national identity.

Cherokee leaders in Georgia had successfully adopted European manners and customs, building their own society on Southern white plantation models that included not only European habits and dress but a slave-labor economy as well. Prominent families, such as those of their leaders Major Ridge and Chief John Ross, owned large plantations, and by the 1835 census, black slaves comprised ten percent of the Cherokee nation's population.[144] The irony of a free class of non-whites living in the midst of Southern society gave the lie to an ideology of race based in paternalism. It is hardly surprising that President Andrew Jackson, a southerner himself, would lead the opposition to such a visible contradiction of the "vanishing race."[145] However, the North engaged in its own form of paternalism toward American Indians, creating special schools designed to educate

Fig. 21
Albert Bierstadt (American, 1830–1902), *The Last of the Buffalo*, ca. 1888. Oil on canvas, 71¼ x 119¼ in. (181 x 302.9 cm). Gift of Mrs. Albert Bierstadt, In the Collection of The Corcoran Gallery of Art, Washington, D.C., 09.12.

Cat. 48
ALBERT BIERSTADT
Indians Hunting Buffalo, ca. 1888

Cherokee and other native children in ways that would allow them to be assimilated into the economic structures of white America. Those who wanted to maintain some ties to their own native heritages were believed to be unsuited to the demands of progress and European civilization that suited America as an emerging national power.

By the outbreak of the Civil War merely twenty-two years later, the removal of the five major tribal nations of the East Coast was complete. Nearly three hundred thousand American Indians had been forcibly settled in territories west of the Mississippi River.[146] In addition to the removal of Eastern tribes to the west, the discovery of gold in California in 1848 with its subsequent explosion of settlers during the next decade disrupted the quiet and peaceful lives of the many small tribes living on the west coast. The war became a convenient opportunity to mount an attack on American Indians living in the west in order to make way for further white settlement. In order to block the advance of Confederate military forces in Arizona and New Mexico, Union General James Carleton marched east from California. After the war, General Carleton continued the systematic attack on the native peoples of the Southwest with the following orders: "There is to be no council held with the Indians, nor any talks. The men are to be slain whenever and wherever they can be found."[147]

Unfortunately, Carleton's attitude was not atypical of national leaders, whether military or political. The same assumptions paved the way for a renewed series of attempts to remove the Eastern tribes from the plains west of the Mississippi, which had been granted to them, in order to make way once again for white settlement. When a group of American Indians under the leadership of Red Cloud successfully resisted a second removal, the United States government was forced to sign a treaty in 1868 recognizing tribal rights to these lands. Upon hearing about the treaty, a governmental official declared:

> *The idea that a handful of wild, half-naked, thieving, plundering, murdering savages should be dignified with the sovereign attributes of nations, enter into solemn treaties, and claim a country five hundred miles wide by one thousand miles long as theirs in fee simple, because they hunted buffalo and antelope over it, might do for beautiful reading in Cooper's novels or Longfellow's Hiawatha, but is unsuited to the intelligence and justice of this age, or the natural rights of mankind.[148]*

By the time that Albert Bierstadt was painting *Indians Hunting Buffalo* (ca. 1888) (cat. 48), both American Indians and the buffalo had succumbed to a national policy of westward expansion and settlement. Under the rhetoric of Manifest Destiny, Americans, principally of English, Dutch, and German heritage, refused to acknowledge the established communities of other nations and cultures living between the Missouri River and the Pacific Ocean.[149] Bierstadt's painting is a finished study, complete in its own right, for the central focus of his final monumental work of the West, *The Last of the Buffalo* (ca. 1888) (fig. 21).[150] Several commentators have remarked on the anachronistic character of Bierstadt's subject matter in 1888.[151] In 1870, approximately fifteen million buffalo were living on the plains. By 1880, they were gone, along with the livelihood that they provided for the native populations in the region.[152]

American Indians, buffalo, and the West were so intertwined in the national narratives of conquest and progress that each served as a metaphor of the other in an interconnected chain of symbolic associations. *Indians Hunting Buffalo* enacts this conflation through its dramatic tableau. Although caught in the midst of a fierce struggle, Bierstadt presents the Indian, horse, and buffalo in the manner of a classical frieze. His warrior skillfully rides bareback on a rearing stead while engaging in combat. Characteristic of its classical antecedents, an intimate contest is monumentalized in order to symbolize an event of historic national importance.[153] Also, as in a frieze, the scene is presented in profile and against an indistinct backdrop. Further, the setting of open prairie and clouded sky flattens the pictorial space in a way that mimics the shallow depth of relief on which a frieze depends. Even the Indian on horseback rushing into view from the middle ground at the right edge of the frame only detracts slightly from the centered stasis of this tightly organized composition. The central Indian figure also echoes classical conventions in the nude, muscular body that rehearses the Greek ideal of the heroic athlete (see fig. 12). Together these classical devices invest the image with the epic allegory and noble narratives that are associated with Greek and Roman mythology.

The language of classical myth announces that the figures in Bierstadt's scene are larger than life. It also elevates the subject matter of this single incident into a rhetorical figure addressing the nation's aspirations toward empire. As metaphors of nature, the American Indian, buffalo, and prairie all carried a different but related understanding of what was at stake in an American empire. All three suggested wildness, the condition of nature at the opposite pole from the structured order of civilized refinement. Since the time of

Rousseau's romantic philosophy, America's native peoples had functioned as a trope of the noble savage. In Rousseau's Enlightenment view, the noble savage represented the condition of human society that was the most pure because it was the closest to the natural world and the least contaminated by the artificial constraints necessary for civilized societies to operate. By a corollary axiom, American Indians also were doomed because the savage state was incompatible with the civilization's needs. The buffalo, because it was a vanishing species, provided a ready-made trope for the fate that awaited whatever (or whomever) was unable to adapt to the changes in nature brought about by an advancing European culture. The prairie itself, with its unending vistas, functioned as a trope for the vast, open, and therefore supposedly empty space that the west represented to empire-minded national leaders.

However, in contrast to these emblems of nature in the painting, the horse signals civilization's forceful role in this dynamic encounter. Although the key actor is the American Indian, the main focus of visual tension in the image is not so much between him and the buffalo as between the buffalo and the horse. It is a contest between nature both as wild and tamed, its primitive power harnessed, literally and figuratively, to human progress. These tropes rhetorically stated the unlimited possibilities that lay before the nation, had it the will to conquer. By implication, national life was reserved for those who were able to participate in the victorious rhetoric of empire and willing to dominate the land, replacing those restrained by a respect for and accommodation to it. *Indians Hunting Buffalo* thus operates as a nostalgic allegory of a power struggle whose outcome has already been decided. By subsuming American Indians and their culture within the narrative of noble origins no longer suited to the national ambitions, the painting rhetorically laments the loss of what is no longer an actual threat.

What did suit the nation's drive toward empire was an understanding of the west as the Promised Land, a trope that went back to the colonial founding of the country, rooted in the language of Reformation protestant, biblical exposition. During the sixteenth century, protestant reformers had created an interpretive system called typology, which tied the Hebrew scriptures to the New Testament writings of the Christian church. Within this interpretive scheme all the promises to Israel as God's favored nation were transferred to the Christian church as a spiritual nation. Such reasoning led directly to a belief that practically any literal promise of a religious nature claimed by the nation of Israel should be understood as an analog for a spiritual promise that Christians, both as individuals and as groups, could

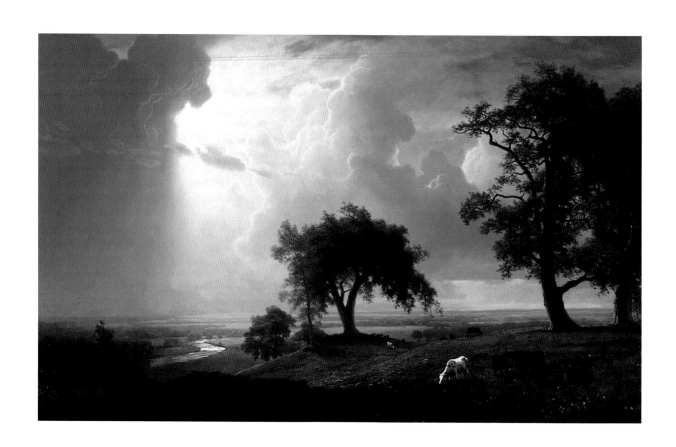

rightfully claim (cat. 12, *Works*). In 1630, the founding governor of the Massachusetts Bay Colony, John Winthrop, had explicitly appealed to the English colonial settlers with him aboard the *Arabella* before they landed in just these terms. He exhorted them to strive together in order that "we shall find that the God of Israel is among us, when ten of us shall be able to resist a thousand of our enemies, when he shall make us a praise and glory, that men shall say of succeeding plantations: the Lord make it like that of New England: for we must Consider that we shall be as a City upon a Hill, the eyes of all people are upon us."[154]

Such figurative language was never far from the nation's discourse. It was, however, the territory to the immediate west of the area already organized as the United States that most captured the imagination of individual Americans when they thought about national expansion. When gold was discovered in California in 1848, it set off a migration westward of numbers that were unprecedented in American settlement. As the site of the nation's future empire, the west, and California in particular, appealed to those searching for a new place that could be claimed as the spiritual inheritance of a new promised land.

Bierstadt had traveled to the West in 1858, 1863, and again in 1871 to 1873, sketching for the large canvases he would create back in his New York studio using the vocabulary of landscape painting that Cole, Church, Durand (cat. 10, 19, 20, *Works*) and the other Hudson River School artists had learned in Düsseldorf, Germany.[155] By the 1860s and '70s, Bierstadt's images of western landscape had earned him a reputation as one of America's foremost painters. His highly detailed yet romantic vision of the nation's natural splendors, especially its terrain of towering mountains and open plains, were synonymous in the minds of many people with the promise of a new start after the physical and psychological devastation of the Civil War. Bierstadt's painting, *California Spring* (1875) (cat. 36), was made as preparations were under way for the nation's centennial celebration and was one of the four canvases that he exhibited in it.

Monumental in scale, the painting is a visual promise congruent with the vocabulary of a Promised Land. The grandeur of the sweeping vista presents California's Sacramento Valley near San Francisco as a broad expanse of fertile fields, open and waiting to be settled. At the same time, in the foreground cows graze amid a colorful array of wildflowers, recalling the idyllic tradition of the pastoral with its abundant promise of repose and plenty. A thunderstorm has just passed through the scene, evident in the shadowed foreground and the bank of dark cumulus clouds at the left where the sun is breaking through with its golden promise of light that colors the sky and glints on the river. The painting is suffused with an atmospheric light that

Cat. 36
ALBERT BIERSTADT
California Spring, 1875

seems to suggest divine intervention, reinforced by the elevated viewpoint that takes in the entire valley. That actual gold had been discovered in Green River not far from Sacramento would not have been lost on the painting's viewers. Sacramento was also the terminus of the Central Pacific Railroad, which had recently linked east to west in 1869 when it joined with the Union Pacific Railroad to create the first transcontinental rail line.[156] The painting metaphorically promises that the dark storm of sectionalism and its turbulence will fade in the golden promise of California's western opportunity (cat. 53, *Works*).

However, the expansionist policies that the language of a western Promised Land supported were more ideological than practical for individual Americans. As we saw in Bierstadt's *Indians Hunting Buffalo*, by 1888 the West was only a romanticized concept that supported the push for empire in the rhetoric of Manifest Destiny. Two years later, the 1890 census delivered a fatal psychological blow when its findings indicated that for the first time in the nation's history, more Americans lived in cities than in rural areas. The high point of this disjunction between ideological rhetoric and the experience of average Americans occurred with the 1893 World's Colombian Exposition in Chicago, a grand display of imperial power celebrating four hundred years of Europe's cultural presence in America.[157] At the Exposition, a historian named Frederick Jackson Turner delivered an address entitled "The Significance of the Frontier in American Life" that summarized the growing anxiety about the future of the nation. Turner argued that Americans had steadily progressed in all spheres because the "free land" of the frontier always had been a safety valve that protected the nation from the ills suffered by European nations.[158] According to Turner, the westward expansion of the nation's political dominance created a culture of retreat from civilization that forced a continual reengagement with wilderness and barbaric conditions. This pattern of retreat, recapitulation, progress, and further retreat had made individual Americans democratic, egalitarian, and optimistic about the future.[159]

Turner's thesis seemed to account for how the individuals who made up a polyglot and heterogeneous immigrant population were forged by the conditions of the frontier into a single, homogeneous, national identity. With the frontier gone, he maintained, Americans were now no different from the Europeans whose social and political conditions they had struggled so diligently to resist (cat. 18, *Works*). However, as nearly all contemporary historians agree, the real import of the census was not the closing of the frontier, which had always been a site defined more by contested cultural terrain than a geographical place. The actual facts of the 1890 census pointed out that the migratory pattern

of most Americans was to the cities rather than to the West.[160] Nevertheless, the language of progress and national identity continued to be grounded in the vocabulary of frontier experience as individual Americans defined their identities by reference to its symbolic tropes.

John Frederick Peto's *The Cup We All Race 4* (ca. 1900) (cat. 60) draws on the conventions of the still life in order to create an image that captures the ambiance of the frontier. The still life as a self-conscious form has its origins in baroque traditions, especially seventeenth-century Dutch painting with its vocabulary of wealth, abundance, and order that celebrated the values of a newly rising mercantile society.[161] Exotic fruits and flowers, expensive containers, and other opulent household objects testified to economic success and its pleasures, metaphorically paying tribute to the role of possessions in defining identity (fig. 22). In a sense, still lifes were portraits of their owners by association and symbols of values based on social arrangements dictated by domestic space.[162] In order to create such metaphoric meaning out of visible objects, most often the still life relies on the vocabulary of realism with its insistence on convincing depictions of physical properties and space.

The realist vocabulary of these still lifes emphasized the materiality of the objects depicted, focusing on the illusionistic representation of their tangible shapes and textures. The visual rendering of sensible detail aligned such images with the language of objective observation and gave them the status of physical truth, an effect heightened by the elimination of brush strokes in the smoothly painted surfaces. Even the light effects contributed to the realistic illusion by creating dramatic tonalities as if originating from a single source. Further, baroque still-life painting developed an elaborate set of coded signs to register abstract concepts. Ripe fruit, for instance, was an emblem of the flesh, its plump, juicy fullness an indication of sensuous pleasure and at the same time a reminder of imminent decay. Flowers, similarly, were an emblem of beauty but also suggested the dangers of vanity by the temporality of their blooms. Thus, from its beginning, the language of the still life insisted on the real presence of the painted scene and deployed the vocabulary of illusionary effects to convince its viewers of its representational space-time truth (cat. 52, *Works*).

The Cup We All Race 4 belongs to a specialized form of still life called trompe l'oeil, from the French for "fool-the-eye" painting, which was popular in America at the end of the nineteenth century (cat. 54, 62, *Works*). As the name implies, such paintings are designed to be elaborate visual deceptions that viewers will mistake for actual three-dimensional tableaus. It is a vocabulary of illusionism that is meant to carry its viewers beyond mere convincingness into the realm

Fig. 22
Willem van Aelst (Dutch, 1627–1683), *Flowers in a Silver Vase*, 1663. Oil on canvas, 26½ x 21½ in. (67.6 x 54.5 cm). Gift of Dr. and Mrs. Hermann Schuelein, Fine Arts Museums of San Francisco, 51.21.

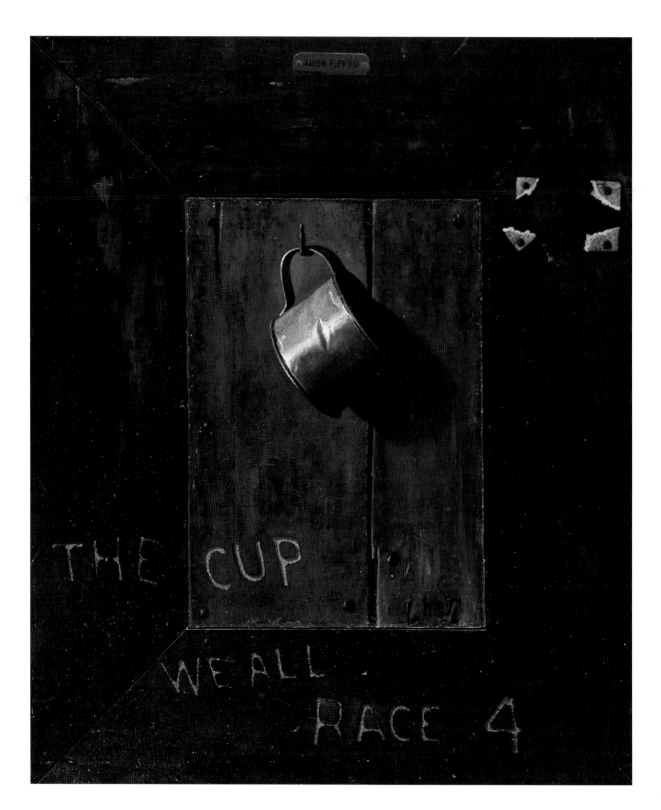

of deception.[163] Peto and William M. Harnett were the best known of the painters working in this genre. Harnett's *After the Hunt* (1885) (cat. 46, *Works*) hung in a Manhattan saloon where its proprietor used the work's super-illusionistic depiction to measure the sobriety of his customers, who often mistook its artifice for actuality.[164] It is true that Harnett and Peto were trained in Philadelphia, where early in the nineteenth century the Peale family dynasty of painters, especially James and Raphaelle, had created highly accomplished still lifes (figs. 23–24)

and experimented with trompe-l'oeil effects.[165] However, in spite of the earlier presence of still-life painting in America, it appears not to have influenced late nineteenth-century trompe-l'oeil artists, who reinvented the form within the symbolic context of Turner's frontier thesis.[166]

Peto's image powerfully evokes the nostalgia of an apparently less complex time and existence than most people would have experienced around 1900. His painting provides a metaphor of rural values, even as the abject and abused nature of the objects in the image records the loss of social and economic conditions that support those values. Everything about the image is designed to suggest that it is a relic from a remote site, the melancholy tone of its rendering countering the assumptions of optimism and progress usually associated with frontier America.[167] The painting presents battered and splintered wooden boards within a wide, rustic wooden frame. A dented tin cup hangs on a crude metal hook in the boards. The words of the painting's title, "the cup we all race 4," appear to be rudely incised into the wooden boards. At the top of the framing boards, a skewed nameplate identifies the work as by "John F. Peto." Near the top of the board frame at the right edge, nails hold down the four corners of a card that otherwise seems to have been torn away. The representation of something apparently made with a combination of primitive tools and materials points to the harsh conditions of survival and hard work that symbolized the frontier for many Americans. Within this context, the humble but pragmatic drinking cup promises a thirst-quenching drink as reward enough for the challenges of rural life. The slogan, carved like a graffito into the boards, appears to suggest that within

Cat. 60
JOHN FREDERICK PETO
The Cup We All Race 4, ca. 1900

Fig. 24
Raphaelle Peale (American, 1774–1825),
Blackberries, ca. 1813. Oil on wood panel,
7¼ x 10¼ in. (18.4 x 26 cm). Gift of Mr.
and Mrs. John D. Rockefeller 3rd, Fine
Arts Museums of San Francisco,
1993.35.23.

the recent, rural past symbolized by these objects, "we"—the individuals in the nation—had striven toward a common goal. Like a drink well-earned at the end of a race, that reward would be shared by both winners and losers.

However, this narrative is told emblematically, using a language of ambiguity, heightened by the conventions of trompe l'oeil. In *The Cup We All Race 4*, Peto created a visual rebus that questions the relation between reality and illusion. The central boards with their hook and nails, tin cup, and incised letters are painted canvas. But the framing boards are actual wooden boards, painted to match the central boards as if they, too, were canvas. The incised letters, card corners, and nails are painted onto the actual boards and continue the painted illusion of three dimensionality; in a final reversal, the nameplate is an actual metal plate nailed into the top framing board. The illusionistic play is made even more convincing by insuring that the scale of all these objects is consistent with expectations of their actual size. Thus, the painting celebrates illusion through its capacity not merely to represent but through its ability to deceive.

But why should the language of deception have such resonance that it became popular at this historical moment in the nation's life? Given the still life's ability to link individuals to cultural assumptions, its popular resurgence at the end of the nineteenth century may relate to the significance of deception as a national trope. Peto's painting creates a tangle of ambiguous visual artifice that doubles the ambiguity of the meaning in the image itself, posing a number of indecipherable interpretations. The word cup occupies the same central section as the tin cup hanging above it, drawing attention to the question of

representation and the relation between image and language. Turn-of-the- century viewers were asked to speculate about what was real and what was a deception in the act of representation itself.

As an image of deception, the painting metaphorically addresses deceit, asking viewers to consider how they recognize and identify an illusion. Within the context of the lost frontier to which its subject alludes, the painting questions reality itself. Does it lie in nostalgia for a simple, rural past, the unvarnished truth of ordinary wisdom, the shared goals of a homogeneous community, the virtue of striving for material reward, the abject quality of discarded sentiments, the application of traditional wisdom in the modern world, the importance of striving for success, the permanence of existence, the drive to possess, the importance of recognition, or the commonplace as container of transcendental truth? As if to underscore the indecipherability of the painting's meaning, remnants of a torn card offer a tantalizing but unrecoverable trace of a label that might have provided an explanation. Ultimately, *The Cup We All Race 4* holds up a vision of the multiple illusions that the frontier offered individuals seeking to participate in American life. It uses the reality of an illusion as a metaphor for the illusion of reality. It is a reminder that the currency of any representational language, whether visual or verbal, lies with its capacity to create a shared meaning that connects individuals to national goals.

As an emblem of frontier nostalgia, Peto's still-life arrangement of homely, commonplace objects uses a vocabulary of visual effects that many American artists of the twentieth century increasingly found inadequate to depict the conditions of modernity. The nostalgic character of Peto's image seems to reject the visual experimentation in the vocabulary of contemporary European avant-garde painters who were celebrating the industrial and urban realities of modern life. In particular, the early decades of the twentieth century saw a new attitude toward both the subject matter and the goal of representation, first among European and then American artists. In place of elevated subjects of public importance, modern artists gravitated to the overlooked objects of ordinary life. Instead of using artifice to mediate the meaning of their depictions, avant-garde artists used the dislocating experiences of modern life to explore the nature of artifice itself. These new goals pushed artistic representations in an increasingly abstract direction (cat. 65, 75, *Works*).

Of course, Peto's trompe-l'oeil image of a tin cup, framed by weathered boards, could also be seen as an image that anticipates the new subject matter of modernism, especially the emphasis on found, discarded, and ordinary objects. Similarly, the painting's shallow, flat space seems to encourage viewers to experience the formal properties

Fig. 25
Pablo Picasso (Spanish, 1881–1973),
Drawing, ca. 1911. Halftone, 10.8 x 6.7
in. (27.8 x 17.2 cm). *Camera Work* 36
(October 1911):71.

of the objects depicted through the interactions of their abstract relations. Even the play between reality and illusion appears to heighten an awareness of the artifice inherent within the tradition of painting. Such a reading suggests that even when adhering to a set of realist conventions, American artists were pursuing a visual vocabulary that could give expression to the changing experience of modern life.

As Americans embraced science, industry, and urbanization with their underlying goals of secular progress that came to define the nation in the twentieth century, artists adopted the representational language of abstraction with its highly personal symbolic vocabulary (cat. 85, 87, *Works*). American artists in the early decades of the twentieth century reversed the understanding of the relation between national life and the individual. Rather than depicting symbolic and representative scenes characterizing a national sensibility, American artists working in a modern idiom made their most intimate and personal experiences serve as metaphors for the nation. The modern artists most closely aligned with both abstraction and personal expression were those associated with photographer and art impresario Alfred Stieglitz. From 1903 to 1917 Stieglitz edited the journal *Camera Work*, which was devoted to introducing to the American public the principles of modern abstraction that had taken hold in Europe in all media (fig. 25). In 1905 he opened a gallery, called 291 after its address on Fifth Avenue in New York City. Through the exhibitions of modern art at 291 and the works Stieglitz championed in *Camera Work*, artists who associated with him became the focus of avant-garde abstraction in America (cat. 67, 73, 74, 77, *Works*).[168]

No American artist is more closely aligned with both Stieglitz and the modernist vocabulary of personal metaphor than Georgia O'Keeffe. First, as lovers, beginning in 1917 and then, as husband and wife, in 1924, O'Keeffe and Stieglitz collaborated in an intense relationship of mutual inspiration and artistic production. The most well-known result of this artistic relationship was a series of strikingly modern, nude photographs that rendered O'Keeffe's body in the fragmented, formalist vocabulary of avant-garde abstraction (fig. 26). Similarly, in her paintings, O'Keeffe employed the language of avant-garde modernism to suspend viewers between representation and abstraction in a manner that also reflected her training under Arthur Wesley Dow at Columbia University. Dow was a champion of Asian art and recommended its principles as a way to reinvent western art traditions. He advocated shifting the focus of representation away from an illusionism that sought to imitate the viewer's perceptual experience, which had been the focus of Western art's visual language

since the Renaissance, to an apprehension of conscious abstract formal relations. Primarily between 1924 and 1932, O'Keeffe painted nearly two hundred monumental, close-up views of flowers and leaves that do just that.[169]

O'Keeffe's *Petunias* (1925) (cat. 76) is one of a series of paintings based on a patch of flowers that she planted at the Stieglitz family summer home near Lake George in upstate New York the year that she and Alfred were married. It is the most complex of the dozen works she would paint from those plants over the next two years.[170] Several large blossoms fill the canvas, pushed to the picture plane's surface and cropped as in a photograph so that psychologically they spill out of the frame and crowd the viewer's space. Subtle tonalities create the naturalistic effects of modeling, and the modulated range of intense purple hues gives these petals a velvety appearance that registers the delicate sensuousness of an actual flower.

Yet in spite of using this realist vocabulary, O'Keeffe resists a realist effect. The sharply delineated forms and the broad planes of rich, saturated color flatten the perspective and visually reduce the flowers to an abstract pattern of lines and shapes. Further isolating them from any context except the viewer's space, the flowers float against an indeterminate ground, anchored to the earth by only the tiniest sprig of green, which is dislocatingly positioned at the top of the painting. The effect, then, is at once abstract and real. The result is a painting that carries the emotional register of a flower's ineffable sensations. Rather than an objectively realized description of the natural world, O'Keeffe's monumentalized, abstract petunias function as a metaphor of sensuous experience, presenting nature as beautiful and even ravishing. They are paintings of strong feeling rather than observation.

As emblems of beauty, domesticity, femininity, and transience, flowers function as tropes that resonate with sexual associations. Not only are flowers literally the sexual organs of plants, but they are also central objects of the rituals of love and romance. That their sensuous experience is also delicate and intimate has served to reinforce as many cultural assumptions about women as it has about flowers. However, O'Keeffe's flowers revolutionized their traditional associations through a vocabulary of modern abstraction that is evident in *Petunias*. These flowers are not the carefully arranged household objects set within a domestic frame that characterize traditional still-life painting. Their setting resists the usual indoor space by suggesting the natural world of sky and clouds that is the theater of landscape painting. The expansive blooms unfold with a monumental scale as their purple petals,

Fig. 26
Alfred Stieglitz (American, 1864–1946), Georgia O'Keeffe, 1919. Palladium print, 9⅝ x 7⅝ in. (24.4 x 19.3 cm). The Metropolitan Museum of Art, Gift of Georgia O'Keeffe through the generosity of The Georgia O'Keeffe Foundation and Jennifer and Joseph Duke, 1997, 1997.61.23. © 1996 The Metropolitan Museum of Art.

resembling silken tongues, are transformed into a looming presence that recalls a devouring mouth.

With their apparent genital reference, such overt figures of erotic sexuality were bound to raise more than eyebrows, and since the first exhibition of these paintings in 1923 people have speculated over what O'Keeffe's painted flowers reveal about her personal life. Nevertheless, it would be a mistake to limit the rhetoric of these petunias to the meaning imposed by metaphoric symbols of protofeminist sexual ecstasy. From the beginning O'Keeffe resisted any association based on female identity that made her work a trope for female genitalia, intuition, or instinctual creativity.[171] Stieglitz himself had contributed to this view, which O'Keeffe believed to be reductive, by casting her as the symbolist muse and artistic product of his own creative power.[172] That O'Keeffe found this role increasingly stifling is indicated by her long visits to, and ultimate resettlement in, New Mexico, far from the influences of Stieglitz and his New York circle. However, her paintings do carry a sexual charge that resonates with the profound changes in national life during the 1920s.

On the one hand, the peacetime economy after World War I was a time of extreme social reorganization in gender roles. The eighteenth amendment to the constitution in 1920 gave women a share in political power through the vote, greatly enlarging the public role of women in national life. O'Keeffe participated actively in the National Women's Party and its campaign for the Equal Rights Amendment.[173] At the same time, this increased public presence created social anxiety and the need for an ideology of the sexes that would reassert more traditional gender roles. Women were encouraged to participate in the new economic boom of the 1920s by turning their homes into showcases for consumer goods. This focus on the home as the natural sphere of women reestablished distinctions that had been articulated in the nineteenth century (cat. 50, *Works*). However, in place of the nineteenth-century ideology of separate spheres based in a gendered division between the woman's private domain of household and the man's public domain of commerce, the new rationale was based in an assumed biological division between the rational male and intuitive female minds. This division, it was argued, mentally equipped men to produce and women to consume. It was this constraining system that O'Keeffe sought to resist in her insistence that her images were not direct analogues for feminine genitalia and sexuality but rather metaphors of more ineffable sensations that belonged to both women and men.[174]

In place of the feminist political statements often attributed to O'Keeffe's flowers as symbols of emancipated womanhood, their

Cat. 76
GEORGIA O'KEEFFE
Petunias, 1925

understanding can be amplified by consideration of the larger philosophical concerns of the still-life's visual vocabulary as it pursues perceptual truth. This is the polar opposite of the idiom of glory and power that was used by the Hudson River School painters to wrest the visual language of Manifest Destiny from the natural landscape. In those images, the actual places were less important than their symbolic roles as metaphors of national identity. Yet O'Keeffe's visual perception lends the specificity of this single bunch of blooms the monumental scale that weighted the nineteenth-century landscape with nationalist associations.

In her avant-garde representations of the natural world, O'Keeffe makes the coded language of national identity the subject of her images. Rather than presenting images as metaphors of an ideological message, she positions her viewers to experience the metaphors themselves. That the spectator's experience determines meaning points to the way that the images themselves suspend viewers between abstraction and representation, artifice and fact, experience and symbol. That the petunias are metaphors is beyond question: what, exactly, they are metaphors for is a very open question. Disengaged from both ground and space, these abstracted flowers implicate the viewer in the painting's meaning, becoming a site where individuals find themselves negotiating their public and personal identities as national tropes.

VARIED ACCENTS/INFLECTED VISIONS O'Keeffe's
Petunias brings us full circle, returning to the Puritan's use of per-
sonal metaphors to construct the symbolic language that mediates the
larger cultural values of the nation. During one of the nation's most
prosperous and materialistic decades, O'Keeffe chose an abstract sym-
bolist vocabulary of transcendental images. It was both a return to
and a reversal of the role played by visual signs in the nation's begin-
ning when *The Mason Children* relied on the language of metaphor to
constitute a shared rhetoric of intangible truths.

This essay has investigated historical American paintings and the
cultural stakes represented in them. As a primary concern, it offered
evidence of how American artists transformed the conventions of art
history that they inherited from European traditions. An equally sig-
nificant concern has been to show how these works also operated as
sites of cultural negotiation within the historical specifics of social,
political, and economic conditions. American paintings continue to
be potent sites where definitions of national life, and how individuals
participate in it, are contested and reconfigured as their viewers change
along with the cultural matrix of the country. That the museum com-
munity recognizes these paintings as masterworks further testifies
to an inherent link between aesthetics and visual culture in shaping
experience from the most personal to the most public.

The Mason Children is a painting that speaks eloquently about the
conditions of family life in Puritan New England by virtue of the visual
tropes that support the theological vocabulary of its contemporaries.
Verbal and visual languages converge in the painting, reinforcing each
other through a mutually symbolic system of meaning. *Petunias* is a
painting that speaks with a similar eloquence, but in the markedly
changed climate of American modernity its visual figures reject the
theological confidence of the Puritans asserting the priority of
emotional ambiguity and the ineffable. At the same time, O'Keeffe's
monumental flowers resonate with landscape painting, but invest the
image with a powerfully personal message about the relation between
intimate experience and national identity. Thus, both paintings con-
nect individual experience and national life through the mutually
defining relation of visual and verbal languages, but the radically dif-
ferent cultural moments of each painting construct those languages
according to their own historically specific contexts.

During the 1930s, the art historian Erwin Panofsky's studies in
iconology focused on imagery as a means to embody ideological
assumptions, providing a new understanding of paintings. Panofsky's
groundbreaking theory shifted visual interpretation from iconography
(the meaning of visual symbols) to iconology (the study of the

principles underlying the meaning of those symbols).[175] More recently, W.J.T. Mitchell has updated Panofsky's notion of iconology by applying to it poststructuralist investigations into the nature of language.[176] By analyzing the ways that verbal and visual meanings are implicated in each other, Mitchell is able to describe how the discourses used in discussing art interact with other discursive fields in the culture.[177] It is this interaction that has allowed the present essay to bring together seemingly unrelated discourses, such as those defining the aesthetic conventions of still life painting and those used to support bourgeois notions of domesticity.

Of course, any reading of these paintings does not exhaust their meanings. Because verbal and visual vocabularies may be related through numerous figurative tropes, they have the capacity to keep redefining each other's terms. Given the subjective associations inherent to figurative language, the meaning of a work of art necessarily changes according to the expectations that form the historical moment of specific viewers.

The priority of conditions at any historical moment is also the reason that certain works may speak more powerfully to one generation over another or to groups united by common experiences. The most obvious examples of such subjective differences are found in alternative readings of the same masterwork painting by those who identify with various cultural subgroups. To cite the most common examples, when the languages of gender, class, or ethnicity are brought to bear on the meaning of a work of art, the verbal-visual associations may line up very differently according to the respective positions of viewers relative to those subgroups. As an example, the classicizing of laborers in Anshutz's *The Ironworker's Noontime* is a visual trope that would interact very differently with the subjective experience of a working-class viewer than it would with a commodities stock holder. Both would understand its visual vocabulary of the hero, but their notions of what constituted a hero probably would be very different. Meaning, therefore, can escape artistic intentions even when the artist's purposes can be documented. For the same reason, masterworks endure: they are complex visual representations that cannot be reduced to incontestable verbal translations.

In a similar manner, American artists continually appropriate the vocabulary of European art traditions for their own purposes by transforming them through their own needs and desires. American artists and American viewers have been engaged in an evolving process of cultural negotiation. They have sought to make sense out of the larger culture and its dominant traditions by introducing their own accents into the language of visual representation. At times, that

accent was broad, as when artists and viewers laid claim to a European vocabulary by giving it an inflection informed by the concerns that defined life in the Americas. At other times, the accent was subtler, as when artists and viewers interjected their particular expressions into the debates over the country's social institutions of family, community, and nation.

Artists and viewers have not always shared the same assumptions about those institutions, or even about the definition of America. The value of a collection of great American paintings when seen all together, such as the one assembled here, is their ability to foster a dialogue regarding the vision of America that each artist sought to represent. Additionally, they offer richly complex sites to explore the use of visual vocabularies and their roles in negotiating the heterogeneous and diverse experiences that compose American culture. This discussion has sought to expand the nature of that dialogue, enriching not only the viewer's experience of these masterworks, but also the understanding of the diverse inflections that make up America's rich and varied accents.

NOTES

1. Within this opposition, genius is usually understood to belong to those who, in Hegel's transcendental formulation, sensuously embody an abstraction from the realm of the philosophical Idea. A philosophical concept growing out of eighteenth-century Enlightenment philosophy and its individualist assumptions, genius is usually assumed to lie outside, and, in the metaphoric language of abstract ideals, above, incident and the commonplace, which is the realm of historical experience.

2. A good general discussion of the influence of Kant on Western aesthetics is in Mary Anne Staniszewski, *Believing is Seeing: Creating the Culture of Art* (New York and London: Penguin Books, 1995), 119–123.

3. A complete summary of how the French Revolution transformed the notion of master-work from the understanding that had defined work previously designated as belonging to an old-master tradition is found in Andrew L. McClellan, "The Musée du Louvre as Revolutionary Metaphor During the Terror," *Art Bulletin* (June 1988): 300–12.

4. Arthur C. Danto, *Encounters and Reflections: Art in the Historical Present* (Berkeley and Los Angeles: University of California Press, 1990), 319.

5. Danto, Encounters, 330.

6. Danto, Encounters, 326.

7. An excellent overview of the historical approaches leading to visual culture studies is offered by Wanda Corn, "Coming of Age: Historical Scholarship in American Art," *Art Bulletin*, 70 (June 1988): 188–207.

8. Foremost among these works is a series of essay collections under the editorship of Norman Bryson, who began as a literary critic and then served as chair of art and architecture at The Massachusetts Institute of Technology. See Norman Bryson et al., *Visual Culture: Images and Interpretations* (Hanover and London: Wesleyan University Press, 1994). This approach was initiated and discussed in a related volume published as Norman Bryson et al., eds., *Visual Theory: Painting and Interpretation* (New York: Harper Collins, 1991).

9. The Louvre was merely the first in a succession of such appropriations as Marcia Pointon points out: "Royal collections in many instances formed the core of national galleries. Moreover the new public collections were often housed in former royal palaces or provided with new buildings resembling palaces." Marcia Pointon, ed., *Art Apart: Art Institutions and Ideology Across England and North America* (Manchester and New York: Manchester University Press, 1994), 1–2.

10. See the discussion about John Vanderlyn's *Caius Marius amid the Ruins of Carthage* (1807) later in this essay for an account of an American artist's frustrating experience at home after his success in the Paris Salon of 1808. In her monograph on American participation in the nineteenth-century Paris Salons, Lois Marie Fink writes, "Whatever their own experiences had been in the French art community, American artists in Paris had glimpsed tantalizing visions of their profession that could not possibly be transferred to the United States." Lois Marie Fink, *American Art at the Nineteenth-Century Paris Salons* (Washington, D.C.: National Museum of American Art, Smithsonian Institution and New York: Cambridge University Press, 1990), 29.

11. Although American artists did not rely on the Salon system, they were aware of its influence in Europe and some artists did participate in them in a limitted way, especially in London and Paris during the modernist period and in the unofficial Salons of Alfred Stieglitz, Mable Dodge, and Walter and Louise Arensberg in New York early in the twentieth century. For an account of their influence, see Robert M. Crunden, *American Salons: Encounters with European Modernism, 1885–1917* (New York: Oxford University Press, 1993).

12. Quoted in Peter N. Carroll and David W. Noble, *The Free and the Unfree: A New History of the United States*, 2nd ed. (New York: Penguin Books, 1988), 103.

13. It is possible, of course, that these paintings are the work of several individuals, maybe even from the same workshop, but they exhibit enough unity of style and technique to be classified as a single school. Jonathan Fairbanks has attempted to explain the possible hands involved in a group of portraits that were all painted in Boston around 1690 in his "Portrait Painting in Seventeenth-Century Boston: Its History, Methods, and Materials," *New England Begins: The Seventeenth Century*, exh. cat. (Boston: Museum of Fine Arts, 1982), 417–418.

14. Fairbanks, "Portrait Painting," 418.

15. Wright studied at the Royal Academy from 1775 to 1781. Michael Quick, "Joseph Wright," *American Portraiture in the Grand*

Manner, 1720–1920, exh. cat. (Los Angeles: Los Angeles County Museum of Art, 1981), 120.

16. Quick, "Joseph Wright," 120.

17. Benson Bobrick, *Angel in the Whirlwind: The Triumph of the American Revolution* (New York: Penguin Books, 1998), 62–3. Bobrick writes that *Cato* was the first English play printed in America (1767), primarily, he contends, because "it seemed to hold up a mirror to the developing struggle between British imperial prerogative and colonial rights. The language of the play became part of the language of political debate" (50). The seminal study of how classical rhetoric shaped revolutionary debate in America remains Bernard Bailyn, *The Ideological Origins of the American Revolution* (Cambridge, Mass.: University Press, 1967; revised, 1992). A more recent account of these ideas is available in the section entitled "Republicanism" in Gordon S. Wood, *The American Revolution: A History* (New York: The Modern Library, 2002), esp. 91–5.

18. Marc Simpson, Sally Mills, and Jennifer Saville, *An American Canvas: Paintings from the Collection of the Fine Arts Museums of San Francisco* (New York: Hudson Hills Press, 1989), 50. For a discussion of republican virtue as a political campaign strategy in the painting of Jacques-Louis David, see McClellan, "Musée du Louvre," 306–308.

19. Wright is known to have made at least one drawing of *Jonathan Buttal* while in London, which he carried with him when he returned to Philadelphia in 1783. Monroe H. Fabian, *Joseph Wright: American Artist, 1756–1793*, exh. cat. (Washington, D.C.: Smithsonian Institution Press and the National Portrait Gallery, 1985), 26.

20. Andrew Wilton, *The Swagger Portrait: Grand Manner Portraiture in Britain from Van Dyck to Augustus John, 1630–1930* (London: Tate Gallery, 1992), 17.

21. It is important to note that Gainsborough had heightened the aristocratic resonance in *Jonathan Buttal* by painting him in clothing that was taken from the baroque styles of van Dyck. Gainsborough's main rival, Sir Joshua Reynolds, often claimed that the artist used "van Dyck dress" in order to associate his paintings with van Dyck's and thus give the impression that they were better than they actually were. Michael Rosenthal, *The Art of Thomas Gainsborough: "a little business for the Eye,"* (New Haven and London: Yale University Press for the Paul Mellon Center for Studies in British Art, 1999), 86.

22. Simpson et al., *American Canvas*, 112.

23. Rosenthal, *Gainsborough*, 86.

24. Christopher Flint, "The Family Piece: Oliver Goldsmith and the Politics of the Everyday in Eighteenth-century Domestic Portraiture," *Eighteenth-century Studies*, 29 (Winter, 1995–1996), 127–152. David Solkin has pointed out that the establishment of the Royal Academy in 1768 was a rear-guard attempt to reassert past standards exemplified by the grand-manner portrait. I would add that the well-known and often public rivalry between its president, Sir Joshua Reynolds, and Thomas Gainsborough exemplified tensions between the conventions of grand-manner portraiture and conversation pieces, given Gainsborough's willingness often to conflate the two traditions. See David H. Solkin, *Painting for Money: The Visual Arts and the Public Sphere in Eighteenth-century England* (New Haven and London: Yale University Press for the Paul Mellon Center for Studies in British Art, 1993).

25. A contemporary account describes the painting in just such language: "The figures of the elder persons are somewhat constrained, but nothing could be more natural than the action of the little child, laying its hand on grandpapa's arm, to attract his attention from the newspaper." "Fine Arts: The National Academy of Design," *New-York Times*, 30 April 1869.

26. For an account of gendered spheres in the Gilded Age, see Linda Nicholson, *Gender and History: The Limits of Social Theory in the Age of the Family* (New York: Columbia University Press, 1986). A comprehensive review of the historical approaches to gendered spheres is available in Linda Kerber, "Separate Spheres, Female Worlds, Woman's Place: The Rhetoric of Women's History," *Journal of American History* 75 (June 1988): 9–39. For the impact of gendered separate spheres on male subjects see R. W. Connell, *Masculinities: Knowledge, Power, and Social Change* (Berkeley and Los Angeles: University of California Press, 1995), esp. 185–199.

27. Simpson, *American Canvas*, 112. Additionally, the painting is something of a commemorative work because James and Eliza Brown were about to move to a new house and the room was to be dismantled the next year.

28. "The Fine Arts: The National Academy of Design," *New-York Daily Tribune*, 22 May 1869.

29. For an extended discussion of the relation between seventeenth-century Dutch realism and bourgeois society, see Svetlana Alpers, *The Art of Describing: Dutch Art in the Seventeenth Century* (Chicago: University of Chicago Press,1983), passim.

30. Although Sargent was not invited to participate in any of the eight major Impressionist exhibitions, he exhibited in other venues with Edgar Degas, Claude Monet, and Pierre Auguste Renoir. Berthe Morisot planned to include him in an American exhibition of contemporary French art. Elaine Kilmurray and Richard Ormond, eds., *John Singer Sargent*, exh. cat. (London: Tate Gallery, 1998), 105.

31. Stephen Kern goes so far as to argue that this is a portrait of disdain. "Vickers faces his wife but is decidedly not interested in looking at her, his thoughts drifting off like the smoke from his cigar." Stephen Kern, *Eyes of Love: The Gaze in English and French Paintings and Novels*, 1840–1900 (London: Reaktion Books, 1996), 217.

32. In *John Singer Sargent*, Kilmurray and Ormond argue that it is this perceptual engagement with the viewer that gives Sargent's portrait its "thoroughly modern" character (108).

33. Cassatt's work was shown in the fourth, fifth, sixth, and eighth exhibitions. Simpson et al., *American Canvas*, 148.

34. Henri studied under two other artists in this exhibition, Thomas Anshutz and Thomas Hovenden, at the Pennsylvania Academy of the Fine Arts, Philadelphia, from 1886 to 1887. In 1888 he entered the Académie Julian, where he studied under Tony Robert-Fleury and William-Adolphe Bouguereau through 1891, when he was admitted to the Ecole des Beaux-Arts. In 1892 he again enrolled in the Pennsylvania Academy of the Fine Arts. During the 1890s he traveled throughout Europe, primarily France and Spain. Valerie Ann Leeds, *"My People": The Portraits of Robert Henri*, exh. cat. (Seattle: University of Washington Press, 1994), 113.

35. The exhibition included Arthur B. Davies, William J. Glackens, Robert Henri, Ernest Lawson, George Luks, Maurice B. Prendergast, Everett Shinn, and John Sloan. Glackens, Luks, Shinn, and Sloan were all illustrators for the *Philadelphia Press*. All eight artists and the exhibition are discussed in Bernard B. Perlman, *The Immortal Eight: American Painting from Eakins to the Armory Show, 1870–1913* (Cincinnati: North Light Publishers, 1979).

36. William Innes Homer in Leeds, *"My People,"* 12.

37. Simpson et al., *American Canvas*, 194.

38. Although Henri had been schooled in the same conventions of portraiture as Sargent, he consciously turned away from upper-class sitters to the urban streets for his subjects.

39. Whitney Chadwick, *Women, Art, and Society*, rev. ed. (London: Thames and Hudson, 1996), 143

40. Chadwick, *Women, Art, and Society*, 143.

41. The motif of the femme fatale was developed by Charles Swinburne and Walter Pater, writers who used it to link female sexuality and the sublime. Catherine Maxwell, "From Dionysus to *Dionea:* Vernon Lee's portraits," *World and Image* 13 (July/September 1997), 254. Henri also avoids presenting Organ as a muse, a primitive, or an odalisque, three other turn-of-the-century tropes of female sexuality that subsume women within the empowerment and satisfaction of the male gaze.

42. Sigmund Freud's German edition of *Studies in Hysteria* was first published in Leipzig and Vienna in 1895. The English translation is 1909.

43. A summary of the female body and the male gaze in art history is available in Norma Broude and Mary D. Garrard, eds., *The Expanding Discourse: Feminism and Art History* (New York: Harper Collins, 1992), 7–12. The classic statement of this theory is Laura Mulvey, "Visual Pleasure and Narrative Cinema," *Visual and Other Pleasures* (Bloomington: Indiana University Press, 1989), 14–28.

44. Stephan Koja, ed., *America: The New World in Nineteenth-century Painting*, exh. cat. (Munich, London, and New York: Prestel Verlag, 1999), 180.

45. Robert N. Bellah et al., *Habits of the Heart: Individualism and Commitment in American Life* (New York: Harper and Row, 1985), ix.

46. Robert N. Bellah et al., *Individualism and Commitment in American Life: Readings on the Themes of Habits of the Heart* (New York: Harper and Row, 1987), 276.

47. Bellah, *Individualism and Commitment*, 277.

48. Bellah, *Habits of the Heart*, 66. This definition has its roots in the protestant religious tradition that dominated colonial American society. The Episcopal *Book of Common Prayer*'s collect for Labor Day reads: "So guide us in the work we do, that we may do it not for the self alone, but for the common good."

49. Peale was sent by a group of Maryland patrons to study at the Royal Academy from 1867–1869. Simpson et al., *American Canvas*, 38.

50. Raymond Williams, *Keywords: A Vocabulary of Culture and Society*, revised ed. (New York: Oxford University Press, 1983), 336.

51. The steamboat was actually invented by John Fitch seventeen years earlier in 1790 but Fulton was the first to navigate a practical vessel. He sailed the *Clermont* up the Hudson River in 1807.

52. David Bjelajac, *American Art: A Cultural History* (London: Laurence King, 2000), 203.

53. Michael Edward Shapiro, *George Caleb Bingham* (New York: Harry N. Abrams, 1993), 51–2.

54. See, for instance, Alex Nemerov, *"Doing the 'Old America':* The Image of the American West, 1880–1920," in *The West as America: Reinterpreting Images of the Frontier, 1820–1920*, ed. William H. Truettner (Washington, D.C.: Smithsonian Institution Press, 1991), 285–343.

55. Bryan J. Wolf argues that the painting appears to be about a historical account of the past versus the present but in actuality it thematizes an ideological debate over national character through a series of substitutions that are made to seem natural by their frontier setting: "unity for division, continuity for change, and regional identity for class difference." See "History as Ideology: Or, 'What You Don't See Can't Hurt You, Mr. Bingham'," *Redefining American History Painting*, eds. Patricia M. Burnham and Lucretia Hoover Giese (London: Cambridge University Press, 1995), 257.

56. Although there were frequent French and German uses that linked the terms industrial and revolution between 1806 and 1930, the preeminent Marxist cultural historian Raymond Williams traces the actual first use of the term "industrial revolution" to Arnold Toynbee in lectures from 1881. Raymond Williams, *Keywords*, 166.

57. The term derives from Baudelaire, who, as Marshall Berman recounts, "did more than anyone in the nineteenth century to make the men and women of his century aware of themselves as moderns. Modernity, modern life, modern art – these terms occur incessantly in Baudelaire's work. . . . If we had to nominate a first modernist, Baudelaire would surely be the man." Marshall Berman, *All That Is Solid Melts into Air: The Experience of Modernity* (New York: Simon and Schuster, 1982), 132–133. Baudelaire's influence was being felt most strongly in France during the 1860s, but his preeminence helped prepare the ground for Marx and Engels throughout the Victorian period.

58. Berman, *All That Is Solid*, 93.

59. Quotation recorded in the painting files at the Fine Arts Museums of San Francisco. Eakins studied at the Ecole des Beaux-Arts in Paris from 1866 to 1869, entering the atelier of Jean-Léon Gérôme. From November 1869 to June 1870 he traveled in Europe, primarily Spain, where he expressed a particular interest in the baroque realists, especially Velázquez's paintings in the Prado Museum. In his notes, Eakins specifically comments on the unsurpassed beauty of the spinner in the foreground of Velázquez's *Las Hilanderas* (1644–48). Simpson et al., *American Canvas*, 144.

60. *Bulfinch's Mythology, Illustrated* (New York: Avenel Books, 1974), 8.

61. Edward Lucie-Smith, *American Realism* (New York: Harry N. Abrams, 1994), 63. My own reading acknowledges Thomas H. Pauly's important article in which he emphasizes the celebratory aspects of this painting, but my reading equally rejects his assertion that the painting is "not criticizing industrialization or its effect upon labor; such concerns are ones our age has read into Anshutz's unusual painting." Thomas H. Pauly, "American Art and Labor: The Case of Anshutz's *The Ironworkers' Noontime*," *American Quarterly* 40 (September 1988): 333–358.

62. Eakins stressed the importance of anatomy in his life drawing instruction at the Pennsylvania Academy of the Fine Arts, and Anshutz served as his assistant in anatomy classes conducted on cadavers during 1879, 1879, and 1981. He took over Eakins's position in 1886 after the later was forced to resign over the scandal (which Anshutz helped to create) over the use of nude male models in Eakins's life drawing classes, which were attended by both male and female students. Simpson et al., *American Canvas*, 160.

63. Wayne Craven makes just such an interpretive association when he writes: "It is not a great step from *Steelworkers — Noontime* [sic] to the art of the Ashcan School." Wayne Craven, *American Art: History and Culture* (Madison: Brown and Benchmark, 1994), 342.

64. Writing about *The Ironworkers' Noontime*, Patricia Hills says, "the nineteenth century witnessed an intensification of the struggies

between labor and capital as industrialization became firmly established in the nation. A new subject entered into art: the urban proletariat. Many artists and writers sympathized with the hopes and goals of this urban proletariat, and were attracted to various socialist groups that advocated reforms and/or the overthrow of the economic and social system of capitalism." Patricia Hills, *The Working American*, exh. cat. (Washington D.C.: Smithsonian Institution, 1979), 8.

65. Robert Hughes, *American Visions: The Epic History of Art in America* (New York: Alfred A. Knopf, 1997), 301.

66. Melissa Dabakis, "Douglas Tilden's Mechanics Fountain: Labor and the *Crisis of Masculinity* in the 1890s," *American Quarterly* 47 (June 1995): 204. She goes on to write: "the strong bodies of contemporary ironworkers formed the focus of attention in Thomas Anshutz's *Ironworkers' Noontime* Positioned as if on a stage set, these workers appear to place their exposed arms, shoulders, and upper torsos deliberately on display for middle-class consumption" (214).

67. Bjelajac, *American Art*, 258.

68. For an account of the cultural implications of the 1876 Centennial Exhibition in Philadelphia as well as the 1877 strike with special attention to the Pennsylvania Railroad in Pittsburgh and Philadelphia, see Herbert G. Gutman, director, and Stephen Brier, ed., *Who Built America: Working People and the Nation's Economy, Politics, Culture and Society, Vol. 2: From the Gilded Age to the Present* (New York: American Social History Project and Pantheon Books, 1992), xvii–xxviii.

69. Lee Hall, *Olmsted's America: An "Unpractical" Man and His Vision of Civilization* (Boston: Little, Brown and Co., 1995), 59–60.

70. Hall, *Olmstead's America*, 61.

71. Hall, *Olmstead's America*, 242.

72. Hall, *Olmstead's America*, 62.

73. Rebecca Zurier, Robert W. Snyder, Virginia M Mecklenburg, *Metropolitan Lives: The Ashcan Artists and Their New York*, exh. cat. (New York and London: National Museum of American Art and W. W. Norton, 1995), 42.

74. For a fuller discussion of the City Beautiful movement, see William H. Wilson, *The City Beautiful Movement* (Baltimore: Johns Hopkins University Press, 1989); for its continuity with transcendentalism see Michael G. Kammen, *Mystic Chords of Memory: The Transformation of Tradition in American Culture* (New York: Knopf, 1991); for its class implications see Paul S. Boyer, *Urban Masses and Moral Order in America, 1820–1920* (Cambridge: Harvard University Press, 1978), passim.

75. Hall also credits Olmsted with the opposite sense of public space that was the hallmark of fairgrounds — with their emphasis on industrial-based urban pleasures rather than rural retreat — through his design of Jackson Park for Chicago's 1893 Colombian Exposition (206–17).

76. In 1900 the nation's three largest cities were Philadelphia and Chicago with over 1 million and New York with over 1.5 million inhabitants. See Gutman and Brier, *Who Built America*, 14. Glackens began drawing comics for the *New York World* in 1896. See Zurier, *The Ashcan School*, 196.

77. "Glackens veered from socially or politically controversial subjects when working in oil, and this is reflected in the paintings he created between 1905 and 1912 of children playing in urban parks." Bruce Weber, *Ashcan Kids: Children in the Art of Henri, Luks, Glackens, Bellows and Sloan*, exh. cat. (New York: Berry-Hill Galleries, 1999), 19.

78. In the catalogue for an exhibition of American Impressionism and Realism at the Metropolitan Museum of Art, the curators argue that even with his ties to the subject matter of French Impressionists, Glackens paints with a more optimistic sensibility: "Glackens's suggestion of the genial pleasures of New York's winter [in a related Central Park painting] is typical of the artist and distinguishes him temperamentally from the French painters of modern life who inspired him." H. Barbara Weinberg, Doreen Bolger, and David Park Curry, *American Impressionism and Realism: The Painting of Modern Life, 1885–1915*, exh. cat. (New York: Harry N. Abrams and The Metropolitan Museum of Art, New York, 1994), 156.

79. Bjelajac, *American Art*, 292.

80. For a fuller discussion of the largely immigrant-based IWW, including its adversarial relations with other union organizations, notably the more highly-skilled craft unionism of the American Federation of Labor (AFL), see Gutman and Brier, *Who Built America*, 189–98.

81. *Encyclopedia Britannica*, 8 (Chicago: University of Chicago, 1948): 288.

82. Adams recorded this observation some years later in his famous autobiography *The Education of Henry Adams: A Study of Twentieth-Century Multiplicity* (Private

Printing, 1907; Boston: The Massachusetts Historical Society, 1918; reprint, New York: Random House, Modern Library Edition, 1931), 382.

83. Karen Tsujimoto, *Images of America: Precisionist Painting and Modern Photography* (Seattle: University of Washington Press, 1982), 17–18.

84. Tsujimoto, *Images of America*, 18.

85. The 1913 International Exhibition of Modern Art is commonly referred to as the Armory Show after the 69th Regiment Armory building on Twenty-fifth Street in Manhattan's Gramercy Park district where it took place. Arthur B. Davies organized the exhibition, which subsequently traveled to Boston and Chicago. Duchamp's most infamous readymade, *Fountain*, is from the second Armory Show exhibition in 1917.

86. A famous cartoon of the time by J. F. Griswold and published in the 20 March 1913 *New York Evening Sun* summarizes the general tenor of the criticism. Entitled *The Rude Descending the Staircase (Rush Hour at the Subway)*, it depicts a jumble of commuters crowding down a subway entrance. Bjelajac, *American Art*, 305.

87. The term "Precisionism" derives from Martin Friedman's pioneering exhibition *The Precisionist View in American Art* in 1960. Earlier terms have included Immaculates, New Classicists, or Cubist-Realists. Tsujimoto, *Images of America*, 22.

88. The Daniel Gallery especially became associated with Precisionism and gave Demuth his first one-person exhibition in 1914. Among the other precisionist artists that it represented were Charles Sheeler, Preston Dickinson, Niles Spencer, and Elsie Driggs. Sheeler was also affiliated with Stieglitz's gallery 291 as both a painter and a photographer. See Tsujimoto, *Images of America*, 169, n. 1.

89. A map identifying all the architectural and industrial sites that Demuth painted in Lancaster is printed in Betsy Fahlman, "Charles Demuth's Paintings of Lancaster Architecture: New Discoveries and Observations," *Arts Magazine* 61 (March 1987): 24.

90. Carroll and Noble, *The Free and the Unfree*, 310–11.

91. Marc Simpson, "Charles Demuth's *From the Garden of the Château*," *Triptych* (April/May 1990): 13–14.

92. Quoted in Carroll and Noble, *The Free and the Unfree*, 335.

93. Between 1929 and 1933 unemployment rose to over fifteen million, industrial production dropped fifty percent, and the national income fell from 82 billion to 40 billion dollars. Carroll and Nobel, *The Free and the Unfree*, 335.

94. Patricia Hills, *Social Concern and Urban Realism*, exh. cat. (Boston: Boston University Art Gallery, 1983), 9.

95. Marsh was a self-taught caricaturist and cartoonist best known for his work with the *New Yorker* magazine. Thomas H. Garver, *Reginald Marsh: A Retrospective Exhibition* (Newport Beach, California: Newport Harbor Art Museum, 1972), [1].

96. Marsh studied painting under Kenneth Hays Miller, whose training in classical techniques led him and his students at the Art Students' League to be known as the Fourteenth Street School. Hills, *Social Concern*, 14. He recorded his most significant influences as Rubens and Delacroix, but also was inspired by copying Rembrandt and Titian at the Louvre. Garver, *Reginald Marsh*, [2].

97. Quoted in Garver, *Reginald Marsh*, [1].

98. It was Thomas Hart Benton, a member of a related school of American scene painting known as Regionalism, who introduced Marsh to the virtues of tempera. Garver, *Reginald Marsh*, [2].

99. This understanding of the document is based in an analysis of the visual effects on which documentary photography relies. See Diana Emery Hulick, *Photography: 1900 to the Present* (Upper Saddle River, N.J.: Prentice Hall, 1998), 14. During the 1930s these documentary aims were advanced by Franklin Roosevelt's New Deal agency, the Farm Security Administration (FSA), when it hired a team of photographers to document the desperate living conditions of American farmers who were especially hard hit by the effects of the depression. The FSA's most famous publication was a photo-illustrated plea for compassion entitled *Let Us Now Praise Famous Men*, published in 1941 by Walker Evans in collaboration with the writer James Agee.

100. For a description of the other works in the cycle, see the analysis of the painting by Timothy Anglin Burgard, "Aaron Douglas's *Aspiration*," *Fine Arts Magazine* (Summer 1998), 4.

101. The term "Harlem Renaissance" was first used by John Hope Franklin in 1947 to designate the development in New York City— between the end of WWI in 1918

and the 1929 stock market crash—of an early twentieth century cultural movement that celebrated and encouraged Americans of African descent to explore their noneuropean heritages and traditions. Richard J. Powell et al., *Rhapsodies in Black: Art of the Harlem Renaissance*, exh. cat. (London, Berkeley, and Los Angeles: Hayward Gallery, Institute of International Visual Arts, and the University of California Press, 1997), 17.

102. Middle passage and diaspora are the terms used by African American scholars to designate the origin of the social, political, economic, and cultural conditions that constituted the system of slavery and the continued legacy of its reliance on human chattel. See Daniell Cornell and Cheryl Finley, *Imaging African Art: Documentation and Transformation*, exh. cat. (New Haven: Yale University Art Gallery, 2000), esp. 9–12 and 24–28.

103. Powell, *Rhapsodies*, 104.

104. Burgard, *"Aspiration,"* 5.

105. Burgard, *"Aspiration,"* 5.

106. Stanley Coben and Norman Ratner, eds. *The Development of an American Culture*, 2nd edition (New York: St. Martin's Press, 1983), 9.

107. For a good discussion of art-historical genres within this classification system see John Berger, *Ways of Seeing* (London and Middlesex: British Broadcasting Corporation and Penguin Books, 1972), 99–108.

108. A poem read at a celebration hosted by administrators of the Paris museums compared West to David's teacher, Joseph-Marie Vien, the acknowledged master of French history painting. For an account of West's visit, see Lois Marie Fink, *American Art at the Nineteenth-Century Paris Salons* (Cambridge and Washington D.C.: Cambridge University Press and the National Museum of American Art, 1990), 13–15.

109. Among the more prominent Americans who are associated with the Royal Academy are John Singleton Copley, Mather Brown, Joseph Wright, John Trumbull, and Robert Fulton.

110. The widely repeated story that the gold medal was given by Napoleon himself is apocryphal. The Salon's jurors awarded the medals before Napoleon's tour of the exhibition.

111. A full account of Burr's bizarre life is available in the introduction to his papers, published in Mary-Jo Kline and Joanne W. Ryan, eds. *Political Correspondence and Papers of Aaron Burr*, 2 vols. (Princeton, N.J.: Princeton University Press, 1982).

112. Diana Strazdes goes as far as to argue that Marius is a "pensive figure whose hidden thoughts are the true subject in the painting." See Theodore E. Stebbins, Jr., *The Lure of Italy: American Artists and the Italian Experience, 1760–1914* (Boston: Museum of Fine Arts and New York: Harry N. Abrams, 1992), 164.

113. One of the earliest and most influential expressions of this argument was presented in a BBC television series that was later published as John Berger's *Ways of Seeing*, noted earlier. An equally important investigation was based in film theory. Its main outlines are discussed in the Introduction to Linda Williams, ed., *Viewing Positions: Ways of Seeing Film* (New Brunswick, N.J.: Rutgers University Press, 1994): 1–20.

114. Although Vanderlyn returned to the United States in 1815, it was not until 1834 that he sold his painting to a friend, Leonard Kip of New York. Simpson et al., *American Canvas*, 56.

115. The sketch is in the collection of the Detroit Institute of Arts. This photography was conducted at the Fine Arts Museums of San Francisco conservation lab. The history of the painting's preparatory stages is discussed in Elwood C. Parry, 3rd edition, *The Art of Thomas Cole: Ambition and Imagination* (Newark, N.J.: University of Delaware Press, 1988), 326–332.

116. Cole's own terminology for this revolution in painting categories was "historical landscape." See the discussion in William H. Truettner and Alan Wallach, eds., *Thomas Cole: Landscape into History*, exh. cat. (New Haven and London: Yale University Press and Washington, D.C.: National Museum of American Art, 1994), 79–84.

117. For this definition and a full discussion of the impact of the sublime on American landscape painting, see the seminal study by Barbara Novak, *Nature and Culture: American Landscape and Painting, 1825–1875* (New York: Oxford University Press, 1980), 34–44.

118. Cole became increasingly devout in his religious beliefs and expressed a desire that his paintings serve the ethical principles and moral values of Christianity. Truettner and Wallach, *Thomas Cole*, 82–84.

119. See the entry on Trumbull's presidential portraits by Timothy Anglin Burgard in Ella M. Foshay, *Mr. Luman Reed's Picture Gallery: A Pioneer Collection of American Art* (New

York: The New-York Historical Society and Harry N. Abrams, 1990), 141–45.

120. Asher B. Durand, "Letters on Landscape Painting: Letter 2," *The Crayon* 1 (17 January 1855): 34. The rest of this letter makes it clear that during his obligatory visit to Europe as an aspiring artist ca. 1840–1841, Durand had been unimpressed with the ruins and other evidence of the continent's historic empires.

121. Locke's principle text on natural law is *Essay Concerning Human Understanding* (1690). William Blackstone's principle text is a set of *Commentaries on the Law*, which was published in England (1765) and in Philadelphia (1771), the center of political life in the American colonies.

122. In a classic study of the impact of industrial technology on the American landscape, the cultural historian Leo Marx first pointed out the rhetorical connection between natural law and the middle landscape in Crèvecouer's *Letters from an American Farmer*. See Leo Marx, *The Machine in the Garden: Technology and the Pastoral Ideal in America* (London: Oxford University Press, 1964), 107–114.

123. From his correspondence, it is clear that Durand had studied Claude's paintings during his 1840–1841 trip. See Novak, *Nature and Culture*, 230–1.

124. Church had Cole's *Prometheus Bound* in his studio by January 1856. See *The Crayon* 3 (January 1856): 30.

125. Letter from Frederic Church to Thomas Cole's son, Theodore, dated "Mexico, March 16, 1859." Quoted in Howard S. Merritt, *Thomas Cole*, exh. cat. (Rochester, New York: University of Rochester Press, 1969), 43.

126. Church moved into Cole's home in 1844 at the age of 18 and lived there as a student and friend until Cole's death in 1848. E.P. Richardson, *American Art: An Exhibition from the Collection of Mr. and Mrs. John D. Rockefeller 3rd, A Narrative and Critical Catalogue*, exh. cat. (San Francisco: The Fine Arts Museums of San Francisco, 1976), 116.

127. Church traveled to Ecuador in 1853 and 1857, Labrador in 1859, Jamaica in 1865, and Greece, Syria, and Palestine in 1868. Richardson, *American Art*, 116.

128. In her pioneering study of nineteenth-century American landscape painting, Barbara Novak writes that Church "exhibits the most frequent, even obsessive, preoccupation with the changing effects of clouds." Novak, *Nature and Culture*, 93. Novak also

explains that Church was following the lead of other American and English romantics who used Luke Howard's first scientific taxonomy of clouds in his *Climate of London* (published from 1818 to 1820) to create a vocabulary of visual effects that combined scientific knowledge and poetic truth. See Novak, *Nature and Culture*, 80–89.

129. Franklin Kelly, "A Passion for Landscape: The Paintings of Frederic Edwin Church," in *Frederic Edwin Church*, exh. cat. (Washington D.C.: National Gallery of Art, 1989), 53.

130. Frederick Church's magnificent and monumental painting *Rainy Season in the Tropics* serves as a Civil War pendent to *Twilight*. Painted in the immediate aftermath of the war, its glowing double rainbow acts as a benediction on the war's end and a promise of national renewal and blessings to come. Although Thomas Moran's painting of Yellowstone is from 1906, it is based on sketches made during trips to the park in the 1870s.

131. James McPherson, "On the Civil War and Reconstruction," in *Great Minds of History: Interviews by Roger Mudd* (New York: John Wiley & Sons, 1999), 56. This statistic, of course, does not include the number of American Indians who were decimated through warfare, disease, and sheer brutality by their encounter with European armies and settlers. The casualties of that conflict are even higher for indigenous peoples.

132. John Pultz, *The Body and the Lens: Photography 1839 to the Present* (New York: Harry N. Abrams, 1995), 32–33.

133. Fletcher Harper, publisher and editor of *Harper's*, hired Homer to serve as an artist-correspondent of the war for the magazine in October 1861. From a letter documented in Marc Simpson, *Winslow Homer: Paintings of the Civil War* (San Francisco: Fine Arts Museums of San Francisco, 1988), 17.

134. Quoted in Simpson, *Homer*, 47.

135. Simpson, *Homer*, 199.

136. For a thorough discussion on the temperament of mules and their comic role in representations at this time, see Simpson, *Homer*, 51–53.

137. Three examples of such humorous images are *"Home, Sweet Home"* (ca. 1863), *Playing Old Soldier* (1863), and *In Front of the Guard-House* (1863). See the catalogue entries for the paintings in Simpson, *Homer*, 142–152 and 160–164.

138. The other painting was the highly Northern-biased *Prisoners from the Front* (1866).

139. Simpson, *Homer*, 48.

140. Herman Hattaway and Archer Jones, *How the North Won: A Military History of the Civil War* (Chicago and London: University of Illinois Press, 1983), 703.

141. This definition is drawn from Patricia M. Burnham and Lucretia Hoover Giese, eds., *Redefining American History Painting* (Cambridge: Cambridge University Press, 1995), 12.

142. Quoted in Kathryn S. Hight, *"Doomed to Perish:* George Catlin's Depictions of the Mandan," in *Reading American Art*, Marianne Doezema and Elizabeth Milroy, eds. (New Haven and London: Yale University Press, 1998), 151.

143. For a complete account of the Trail of Tears and the Cherokee Nation's attempt to maintain its lands in the face of Andrew Jackson's U.S. policy known as The Removal, see John Ehle, *Trail of Tears: The Rise and Fall of the Cherokee Nation* (New York: Doubleday, 1988); and Joan Gilbert, *The Trail of Tears Across Missouri* (Columbia and London: University of Missouri Press, 1996).

144. Samuel Carter III, *Cherokee Sunset: A Nation Betrayed, A Narrative of Travail and Triumph, Persecution and Exile* (Garden City, New York: Doubleday, 1976), esp. 22.

145. Jackson had gained notoriety as an "Indian-killer" and often referred to American Indians as "savage bloodhounds." Quoted in Hughes, *American Visions*, 182.

146. Carroll and Noble, *The Free and the Unfree*, 231.

147. Quoted in Carroll and Noble, *The Free and the Unfree*, 231.

148. Quoted in Carroll and Noble, *The Free and the Unfree*, 233. The general outlines and major conflicts of the contest between American Indians and the United States government from the Civil War (1861) to the battle at Wounded Knee Creek (1890) is detailed in Carroll and Noble, 231–237.

149. A group of scholars called the New Historians have "looked at the West as a region that was already settled by people before Americans got there." Richard White, in *Great Minds of History*, 96. The seminal text is Richard White, *"It's Your Misfortune and None of My Own": A New History of the American West* (Norman: University of Oklahoma Press, 1991).

150. There are two versions of the painting. The larger of the two is in the collection of the Corcoran Gallery of Art in Washington, D.C., and the other is in the Buffalo Bill Historical Center in Cody, Wyoming. For a comparison of the two paintings and their relationship see Dare Myers Hartwell and Helen Mar Parkin, "Corcoran and Cody: The Two Versions of *The Last of the Buffalo*," *Journal of the American Institute for Conservation* 38 (1999): 45–54.

151. Two examples are: John Wilmerding, *American Art* (Harmondsworth: Penguin Books, 1976), 126–127; Bjelajac, *American Art*, 269. Bierstadt's Hudson River School style with its Düsseldorf-influenced attention to realistic detail and smooth surface was also anachronistic, evident in the American jury's rejection of the work for inclusion in the nation's exhibition at the Paris Exposition of 1889. Nancy K. Anderson and Linda S. Ferber, *Albert Bierstadt: Art and Enterprise*, exh. cat. (Brooklyn: The Brooklyn Museum, 1990), 62–64.

152. Recent scholarship has suggested that Americans from both native and European descent shared in this slaughter, albeit for different reasons: American Indians for trading profits and white Americans to deprive the Indians of their sustenance. Carroll and Noble, *The Free and the Unfree*, 233. See also *The Ecological Indian: Myth and History* (New York: Norton, 1999) by Shepard Krech III, who challenges the romantic view of Indian cultures as an ecology-minded, calling such a view insulting because it obscures how American Indian cultures were nuanced in ways that led them to participate in the demise of the buffalo every bit as much as European cultures.

153. Two clear examples would be the *Horsemen* (ca. 440 B.C.E.) from the Parthenon or the *Battle of Greeks and Amazons* (359–351 B.C.E) from the Halicarnassus Mausoleum.

154. John Winthrop, "A Modell of Christian Charity," in *Ideas in America: Source Readings in the Intellectual History of the United States*, Gerald N. Grob and Robert N. Beck, eds. (New York: The Free Press, 1970), 32–33.

155. In fact, Bierstadt was born in Solingen, near Düsseldorf, immigrating with his family to New Bedford, Massachusetts, at the age of two. In 1853 he returned to Düsseldorf to study for two years where he imbibed the lessons of realistic description and the historical mode favored by artists at the Düsseldorf Academy. For the influence of the Düsseldorf Academy on American artists, see *American Artists in Düsseldorf: 1840–1865*, exh. cat.

(Danforth, N.H.: Danforth Museum, 1982), esp. 7–16. For Bierstadt in Düsseldorf, see 18–19. See also cat. 23, *Works*.

156. The transcontinental rail line was a joint venture between the Central Pacific Railroad out of Sacramento and the Union Pacific Railroad out of St. Louis.

157. Turner first delivered his paper in 1892 for the University of Wisconsin, where he was a professor. White in *Great Minds*, 104.

158. According to a recent exhibition on depictions of the West, Turner provided the terms for the "fatalist discourse" that fed anxiety about the nation's future at the turn of the nineteenth century. Bradley A. Finson, in *The American West: Out of Myth, into Reality*, exh. cat., Peter H. Hassrick, curator (Washington, D.C.: Trust for Museum Exhibitions, 2000), 142.

159. White, *Great Minds*, 103.

160. White, *Great Minds*, 105.

161. Norbert Schneider, *The Art of The Still Life: Still Life Painting in the Early Modern Period* (Cologne: Benedikt Taschen, 1990), 7–8.

162. Seventeenth-century Dutch still life, specifically, had resonance for nineteenth-century Americans because "the cultures in the two countries in these respective centuries shared similar values. Both were nations grounded in Protestantism, giving rise to moralizing impulses; in commerce and mercantilism, investing value in material well-being; and in scientific exploration, finding expression in adventurous pioneering and technical ingenuity." John Wilmerding, *American Views: Essays on American Art* (Princeton: Princeton University Press, 1991), 278.

163. Nicolai Cikovsky, Jr., in *William M Harnett*, exh. cat., Doreen Bolger, Marc Simpson, and John Wilmerding, eds. (New York: Harry N. Abrams, 1992), 20.

164. Simpson et al., *American Canvas*, 154.

165. The two most famous of these works are Charles Willson Peale, *The Staircase Group: Raphaelle and Titian Ramsay Peale I* (1795), now at the Philadelphia Museum of Art and Raphaelle Peale, *Venus Rising from the Sea— A Deception* [also called *After the Bath*] (1822), now at the Nelson-Atkins Museum of Art, Kansas.

166. Cikovsky, *Harnett*, 25.

167. Wilmerding, *American Views*, 277–8.

168. In 1910, Stieglitz organized an exhibition at 291 entitled "Younger American Painters" that received enormous attention and the hostility of the established New York critics. The exhibition included abstract works by Arthur B. Carles, Arthur Dove, Marsden Hartley, John Marin, Alfred Maurer, Edward Steichen, and Max Weber, who, along with Georgia O'Keeffe, defined modern abstraction in America. O'Keeffe joined the Stieglitz circle in 1915.

169. One hundred of them have been published in Nicholas Callaway, ed., *Georgia O'Keeffe: One Hundred Flowers* (New York: Alfred A. Knopf, 1989).

170. Marc Simpson, "Georgia O'Keeffe's *Petunias*," *Triptych* (April/May 1991): 21.

171. Anna Chave has written summarizing this view and critiqued it in light of contemporary feminist challenges to male constructions of woman. See her "O'Keeffe and the Masculine Gaze," in *Reading American Art*, Marianne Doezema and Elizabeth Milroy, eds. (New Haven: Yale University Press, 1998), 350–352.

172. Chadwick, *Women, Art, and Society*, 306.

173. Barbara Buhler Lynes, *O'Keeffe, Stieglitz and the Critics, 1916–1929* (Ann Arbor: UMI Research Press, 1989), 135.

174. The need for O'Keeffe's resistance in the face of her critics is discussed in Chadwick, *Women, Art, and Society*, 305–307.

175. For his principle text, see Erwin Panofsky, *Studies in Iconology: Humanistic Themes in the Art of the Renaissance* (London: Oxford University Press, 1939; New York: Harper and Row, reprint, 1967).

176. For his principle text, see W. J. T. Mitchell, *Iconology: Image, Text and Ideology* (London and Chicago: University of Chicago Press, 1986).

177. For a sympathetic analysis of W.J.T. Mitchell, which also seeks to reverse the priority that his understanding gives to textuality over imagery, see David C. Miller, ed., *American Iconology: New Approaches to Nineteenth-Century Art and Literature* (New Haven and London: Yale University Press, 1993), 276–296.

Works in the Exhibition

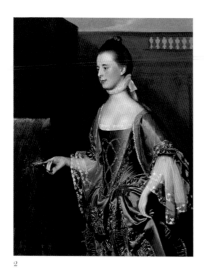

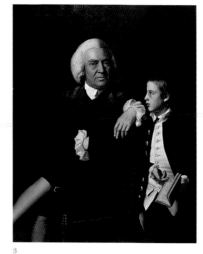

3

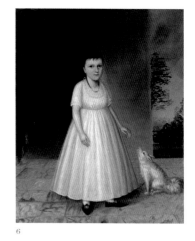

6

2

1. ATTRIBUTED TO THE FREAKE-
GIBBS PAINTER
Active in Boston, Mass. ca. 1670
*The Mason Children: David, Joanna,
and Abigail*, 1670
Oil on canvas, 39 x 42½ in.
(99 x 108 cm)
Gift of Mr. and Mrs. John D.
Rockefeller 3rd, 1979.7.3
Page 13

2. JOHN SINGLETON COPLEY
Boston, Mass. 1738–1815
London, England
*Mary Turner Sargent (Mrs. Daniel
Sargent)*, 1763
Oil on canvas, 49½ x 39¼ in.
(126 x 100 cm)
Gift of Mr. and Mrs. John D.
Rockefeller 3rd, 1979.7.31

3. JOHN SINGLETON COPLEY
Boston, Mass. 1738–1815
London, England
William Vassall and His Son Leonard,
ca. 1771
Oil on canvas, 49¾ x 40⅜ in.
(126.4 x 102.5 cm)
Gift of Mr. and Mrs. John D.
Rockefeller 3rd, 1979.7.30

4. CHARLES WILLSON PEALE
Queen Anne's County, Md. 1741–1827
Philadelphia, Pa.
Mordecai Gist, ca. 1774
Oil on canvas, 29¾ x 24¾ in.
(75.6 x 63 cm)
Gift of Mr. and Mrs. John D.
Rockefeller 3rd, 1979.7.79
Page 34

5. JOSEPH WRIGHT
Bordentown, N.J. 1756–1793
Philadelphia, Pa.
John Coats Browne, ca. 1784
Oil on canvas, 61⅜ x 42⅞ in.
(156 x 109 cm)
Gift of Mr. and Mrs. John D.
Rockefeller 3rd, 1979.7.107
Page 14

6. JOSHUA JOHNSON
Active in Baltimore, Md. 1796–1824
Letitia Grace McCurdy, ca. 1800–1802
Oil on canvas, 41 x 34½ in.
(104.4 x 87.6 cm)
Acquired by public subscription on the
occasion of the centennial of the M. H.
de Young Memorial Museum with major
contributions from The Fine Arts
Museums Auxiliary, Bernard and Barbro
Osher, the Thad Brown Memorial Fund,
and the Volunteer Council of the Fine
Arts Museums of San Francisco, 1995.22

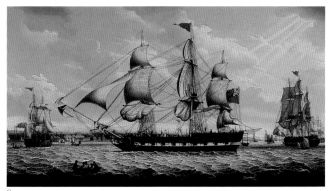

8

10

12

9

7. JOHN VANDERLYN
Kingston, N.Y. 1775–1852
Kingston, N.Y.
Caius Marius Amid the Ruins of Carthage, 1807
Oil on canvas, 87 x 68½ in.
(221 x 174 cm)
Gift of M. H. de Young, 49835
Page 63

8. ROBERT SALMON
Whitehaven, Cumberland, England
1775–between 1848 and 1851
(place unknown)
British Merchantman in the River Mersey Off Liverpool, 1809
Oil on canvas, 28 x 50⅝ in.
(71 x 128.6 cm)
Gift of Mr. and Mrs. John D. Rockefeller 3rd, 1979.7.89

9. CHARLES WILLSON PEALE
Queen Anne's County, Md. 1741–1827
Philadelphia, Pa.
Self-Portrait, 1822
Oil on canvas, 29¼ x 24⅛ in.
(74 x 61 cm)
Gift of Mr. and Mrs. John D. Rockefeller 3rd, 1993.35.22

10. THOMAS COLE
Bolton-le-Moor, Lancashire, England
1801–1848 Catskill, N.Y.
Peace at Sunset (Evening in the White Mountains), ca. 1827
Oil on canvas, 27 x 32 in.
(68.6 x 81 cm)
M. H. de Young Memorial Museum Purchase, 46.13

11. GEORGE CALEB BINGHAM
Augusta County, Va. 1811–1879
Kansas City, Mo.
Boatmen on the Missouri, 1846
Oil on canvas, 25⅛ x 30¼ in.
(64 x 77 cm)
Gift of Mr. and Mrs. John D. Rockefeller 3rd, 1979.7.15

12. EDWARD HICKS
Attleborough (now Langhorne), Pa.
1780–1849 Newton, Pa.
The Peaceable Kingdom, ca. 1846
Oil on canvas, 25 x 28½ in.
(63.5 x 72 cm)
Gift of Mr. and Mrs. John D. Rockefeller 3rd, 1993.35.14

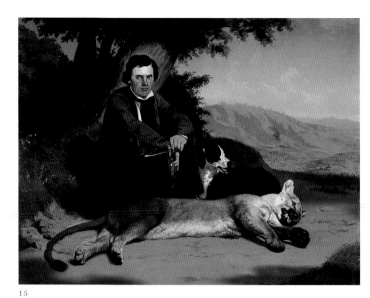

15

14

16

13. THOMAS COLE
Bolton-le-Moor, Lancashire, England
1801–1848 Catskill, N.Y.
Prometheus Bound, 1847
Oil on canvas, 64 x 96 in.
(162.6 x 244 cm)
Gift of Mr. and Mrs. Steven MacGregor
Read and the estate of Joyce I. Swader,
1997.28
Page 67

14. GEORGE CALEB BINGHAM
Augusta County, Va. 1811–1879
Kansas City, Mo.
Country Politician, 1849
Oil on canvas, 20⅜ x 24 in.
(51.7 x 61 cm)
Gift of Mr. and Mrs. John D.
Rockefeller 3rd, 1979.7.16

15. CHARLES CHRISTIAN NAHL
Kassel, Germany 1818–1878
San Francisco
Peter Quivey and the Mountain Lion, 1857
Oil on canvas, 26 x 34 in.
(66 x 86 cm)
Museum purchase, James E. Harrold,
Jr., Bequest and gift of an anonymous
donor, 1998.32

16. GEORGE HENRY DURRIE
Hartford, Conn. 1820–1863
New Haven, Conn.
Winter in the Country, 1857
Oil on canvas, 18 x 24 in.
(45.7 x 61 cm)
1985.47

17

21

18

22

17. JAMES BARD
New York, N.Y. 1815–1897
White Plains, N.Y.
The Steamship "Syracuse," 1857
Oil on canvas, 30 x 52 in.
(76 x 132 cm)
Gift of Mr. and Mrs. J. Burgess
Jamieson, 1996.6

18. ALBERT BIERSTADT
Solingen, Germany 1830–1902
New York, N.Y.
*Roman Fish Market. Arch of
Octavius,* 1858
Oil on canvas, 27⅞ x 37⅜ in.
(70 x 95 cm)
Gift of Mr. and Mrs. John D.
Rockefeller 3rd, 1979.7.12

19. FREDERIC EDWIN CHURCH
Hartford, Conn. 1826–1900
New York, N.Y.
Twilight, 1858
Oil on canvas (now mounted on hard-
board), 23⅞ x 35⅞ in. (60.6 x 91 cm)
Gift of Mr. and Mrs. John D.
Rockefeller 3rd, 1993.35.6
Page 75

20. ASHER BROWN DURAND
Jefferson Village (now Maplewood), N.J.
1796–1886 Maplewood, N.J.
A River Landscape, 1858
Oil on canvas, 32 x 48 in. (81.3 x 122 cm)
Gift of Mr. and Mrs. John D.
Rockefeller 3rd, 1993.35.8
Page 73

21. JOHN FREDERICK KENSETT
Cheshire, Conn. 1816–1872
New York, N.Y.
*Sunrise Among the Rocks of Paradise at
Newport,* 1859
Oil on canvas, 18 x 30 in. (45.7 x 76 cm)
Gift of Mr. and Mrs. John D.
Rockefeller 3rd, 1979.7.69

22. LOUIS REMY MIGNOT
Charleston, S.C. 1831–1870 Brighton,
England
Sunset on White Mountains, 1861
Oil on canvas, 16¼ x 26 in.
(41 x 66 cm)
Museum purchase, Ednah Root Fund in
honor of Marc Simpson, 1994.108

24

25

23

23. ALBERT BIERSTADT
Solingen, Germany 1830–1902
New York, N.Y.
Sunlight and Shadow, 1862
Oil on canvas, 39 x 32½ in.
(99 x 82.6 cm)
Gift of Mr. and Mrs. John D.
Rockefeller 3rd, 1979.7.10

24. MARTIN JOHNSON HEADE
Lumberville, Pa. 1819–1904
St. Augustine, Fla.
Twilight, Singing Beach, 1863
Oil on canvas, 20 x 36 in. (51 x 91.4 cm)
Gift of Mr. and Mrs. John D.
Rockefeller 3rd, 1993.35.12

25. SANFORD ROBINSON GIFFORD
Greenfield, N.Y. 1823–1880
New York, N.Y.
*A View from the Berkshire Hills, near
Pittsfield, Massachusetts*, 1863
Oil on canvas, 22⅛ x 36⅛ in.
(56 x 92 cm)
Gift of Mr. and Mrs. Will Richeson, Jr.,
78.74

26. WINSLOW HOMER
Boston, Mass. 1836–1910
Prout's Neck, Me.
The Bright Side, 1865
Oil on canvas, 12¾ x 17 in.
(32.4 x 43 cm)
Gift of Mr. and Mrs. John D.
Rockefeller 3rd, 1979.7.56
Page 80

27

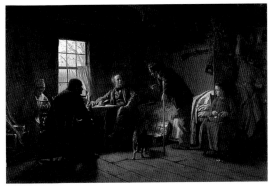

29

28

30

27. EASTMAN JOHNSON
Lovell, Maine 1824–1906
New York, N.Y.
Sugaring Off, ca. 1865
Oil on canvas, 16⅞ x 32 in.
(43 x 81.3 cm)
Gift of Mr. and Mrs. John D.
Rockefeller 3rd, 1979.7.63

28. THOMAS EAKINS
Philadelphia, Pa. 1844–1916
Philadelphia, Pa.
Female Model (formerly, *Negress*),
ca. 1867–1869
Oil on canvas, 23 x 19¾ in.
(58.4 x 50 cm)
Mildred Anna Williams Collection,
1966.41

29. EASTMAN JOHNSON
Lovell, Maine 1824–1906
New York, N.Y.
The Pension Claim Agent, 1867
Oil on canvas, 25¼ x 37⅜ in.
(64 x 95 cm)
Mildred Anna Williams Collection,
1943.6

30. JOHN GEORGE BROWN
Durham, England 1831–1913
New York, N.Y.
On the Hudson, 1867
Oil on canvas, 39 x 72 in.
(99 x 183 cm)
Gift of Mr. and Mrs. John D.
Rockefeller 3rd, 1979.7.19

34

31

33

35

31. MARTIN JOHNSON HEADE
Lumberville, Pa. 1819–1904
St. Augustine, Fla.
The Great Swamp, 1868
Oil on canvas, 14⅞ x 30⅛ in.
(38 x 76.5 cm)
Gift of Mr. and Mrs. John D.
Rockefeller 3rd, 1993.35.11

32. EASTMAN JOHNSON
Lovell, Maine 1824–1906
New York, N.Y.
The Brown Family, 1869
Oil on canvas, 38½ x 32⅜ in.
(98 x 82 cm)
Gift of Mr. and Mrs. John D.
Rockefeller 3rd, 1979.7.67
Page 19

33. GEORGE INNESS
Newburgh, N.Y. 1825–1894
Bridge of Allan, Scotland
Evening at Medfield, Massachusetts, 1869
Oil on canvas, 11¾ x 17½ in.
(30 x 44.5 cm)
Gift of Mr. and Mrs. John D.
Rockefeller 3rd, 1993.35.19

34. WORTHINGTON WHITTREDGE
Springfield, Ohio 1820–1910
Summit, N. J.
On the Cache la Poudre River, Colorado,
1871
Oil on canvas, 15⅜ x 23⅛ in.
(39 x 59 cm)
Museum purchase, Roscoe and
Margaret Oakes Income Fund, the
Fine Arts Museums of San Francisco,
1986.39

35. WILLIAM MORRIS HUNT
Brattleboro, Vt. 1824–1879
Appledore, N.H.
Governor's Creek, Florida, 1874
Oil on canvas, 25 x 39 in.
(63.5 x 99 cm)
Gift of Mr. and Mrs. John D.
Rockefeller 3rd, 1993.35.18

38

40

39

36. ALBERT BIERSTADT
Solingen, Germany 1830–1902
New York, N.Y.
California Spring, 1875
Oil on canvas, 54¼ x 84¼ in.
(138 x 214 cm)
Presented to the City and County of San
Francisco by Gordon Blanding, 1941.6
Page 88

37. THOMAS EAKINS
Philadelphia, Pa. 1844–1916
Philadelphia, Pa.
The Courtship, ca. 1878
Oil on canvas, 20 x 24 in.
(51 x 61 cm)
Gift of Mrs. Herbert Fleishhacker,
M. H. de Young, John McLaughlin,
J. S. Morgan and Sons, and Miss
Keith Wakeman by exchange, 72.7
Page 41

38. ELIHU VEDDER
New York, N.Y. 1836–1923 Rome, Italy
The Sphinx of the Seashore, 1879
Oil on canvas, 16 x 27⅞ in.
(40.6 x 71 cm)
Gift of Mr. and Mrs. John D.
Rockefeller 3rd, 1979.7.102

39. FRANK DUVENECK
Covington, Ky. 1848–1919
Covington, Ky.
Study for Guard of the Harem, 1879
Oil on canvas, 30 x 26 in.
(76 x 66 cm)
Gift of Peter McBean, 1990.11

40. WILLIAM BRADFORD
Fairhaven, Mass. 1823–1892
New York, N.Y.
Scene in the Artic, ca. 1880
Oil on canvas, 29⅝ x 47⅝ in.
(75 x 121 cm)
Gift of Agnes van Eck Reed, 1991.39

41. THOMAS POLLOCK ANSHUTZ
Newport, Ky. 1851–1912
Fort Washington, Pa.
The Ironworkers' Noontime, 1880
Oil on canvas, 17 x 23⅞ in.
(43 x 60.6 cm)
Gift of Mr. and Mrs. John D.
Rockefeller 3rd, 1979.7.4
Page 44, frontispiece

42

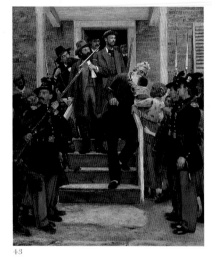

43

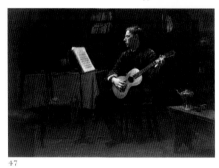

46

47

42. ALBERT PINKHAM RYDER
New Bedford, Mass. 1847–1917
Elmhurst, N.Y.
The Lone Scout, ca. 1880
Oil on canvas, 13 x 10 in.
(33 x 25.4 cm)
Gift of Mr. and Mrs. John D.
Rockefeller 3rd, 1979.7.88

43. THOMAS HOVENDEN
Dunmanway, County Cork, Ireland
1840–1895 Norristown, Pa.
The Last Moments of John Brown,
ca. 1884
Oil on canvas, 46⅛ x 38⅛ in.
(117 x 97 cm)
Gift of Mr. and Mrs. John D.
Rockefeller 3rd, 1979.7.60

44. JOHN SINGER SARGENT
Florence, Italy 1856–1925
London, England
*Caroline de Bassano, Marquise
d'Espeuilles*, 1884
Oil on canvas, 62⅞ x 41⅜ in.
(159.7 x 105 cm)
Gift of Mr. and Mrs. John D.
Rockefeller 3rd, 1979.7.90
Page 27

45. JOHN SINGER SARGENT
Florence, Italy 1856–1925 London,
England
*A Dinner Table at Night (The Glass
of Claret)*, 1884
Oil on canvas, 20¼ x 26¼ in.
(51.4 x 66.7 cm)
Gift of the Atholl McBean
Foundation, 73.12
Page 23

46. WILLIAM MICHAEL HARNETT
Clonakilty, County Cork, Ireland
1848–1892 New York, N.Y.
After the Hunt, 1885
Oil on canvas, 71½ x 48½ in.
(181.6 x 123 cm)
Mildred Anna Williams Collection,
1940.93

47. DENNIS MILLER BUNKER
New York, N.Y. 1861–1890
Boston, Mass.
A Bohemian, 1885
Oil on canvas, 25¾ x 36 in.
(65.4 x 91.5 cm)
Gift of Mr. and Mrs. John D.
Rockefeller 3rd, 1993.35.1

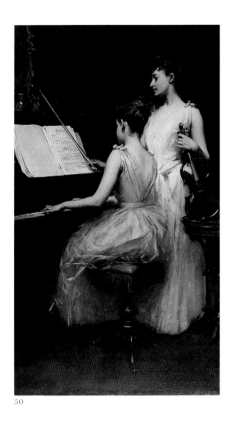

50

52

51

48. ALBERT BIERSTADT
Solingen, Germany 1830–1902
New York, N.Y.
Indians Hunting Buffalo, ca. 1888
Oil on canvas, 4¾ x 35⅞ in.
(63 x 91 cm)
Gift of Mr. and Mrs. John D.
Rockefeller 3rd, 1979.7.11
Page 85

49. MARY CASSATT
Allegheny City, Pa. 1844–1926
Mesnil-Théribus, France
*Mrs. Robert S. Cassatt, the Artist's Mother
(Katherine Kelso Johnston Cassatt)*,
ca. 1889
Oil on canvas, 38 x 27 in.
(96.5 x 68.6 cm)
William H. Noble Bequest Fund,
1979.35
Page 25

50. IRVING RAMSAY WILES
Utica, N.Y. 1861–1948 Peconic, N.Y.
The Sonata, 1889
Oil on canvas, 44¼ x 26 in.
(112.4 x 66 cm)
Gift of Mr. and Mrs. John D.
Rockefeller 3rd, 1985.7

51. WILLIAM STANLEY HASELTINE
Philadelphia, Pa. 1835–1900 Rome, Italy
*Ruins of the Roman Theatre at Taormina,
Sicily*, 1889
Oil on canvas, 32⅝ x 56½ in.
(83 x 143.5 cm)
Gift of Peter McBean, 1986.41

52. WILLIAM J. McCLOSKEY
Philadelphia, Pa. 1859–1941
Orange County, Calif.
Oranges in Tissue Paper, ca. 1890
Oil on canvas, 10 x 17 in.
(25.4 x 43 cm)
Gift of Mr. and Mrs. John D.
Rockefeller 3rd, 1993.35.21

53

55

54

53. WILLIAM KEITH
Old Meldrum, Scotland 1838–1911
Berkeley, Calif.
The Glory of the Heavens, 1891
Oil on canvas, 35¼ x 59¼ in.
(89.5 x 150.5 cm)
Presented to the City and County of San
Francisco by Gordon Blanding, 1941.16

54. JOHN FREDERICK PETO
Philadelphia, Pa. 1854–1907
New York, N.Y.
Job Lot Cheap, 1892
Oil on canvas, 29⅝ x 39¾ in.
(75 x 101 cm)
Gift of Mr. and Mrs. John D.
Rockefeller 3rd, 1979.7.81

55. WILLIAM MERRITT CHASE
Williamsburg, Ind. 1849–1916
New York, N.Y.
A Corner of My Studio, ca. 1895
Oil on canvas, 24⅛ x 36 in.
(61.3 x 91.4 cm)
Gift of Mr. and Mrs. John D.
Rockefeller 3rd, 1979.7.29

57

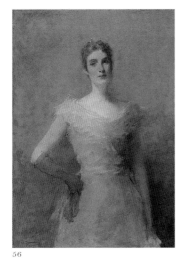

56

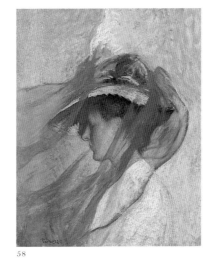

58

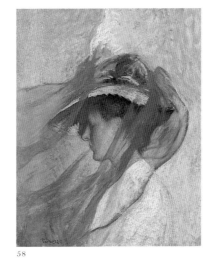

59

56. THOMAS WILMER DEWING
Boston, Mass. 1851–1938
New York, N.Y.
Elizabeth Platt Jencks, 1895
Oil on canvas, 23¼ x 16¾ in.
(59 x 42.6 cm)
Gift of the Atholl McBean Foundation,
1987.40

57. THOMAS EAKINS
Philadelphia, Pa. 1844–1916
Philadelphia, Pa.
Professor William Woolsey Johnson,
ca. 1896
Oil on canvas, 24 x 20 in. (61 x 51 cm)
Gift of Mr. and Mrs. John D.
Rockefeller 3rd, 1993.35.28

58. EDMUND C. TARBELL
West Groton, Mass. 1862–1938
New Castle, N.H.
The Blue Veil, 1898
Oil on canvas, 29 x 24 in. (73.7 x 61 cm)
Mildred Anna Williams Collection,
1942.26

59. CECILIA BEAUX
Philadelphia, Pa. 1855–1942
Gloucester, Mass.
Little Lamerche, ca. 1900
Oil on canvas, 24 x 19 in. (61 x 48 cm)
Gift of Mr. and Mrs. John D.
Rockefeller 3rd, 1979.7.7

60. JOHN FREDERICK PETO
Philadelphia, Pa. 1854–1907
New York, N.Y.
The Cup We All Race 4, ca. 1900
Oil on canvas and wood boards with
brass plate, 25½ x 21½ in.
(65 x 54.6 cm)
Gift of Mr. and Mrs. John D.
Rockefeller 3rd, 1979.7.80
Page 92

62

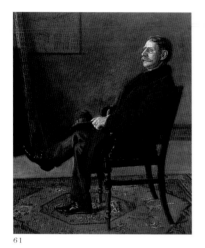

61

64

61. THOMAS EAKINS
Philadelphia, Pa. 1844–1916
Philadelphia, Pa.
Frank Jay St. John, 1900
Oil on canvas, 23⅞ x 19⅞ in.
(60.6 x 50.5 cm)
Gift of Mr. and Mrs. John D.
Rockefeller 3rd, 1979.7.37

62. ALEXANDER POPE
Dorchester, Mass. 1849–1924
Hingham, Mass.
The Trumpeter Swan, 1900
Oil on canvas, 57 x 44½ in.
(145 x 113 cm)
Purchased through gifts from
members of the Board of Trustees,
The de Young Museum Society
and the Patrons of Art and Music,
friends of the Museums, and, by
exchange, Sir Joseph Duveen, 72.28

63. WILLIAM J. GLACKENS
Philadelphia, Pa. 1870–1938
Westport, Conn.
May Day, Central Park, ca. 1905
Oil on canvas, 25⅛ x 30¼ in.
(64 x 77 cm)
Gift of the Charles E. Merrill Trust
with matching funds of The de Young
Museum Society, 70.11
Page 48

64. THOMAS MORAN
Bolton, Lancashire, England 1837–1926
Santa Barbara, Calif.
*Grand Canyon of the Yellowstone,
Wyoming*, 1906
Oil on canvas, 20 x 30 in.
(51 x 76 cm)
Gift of Anna G. Bennett, in memory of
Augustus F. Jones, Jr., to the Fine Arts
Museums of San Francisco, 1990.50

65

67

66

68

65. ROCKWELL KENT
Tarrytown Heights, N.Y. 1882–1971
Plattsburgh, N.Y.
Afternoon on the Sea, Monhegan, 1907
Oil on canvas, 34 x 44 in.
(86.4 x 112 cm)
Museum purchase, Richard B. Gump
Trust Fund, Bequest of Katherine
Hayes Trust, Art Trust Fund, and
Unrestricted Art Acquisition
Endowment Income, and partial
gift in memory of Mr. and Mrs.
Langdon W. Post, 1994.107

66. MAURICE PRENDERGAST
St. John's, Newfoundland 1859–1924
New York, N.Y.
The Holiday, ca. 1907–1909
Oil on canvas, 27 x 34⅜ in.
(68.6 x 87.3 cm)
Gift of the Charles E. Merrill Trust
with matching funds from The de
Young Museum Society, 68.14

67. MARSDEN HARTLEY
Lewiston, Me. 1877–1943
Ellsworth, Me.
The Summer Camp, Blue Mountain,
ca. 1909
Oil on canvas, 30 x 34 in.
(76 x 86.4 cm)
Gift of Mr. and Mrs. John D.
Rockefeller 3rd, 1979.7.47

68. EVERETT SHINN
Woodstown, N.J. 1876–1953
New York, N.Y.
Outdoor Stage, France, 1905
Oil on canvas, 24¾ x 21½ in.
(63 x 54.6 cm)
Memorial gift from Dr. T. Edward and
Tullah Hanley, Bradford, Pennsylvania,
69.30.190

69. ROBERT HENRI
Cincinnati, Ohio 1865–1929
New York, N.Y.
*O in Black with Scarf (Marjorie
Organ Henri)*, 1910
Oil on canvas, 77¼ x 37 in.
(196 x 94 cm)
Gift of the de Young Museum Society,
purchased from funds donated by the
Charles E. Merrill Trust, 66.27
Page 30

70

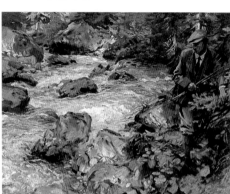

71

72

70. (FREDERICK) CHILDE HASSAM
Dorchester, Mass. 1859–1935
East Hampton, N.Y.
Seaweed and Surf, Appledore,
at Sunset, 1912
Oil on canvas, 25½ x 27¼ in.
(65 x 69 cm)
Gift of the Charles E. Merrill Trust
with matching funds from The
de Young Museum Society to the
M. H. de Young Memorial Museum,
67.23.2

71. JOHN SINGER SARGENT
Florence, Italy 1856–1925
London, England
Trout Stream in the Tyrol, 1914
Oil on canvas, 22 x 28 in.
(56 x 71 cm)
Gift of Isabella M. Cowell Estate,
1951.24

72. GEORGE LUKS
Williamsport, Pa. 1867–1933
New York, N.Y.
Innocence, ca. 1916
Oil on canvas, 30 x 25 in.
(76 x 63.5 cm)
Gift of Mrs. Horace Hill, 1967.2

73

75

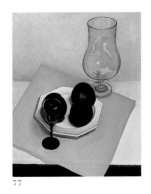

77

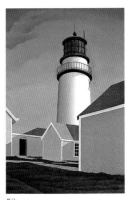

78

73. MARSDEN HARTLEY
Lewiston, Me. 1877–1943
Ellsworth, Me.
A Bermuda Window in a Semi-Tropic Character, 1917
Oil on composition board, 31¾ x 26 in.
(80.7 x 66 cm)
Memorial gift of Dr. T. Edward and Tullah Hanley, Bradford, Pennsylvania, 69.30.94

74. CHARLES DEMUTH
Lancaster, Pa. 1883–1935 Lancaster, Pa.
From the Garden of the Château, 1921
(reworked 1925)
Oil on canvas, 25 x 20 in.
(63.5 x 51 cm)
Museum purchase, Roscoe and Margaret Oakes Income Fund, Ednah Root, and the Walter H. and Phyllis J. Shorenstein Foundation Fund, 1990.4
Page 52

75. EDWIN DICKINSON
Seneca Falls, N.Y. 1891–1978
South Orleans (Wellfleet), Mass.
The Cello Player, 1924–1926
Oil on canvas, 60¼ x 48½ in.
(153 x 123 cm)
Museum purchase, Roscoe and Margaret Oakes Income Fund, 1988.5

76. GEORGIA O'KEEFFE
Sun Prairie, Wis. 1887–1986
Santa Fe, N. Mex.
Petunias, 1925
Oil on hardboard, 18 x 30 in.
(45.7 x 76 cm)
Gift of the M. H. de Young Family to the Fine Arts Museums of San Francisco, 1990.55
Page 98

77. CHARLES SHEELER
Philadelphia, Pa. 1883–1965
Dobbs Ferry, N.Y.
Still Life, 1925
Oil on canvas, 24 x 20 in.
(61 x 51 cm)
Gift of Max L. Rosenberg, 1931.34

78. GEORGE AULT
Cleveland, Ohio 1891–1948
Woodstock, N.Y.
Highland Light, 1929
Oil on canvas, 24 x 16 in.
(61 x 40.6 cm)
Gift of Max L. Rosenberg to the California Palace of the Legion of Honor, 1931.27

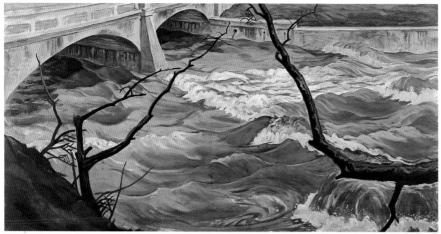

79

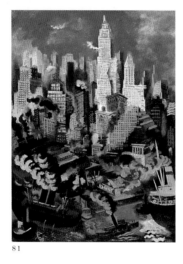

81

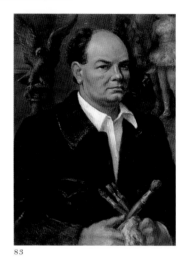

83

79. CHARLES E. BURCHFIELD
Ashtabula, Ohio 1893–1967
West Seneca, N.Y.
Spring Flood, 1931
Oil on canvas, 26 x 50 in. (66 x 127 cm)
Gift of Mr. and Mrs. John D.
Rockefeller 3rd, 1979.7.20

80. REGINALD MARSH
Paris, France 1898–1954 Dorset, Vt.
The Limited, 1931
Tempera on canvas mounted on
hardboard, 24 x 48 in. (61 x 122 cm)
Bequest of Felicia Meyer Marsh,
1980.84
Page 56

81. GEORGE GROSZ
Berlin, Germany 1893–1959
Berlin, Germany
Lower Manhattan, 1934
Oil on cardboard, 18 x 24 in.
(45.7 x 61 cm)
Gift of Dalzell Hatfield to the California
Palace of the Legion of Honor,
1956.226

82. AARON DOUGLAS
Topeka, Kans. 1899–1979
Nashville, Tenn.
Aspiration, 1936
Oil on canvas, 60 x 60 in.
(152 x 152.4 cm)
Museum purchase, the estate of Thurlow
E. Tibbs, Jr., The Museum Auxiliary,
American Art Trust Fund, Unrestricted
Art Trust Fund, partial gift of Dr.
Ernest A. Bates, Sharon Bell, Jo-Ann
Beverly, Barbara Carleton, Dr. and Mrs.
Arthur H. Coleman, Dr. and Mrs.
Coyness Ennix, Jr., Nicole Y. Ennix,

Mr. and Mrs. Gary François, Dennis L.
Franklin, Mr. and Mrs. Maxwell C.
Gillette, Zuretti L. Goosby, Mr. and Mrs.
Richard Goodyear, Marion E. Greene,
Mrs. Vivian S. W. Hambrick, Laurie
Gibbs Harris, Arlene Hollis, Louis A.
and Letha Jeanpierre, Daniel and Jackie
Johnson, Jr., Stephen L. Johnson, Mr.
and Mrs. Arthur Lathan, Mr. and Mrs.
Gary Love, Lewis & Ribbs Mortuary
Garden Chapel, Glenn R. Nance, Mr.
and Mrs. Harry S. Parker III, Mr. and
Mrs. Carr T. Preston, Fannie Preston,
Pamela R. Ransom, Dr. and Mrs.
Benjamin F. Reed, San Francisco Black
Chamber of Commerce, San Francisco
Chapter of Links, Inc., San Francisco
Chapter of the N.A.A.C.P., Sigma Pi Phi
Fraternity, Dr. Ella Mae Simmons, Mr.
Calvin R. Swinson, Joseph B. Williams,
and Mr. and Mrs. Alfred S. Wilsey, and
the people of the Bay Area, 1997.84
Page 59

84

86

85

87

83. JOHN STEUART CURRY
Dunavant, Kans. 1897–1946
Madison, Wis.
Self-Portrait, 1937
Oil and tempera on canvas, 30 x 24 in.
(76 x 61 cm)
Gift of Mr. and Mrs. J. Burgess
Jamieson, 1996.129

84. CHARLES SHEELER
Philadelphia, Pa. 1883–1965
Dobbs Ferry, N.Y.
Kitchen, Williamsburg, 1937
Oil on hardboard, 10 x 14 in.
(25.4 x 35.6 cm)
Gift of Mr. and Mrs. John D.
Rockefeller 3rd, 1993.35.24

85. AGNES PELTON
Stuttgart, Germany 1881–1961
Cathedral City, Calif.
Challenge, 1940
Oil on canvas, 32 x 26 in.
(81.3 x 66 cm)
Museum purchase, Harriet and Maurice
Gregg Fund for American Abstract Art,
2000.134

86. HORACE PIPPIN
West Chester, Pa. 1888–1946
West Chester, Pa.
The Trial of John Brown, 1942
Oil on canvas, 16½ x 20⅛ in.
(42 x 51 cm)
Gift of Mr. and Mrs. John D.
Rockefeller 3rd, 1979.7.82

87. BEN SHAHN
Kovno, Lithuania, Russia 1898–1969
New York, N.Y.
Ohio Magic, 1945
Tempera on board, 26¼ x 39⅜ in.
(66.7 x 100 cm)
Mildred Anna Williams Collection,
1948.14

Biographies of the Artists

By Robert Marc Savoie, except as noted

Thomas Anshutz (1851–1912)

After a brief stint as an art student in New York, Thomas Anshutz moved to Philadelphia in order to study at the Pennsylvania Academy of the Fine Arts under the instruction of the controversial Thomas Eakins. Anshutz later taught there, becoming the director of painting after the dismissal of Eakins in 1886. He kept alive many of the pedagogical principles championed by Eakins, encouraging students to paint directly from life instead of the plaster cast of a classical sculpture. Anshutz also allowed his students to embrace the unflattering details of everyday life, instead of beautifying the world around them. With this artistic philosophy he instructed a number of members of the Ashcan School. Later in his own career Anshutz painted landscapes and beach scenes, never again revisiting the theme of industrial labor that he explored in the painting for which he is best known, *The Ironworkers' Noontime*. *(Cat. 41, frontispiece)*

George Ault (1891–1948)

A native of Cleveland, George Ault and his family moved to London in 1899 where for twelve years he was exposed to the latest avant-garde art movements, both in London and on the continent. He returned to the United States in 1911, settling outside of Woodstock, New York, until his death in 1948. Ault's adult life was full of tragedy. His mother passed away in a mental hospital and all three of his brothers committed suicide. His father was an alcoholic who went blind and lost the family fortune. Though he experimented with a variety of modernist styles, Ault developed a brand of painting that combined Surrealism with Precisionism. Despite the indus-trial pretenses and architectural austerity of Precisionism, Ault's work seems to invoke a sense of psychological and physical isolation. While many precisionist paintings celebrate the rise of the machine and mass production, Ault's work makes subtle note of the essential discomfort of individuals in the artificial environment of the modern era. *(Cat. 78)*

James Bard (1815–1897)

Born in New York City, James Bard would become one of the nation's top marine painters, chronicling the commercial activity of the Hudson River. Although he occasionally painted schooners and yachts, he is best known for depicting steamboats, the technological marvel of his generation. Until about 1849 he worked in collaboration with his brother, John Bard, producing mainly watercolor paintings that they cosigned. Following his brother's death in 1856, James Bard had a successful career as an oil painter, benefiting by the rise in steamboat construction, which industry provided clients. While his paintings are remarkable for their draftsmanship and actual nautical detail, they are flawless idealizations rather than working vessels. *(Cat. 17)*

Cecilia Beaux (1855–1942)

Following the early death of her mother, Cecilia Beaux was raised by her grandmother and aunt. From the latter she learned a sense of independence uncharacteristic of women of her time. Beaux began to study drawing at the age of sixteen and would eventually study for two years under the instruction of Thomas Eakins at the Pennsylvania Academy of the Fine Arts. She then traveled to France where she studied with William-Adolphe Bouguereau, one of the

leading academic painters of the nineteenth century. Upon her return to the United States, Beaux became the first female faculty member at the Pennsylvania Academy, teaching there for over twenty years. By the turn of the century, she was regarded as one of the top portrait painters in America. In 1901 she was invited to the White House to paint the portrait of the wife and daughter of Theodore Roosevelt. Later, in 1919, Beaux transcended one of the most stringent gender barriers in the fine arts when the U.S. War Portraits Commission selected her during World War I as one of their artists. *(Cat. 59)*

Albert Bierstadt (1830–1902)

Perhaps no other American painter is more closely associated with the mythology of the American West than Albert Bierstadt. He was brought to the United States by German parents and would later return to study in Düsseldorf, a mecca for grand-manner landscape painting. Bierstadt made his first trip to the Rocky Mountains in 1859 on a military expedition with the famed explorer Colonel Frederick Lander. Although the conditions of the expedition were treacherous, as the West at that time was relatively unexplored, Bierstadt industriously made numerous sketches and drawings of what he saw. Back at his studio in New York City, he consolidated these studies into panoramic images that thrilled the public of his day. While his paintings included images of actual geographical features, they are composite images rather than faithful renditions of the actual landscape. Nonetheless Bierstadt provided for many east coast viewers their first and perhaps only view of the West. While earlier historians praised

Bierstadt for his anthropological accuracy, it is now generally agreed that his images served more to mythologize than describe the majesty of the West. Throughout his life Bierstadt would make additional excursions, leaving an indelible mark on the American psyche with his view of the Rockies, the Pacific Northwest, California, and especially Yosemite. *(Cat. 18, 23, 36, 48)*

George Caleb Bingham (1811–1879)

Perhaps no other genre painter better typifies the idealization of the American frontier than George Caleb Bingham. Growing up in St. Louis, Bingham was almost entirely self-taught, except for a brief time spent as an art student in Philadelphia. He was one of the first artists to benefit from a new breed of patrons in what is now considered the midwest. Best known for his depictions of frontiersmen and fur traders on the Missouri and Mississippi rivers, many of the scenes that Bingham created can best be described as idyllic fraternal communities where men worked and played together at the periphery of Western civilization. Despite his lack of formal training, his paintings are remarkable for their crispness and clarity and sometimes are based on the compositions of canonical European painters, such as Théodore Géricault. Himself a minor elected official, Bingham also is well known for painting scenes of election day on the frontier, images that celebrate the functionality of democracy in the wilderness and thus legitimate westward expansion. Some twenty years before the writings of Mark Twain, Bingham's work helped to mythologize life on the frontier and to make heroes of men like Daniel Boone, whom he painted in 1852. *(Cat. 11, 14, back cover)*

William Bradford (1823–1892) A failed farmer and merchant, William Bradford began to paint seriously at the age of thirty-two, trading studio space for instruction from a minor Dutch painter visiting the United States. Bradford grew up as a Quaker in New Bedford, Massachusetts, believing that the pursuit of beauty in the arts could lead to a larger pursuit of truth. Eventually he voyaged to the Arctic a number of times in the 1860s, culminating in an 1869 trip to Melville Bay as part of a crew that included both photographers and scientists. From these excursions, Bradford produced drawings and sketches that provided years of material for his Arctic paintings. In 1873 he went to London to publish 300 editions of a major folio of his polar work, the first edition being purchased by Queen Victoria; many of these works depicting entrapped vessels represent the more general dangers and trials of the human experience. By the middle of the 1870s Bradford turned away from polar subject matter, eventually moving to San Francisco where he would produce a sizable number of western landscapes. *(Cat. 40)*

John George Brown (1831–1913) The son of an unsuccessful lawyer, Brown was initially discouraged from going into painting by his father. He took up a trade of glassblowing, working first in his home nation of Scotland and then moving to Brooklyn at the age of twenty-two. Once in the United States, Brown began to take painting classes during the evenings at the National Academy of Design. By 1856 he was able to afford his own studio. He became well known as a genre painter who specialized in children, often painting the street urchins of New York and Brooklyn who hustled newspapers for a living. The time in which Brown worked is often thought of as the period when modern conceptions of childhood developed. While previous eras regarded children as miniature adults, the Victorians viewed children as living through a special moment of purity and innocence. Despite the impoverished situations of the children Brown depicted, their unmarred joy seems to subscribe to these new Victorian ideas. *(Cat. 30)*

Dennis Miller Bunker (1861–1890) Born and raised in New York City, Bunker studied briefly at both the National Academy and the Art Students' League until he set sail for Paris in fall 1881. Once in Paris, Bunker enrolled in the Académie Julian, ultimately finding a mentor in the famed Jean-Léon Gérôme of the Ecole des Beaux-Arts, with whom he studied until 1884. Upon his return to the United States, Bunker was inducted into the circle of artists and writers who surrounded Isabella Stewart Gardner, the Boston socialite and art collector who formed one of the first major collections of European painting in America. In the midst of Gardner's intellectual milieu, Bunker was exposed to authors such as Henry James and William Dean Howells, and he came to greatly admire John Singer Sargent for his experimentation with light and color. Bunker worked as the principal instructor of drawing and painting at the Cowles Art School in Boston. Cramped by Boston social life, he resigned his teaching position in 1889 and moved back to New York. After less than a year, Bunker died before his thirtieth birthday on a Christmas visit to Boston. *(Cat. 47)*

Charles Burchfield (1893–1967) Charles Burchfield lived much of his life in small town Ohio and Buffalo, New York, despite studying briefly at both the Cleveland School of Art and the National Academy of Art. He

initially supported himself by working in a factory, all the while finding time to paint scenes of the outdoors. Many of these works seem melancholy or macabre, leading some to view his images either as psychological landscapes or to associate his work with European Expressionism. After serving in World War I, Burchfield spent eight years as the head of a wallpaper company in upstate New York. He resigned in 1929 to focus exclusively on painting. His localized focus has led some historians to consider him as part of the Regionalist movement of the 1930s, although he actually had very little contact with the loose association of painters who would come to be identified by that name. *(Cat. 79)*

Mary Cassatt (1844–1926)

Mary Cassatt was the only American to join the ranks of the French Impressionists. Born outside of Pittsburgh, she received her first instruction at the Pennsylvania Academy of the Fine Arts, subsequently traveling in 1866 to Paris, the city that would become her home, to study with the esteemed Jean-Léon Gérôme at the Ecole des Beaux-Arts. After studying Diego Velázquez and other old masters, Cassatt became interested in the work of Gustave Courbet and Edouard Manet. She also developed a very close friendship with Edgar Degas, who championed her inclusion in what would become the impressionist pantheon. The opera house soon became one of Cassatt's favorite subjects. Reflecting her interest in spectatorship, her opera-goers wish to see and be seen, gazing at one another instead of the stage. Cassatt also became intensely interested in the relationship between mother and child. Never willing to accept pictorial convention, the infants in Cassatt's paintings rarely sit peacefully. Instead they shift and squirm, providing ripe

subject matter for an artist interested in capturing the moment-to-moment impressions of everyday life. In addition to her work as an artist, Cassatt also encouraged several American families, including the Havemeyers, whose works now form the heart of the Impressionism galleries at New York's Metropolitan Museum of Art, to form their own collections of French Modernism. *(Cat. 49)*

William Merritt Chase (1849–1916)

William Merritt Chase was a portrait painter at the forefront of fashion, catering to the upper-class tastes of New York. Despite a well-practiced bohemianism, Chase exemplified a conservative style. When painting portraits, Chase often employed the dark palette learned from old-master study at the Royal Academy in Munich. When painting landscapes, however, Chase called upon the bright and colorful impressionist style pioneered earlier by Claude Monet and other French artists, moving between techniques at will. He soon became identified with his famously cluttered Tenth Street studio (51 West Tenth), the interior of which he painted several times. Its plush interior, saturated with colorful fabrics and imported Asian accoutrements, blurred the line between the products and the terms of their production — it became a place to produce paintings and a theatrical experience for his sitters and patrons. In addition, he was one of the great teachers of his day, taking on numerous students at the Art Students' League. *(Cat. 55)*

Frederic Edwin Church (1826–1900)

The only painter instructed directly by Thomas Cole, Frederic Edwin Church relied more on precise detail and quasi-scientific observation than did his mentor. While each artist believed that landscape painting should reveal a

divine presence in the world, Church's work goes further, allowing the coexistence of science and religion. Heavily influenced by the writings of the famed naturalist Alexander von Humboldt, Church made his first trip to South America in 1853. Fascinated by the lush vegetation and rugged mountains of Ecuador and Colombia, he produced numerous panoramic landscapes that have been variously described as antediluvian, primordial, and edenic. Church also was fascinated by the site of Niagara Falls, the part of the American landscape favored by artists ranging from Edward Hicks to John Kensett. Later in life Church was stricken with rheumatism of the hands and almost completely stopped painting by 1870. He then turned his attention to Olana, a large house overlooking the Hudson River that he had started to build in the 1860s. Church imported furnishings from every corner of the world, making the house one of today's outstanding monuments of nineteenth-century eclecticism. *(Cat. 19, fig. 18)*

Thomas Cole (1801–1848)

Thomas Cole laid the foundation for what would become a rich tradition of nineteenth-century landscape painting. The son of a manufacturer in the English town of Bolton le Moor, Cole moved with his family to the United States in 1818. Spending time in Ohio and Pennsylvania, he became enamored of the American wilderness, which he found relatively free of signs of the early industrialism that had begun to saturate the English countryside. Cole fervently painted his adopted land, though he was largely self-taught. His seeming religious fascination with the land exemplifies the Transcendentalist belief that the divine presence could be located in all facets of the natural world. In 1829 Cole returned

to Europe for three years to paint, spending the last year in Italy studying ruins of the Roman Empire. Increasingly including fantastical architectural features in his work, Cole advanced in a series of five epic paintings—*The Course of Empire*—the idea that all civilizations are subject to similar cycles of growth, destruction, and rebirth. While this series may have expressed fear for the future of the United States, it also locates a sense of past for the nation in the land itself, rather than in any traditional historical narrative. *(Cat. 10, 13)*

John Singleton Copley (1738–1815)

John Singleton Copley can perhaps best be described as the most precocious of colonial painters, one whose technical virtuosity can match the best of eighteenth-century European portrait face painters. He learned the craft of painting from his stepfather, Peter Pelham, a mezzotint engraver in Boston. After Pelham's death, Copley continued to learn from the scant sources available in colonial Boston, at times copying anatomical figures from the encyclopedia. By the age of twenty he had begun to make paintings of the elite of Boston society that were remarkable for the richness of the material he rendered and the lifelike expressions of his sitters. Although Copley was quite successful and able to purchase a fine home in the Beacon Hill neighborhood, he soon became frustrated by the lack of sophistication of his mercantile patrons. After the Boston Tea Party made clear that the colonies were destined for turbulent times, Copley moved to London after taking a year to study in Italy. Despite a feud with Benjamin West, who had originally encouraged his move, Copley resumed his career in London with great success. Despite his apparent commitment to the English

Crown, Copley is remembered for his depictions of the American revolutionaries Samuel Adams and Paul Revere. *(Cat. 2, 3)*

John Steuart Curry (1897–1946)

Along with Grant Wood and Thomas Hart Benton, John Steuart Curry completes the triumvirate of artists who form the core of American Regionalism. These artists independently developed their styles and only later associated as members of a loosely connected movement. Curry and the other Regionalists rejected the abstract tendencies of High Modernism in favor of homespun figurative styles that employed the midwestern environment as subject matter. Their examination of the placid American heartland is indelibly linked to the state of the nation in the wake of the Great Depression. Curry was born and raised in Kansas, later studying at the Kansas City Art Institute and the Art Institute of Chicago. Although he would later teach at the Art Students' League in New York City, he would remain faithful to subjects drawn from his youth in Kansas. In 1936 Curry again returned home to the midwest as artist-in-residence at the University of Wisconsin. While the Regionalists are sometimes portrayed as anti-modern for their stance against abstraction, their work advances a modern aesthetic. Many of Curry's figures, for example, embody a sense of dynamism that was pervasive throughout early twentieth-century art. *(Cat. 83)*

Charles Demuth (1883–1935)

Born in Lancaster, Pennsylvania, Charles Demuth became one of the most advanced modernist artists in America in the first half of the twentieth century. He began his artistic career in Philadelphia, first at the Drexel Institute of Art, Science, and Industry, and then under the instruction of Thomas Anshutz at the Pennsylvania Academy of the Fine Arts. After a trip to Paris in 1907, Demuth's style underwent a radical revision. There he met with the leaders of several modernist movements, including Henri Matisse and Georges Braque, also becoming fascinated by the work of Paul Cézanne, whom he would later emulate by infusing his landscapes with a rectilinear substructure. Upon his return to America, Demuth relocated to New York City, where he developed an influential friendship with Charles Sheeler and other members of the avant-garde circle of Alfred Stieglitz. In 1928, a poem of William Carlos Williams inspired Demuth to paint *I Saw the Figure 5 in Gold*, an icon of American Modernism that reduced the dynamism of modern life to a system of abstract patterns and text. In addition to his precisionist style, Demuth also produced a variety of male nude watercolors whose graphic homosexual content provides insight into gay life in the first third of the twentieth century. *(Cat. 74, front cover)*

Thomas Wilmer Dewing (1851–1938)

A native of Boston, Thomas Dewing began his formal training in Paris in 1876 at the Académie Julian under the instruction of Gustave Boulanger and Jules-Joseph Lefebvre. Upon his return to the United States, Dewing almost immediately settled in New York, where his initial work was heavily influenced by the English Pre-Raphaelite painters, which depicted idealized female figures in quasi-renaissance or classical dress. Dewing's work shifted dramatically when he began to dissolve his figures into diffuse landscapes made from muted fields of color. In addition to Tonalism, he grappled with the style of Whistler,

who championed the notion of art for art's sake. In Whistler's Aesthetic philosophy, color and form were pre-eminent and the subject matter of the painting virtually incidental. Dewing was able to make Whistler's ideas acceptable to an upper-middle-class audience by the inclusion of female figures who were often read as embodiments of refined elegance and virtue. *(Cat. 56)*

Edwin Dickinson (1891–1978)
Born in upstate New York, Dickinson studied with William Merritt Chase in New York City before moving to the Massachusetts coastal village of Provincetown in 1913. Dickinson then enrolled at the Cape Cod School of Art, founded by Chase disciple Charles W. Hawthorne. From Chase and Hawthorne Dickinson learned to value technique over subject matter. He painted directly on canvas without the need for a detailed underdrawing and could produce a landscape in few hours. Though he gained much from his formal training, Dickinson was a staunchly independent artist. He admired the loose and subjective brushstroke of John Constable and brought James Whistler's use of the muted landscape to a new extreme. Like Albert Pinkam Ryder, Dickinson produced landscapes that are more connected to a romantic world view than to visual detail. He liked to find the aesthetic appeal of the common or discarded object, later finding artistic resonance in fossils. Despite his refinement as a painter, Dickinson was an avid sailor and rugged outdoorsman who would often walk for miles along the Massachusetts coastline in search of ideas for his work. *(Cat. 75)*

Aaron Douglas (1899–1979)
Born in Topeka, Kansas, Aaron Douglas attended the University of Nebraska at Lincoln. After a brief time as a drawing instructor in Kansas City, he moved to New York City and soon became associated with a group of American artists of African descent —the writers, musicians, and intellectuals of the Harlem Renaissance. Earning several commissions from the Works Progress Administration, Douglas gained a reputation as a leading muralist whose oeuvre included a major work for the 135th Street branch of the New York City Library. Combining abstract geometrical patterns with figurative imagery, he allegorically represented the black experience in America. Many of his images centered around ideas of liberation and victory in the face of adversity, employing the aesthetics of traditional African art and the propensity toward abstraction that were the hallmarks of early twentieth-century Modernism. Later in life Douglas developed the art department at Fisk University in Nashville. *(Cat. 82)*

Asher B. Durand (1796–1886)
Asher Durand, the primary successor of Thomas Cole, began his career as an engraver. Aside from working on banknotes and other commercial endeavors, Durand also produced many artistically successful engravings based on the work of painters such as John Trumbull and John Vanderlyn. In the 1830s Durand began to work in oil painting, aided by the encouragement of Luman Reed, a prominent grocery merchant and early collector of American art. Following a commission to paint the portraits of the first seven presidents, Durand worked almost entirely in oil paint. In 1840 he traveled to Europe to study old masters, but was reportedly unmoved by the classical subject matter that saturated the European canon. Upon his return Durand painted the American landscape almost exclusively, and was elected president of the National

Academy of Design in 1845. Four years later he produced a painting entitled *Kindred Spirits*, one of the icons of American painting for its exploration of the role of humankind in nature. Durand directly endorsed the idea of Manifest Destiny, in 1853, for example, creating a work entitled *Progress*, which championed the rise of industrialization in the American landscape. *(Cat. 20)*

George Henry Durrie (1820–1863)

Living most of his life in New Haven, Connecticut, Durrie nearly single-handedly created the genre of the American snow scene. By the age of nineteen he received his first instruction from Nathaniel Jocelyn, a local artist who specialized in banknote engraving and miniature portraits. Exhibiting his first paintings at his father's stationery store and bookshop, Durrie earned a living through portrait commissions and painting signs and the occasional coat of arms. By the middle of the 1840s, he began to paint his famed snow scenes, exhibiting at both the National Academy of Design and the New Haven Horticultural Society. His work, finished with copious anecdotal detail, became widely distributed through the publication of ten large folio lithographs in the 1860s by Currier and Ives. Details such as dogs, sleighs, horses, barns, and smoking chimneys made the paintings ripe for large-scale reproduction, as they focused the viewer more on subject matter instead of brushwork and painterly technique. *(Cat. 16)*

Frank Duveneck (1848–1919)

Growing up outside of Cincinnati, Frank Duveneck began his career in his early teens by helping a group of painters hired to decorate local Catholic churches. In 1870 he became one of the first Americans to travel to Munich to study at the Royal Academy under Wilhelm von Diez. Three years later he moved back to the United States, finding critical success only after an exhibition in Boston in 1875, after which he returned to Munich, sharing a studio with William Meritt Chase. By 1878 Duveneck began to teach at an artists colony he founded in Palling, Bavaria, which attracted a group of promising young American artists who had come to study in Munich, including John White Alexander and Joseph Rodefer De Camp. He next moved to Italy, living in both Venice and Florence and for a short time being acquainted with Whistler. He returned home to Cincinnati in 1889 following the death of his wife of two years, where he would remain for the rest of his life. A beloved teacher, Duveneck spent the last twenty-five years of his life instructing at the Cincinnati Art Academy and the Cincinnati Museum. *(Cat. 39)*

Thomas Eakins (1844–1916)

After studying with Jean-Léon Gérôme at the Ecole des Beaux-Arts in the late 1860s, Eakins returned to his native Philadelphia to paint. Although he is often considered one of the most prominent American artists of his day, Eakins built his reputation more from teaching than from success in the art market. Between 1879 and 1886, he taught painting at the Pennsylvania Academy of the Fine Arts, one of the earliest artistic academies in America. Unlike his contemporaries at European academies, Eakins insisted that his students learn to paint directly from the live model instead of the plaster cast. This insistence eventually cost Eakins his faculty position, as he was dismissed from the Pennsylvania Academy in 1886 for removing the loincloth from a male model during a mixed class of male and female students. Along with Winslow Homer, Eakins has come to be regarded as one of the two major

American practitioners of late nineteenth-century realism, because of his quasi-scientific techniques and inclusion of often unflattering detail. Indeed, even his admirers complained that he made his sitters and models look aged or ugly. Contemporary scholars no longer consider Eakins's work to represent an unbiased or transparent depiction of reality. Instead, his images of athletes, musicians, and doctors perpetuated a middle-class ethos of strenuous effort, empirical fidelity, and self-made accomplishment. *(Cat. 28, 37, 57, 61)*

Freake-Gibbs Painter (ca. 1670)

The term "Freake-Gibbs Painter" refers specifically to a body of work or signature style rather than a particular individual. Representing eight portraits featuring the Mason, Rawson, Gibbs, and Freake families, these works constitute the largest classification of what are less than thirty colonial portraits that survive today. The flat single-point perspective exhibited in all eight of the Freake-Gibbs portraits suggests that the artist was trained in the Elizabethan tradition, popular in seventeenth-century middle-class English society. It has been speculated that the Freake-Gibbs Painter may be connected to Augustine Clement, a trained portraitist who arrived in the new world in 1634 or 1635 and lived in the Boston area until his death in 1674. While no documentation directly connects Augustine Clement to any of the Freake-Gibbs portraits, his presence attests to the existence of a traditionally trained portrait artist in the colonies. The style of the Freake-Gibbs Painter is characterized by a linear rather than atmospherical construction, allowing the artist to focus upon the representation of form as opposed to the depiction of light and shadow. These works are also unified by a precise and sensitive rendering of detail, which symbolically represent the sitter's personality and role within society. The importance of material goods within these works dispels the traditional minimalist understanding of the Puritan state, revealing the growing capitalist ethic of the merchant class. *(Cat. 1)*

(Emily K. Doman)

Sanford Robinson Gifford (1823–1880)

Born the son of wealthy industrialists, Sanford Gifford spent two years at Brown University before leaving school to devote his full attention to painting. He studied in New York under an expert in the depiction of anatomy but was soon drawn to landscape painting. Growing up across the river from the Catskill home of Thomas Cole, Gifford learned to paint in the tradition of the Hudson River School. He worked in New York until an 1885 trip to England, where he was exposed to the paintings of Turner and the theories of the art critic John Ruskin. Gifford next traveled to Italy with Albert Bierstadt and then journeyed to France to work with the Barbizon painters. Upon returning to New York Gifford set up studio in the Tenth Street Building, where he developed his mature style. He is often credited for emphasizing the importance of light in landscape painting, his work being as much associated with Luminism as the Hudson River School. Later in life Gifford traveled to the American West and the Middle East, adding to his repertory of imagery. *(Cat. 25)*

William Glackens (1870–1938)

Like fellow members of the Ashcan School Luks and Shinn, William Glackens began his career as a newspaper illustrator. He also studied under Thomas Anshutz at the Pennsylvania Academy of the Fine Arts before

becoming influenced by Robert Henri, who encouraged him to visit Paris in 1895. As a native of Philadelphia, Glackens quickly took to cosmopolitan life, painting nightspots and other scenes of Parisian life that resembled the work of Edouard Manet and the Impressionists. Upon his return to the United States, Glackens settled in New York City where he soon abandoned newspaper illustration in favor of oil painting. Later in his career, his brightening palette demonstrated a growing interest in the work of Pierre Renoir. By the eve of World War I, Glackens began to aide the noted art collector Albert C. Barnes in the formation of one of the earliest and best collections of French Modernism in the United States. *(Cat. 63)*

George Grosz (1893–1959)

Before emigrating to New York City in 1932, George Grosz established his work as one of the modernist staples of the German Weimar Republic. Grosz was born in Berlin, where by age nineteen he studied under Emil Orlik at the School of Applied Arts. During World War I he served in the German military, but was soon dismissed for insubordination. As prolific printmaker and illustrator, Grosz was one of the founders of German Dada, a left-wing art movement that was mockingly critical of the nationalism and militarism of the day. His Marxist ties forced him to flee his homeland and eventually he established himself as an American citizen. Grosz enjoyed widespread success in New York, though by midcentury he would turn away from the growing tide of abstract expressionist painters. Instead, Grosz tended to focus more on figurative painting, often using his wife as a nude model. Throughout his career, Grosz favored warped perspective, vibrant colors, and underworld themes that have their roots in German Expressionism. Toward the

end of his life, he opened his own art school and produced a number of stage designs for the opera. *(Cat. 81)*

William Michael Harnett (1848–1892)

Considered by many the finest trompe-l'oeil painter of nineteenth-century America, the works of William Michael Harnett were more likely to be exhibited in the local saloon than in the halls of an academy of fine arts. Literally translated as "fool the eye," trompe-l'oeil is a term used to describe an image so lifelike as to merit a second look from the viewer. Despite his training at the prestigious Pennsylvania Academy of the Fine Arts in Philadelphia and the National Academy in New York, Harnett earned little respect from the art establishment of the nineteenth century. Critics dismissed his work as merely craft and chicanery, while others found his attention to material culture immoral. Nonetheless Harnett was embraced by the public who steadily demanded his work. Today, the work of Harnett and other trompe-l'oeil painters is highly valued, both for its qualities of formal design and conceptual complexity. By the mid-twentieth century, modern artists and critics admired Harnett's ability to disrupt the distinction between object and image. *(Cat. 46)*

Marsden Hartley (1977–1943)

Born and raised in Maine, Marsden Hartley began his career as a landscape painter. An avid reader of Henry Thoreau, Ralph Waldo Emerson, and Walt Whitman, Hartley infused his depictions of the mountains and woodlands of his home state with psychological and spiritual intensity. Nearly ten years after winning a scholarship to study at the National Academy of Design, he gained the attention of the photographer Alfred Stieglitz, who invited Hartley to

exhibit at 291, Stieglitz's famed vanguard gallery. Traveling to Europe, Hartley was greatly interested in Cubism and Expressionism and influenced by the writings of Wassily Kandinsky, whose strongly held spiritual view of modern art added a new dimension to the role of symbolism and abstraction in his work. Liberated by the relatively open sexual atmosphere in many parts of early twentieth-century Europe, in Paris, Hartley fell deeply in love with Karl Von Freyburg, a handsome German officer for whom he moved to Berlin. Hartley was devastated when Von Freyburg was killed shortly after the outbreak of World War I. In grief, he turned to his painting, producing abstract portraits of his lover that expanded the scope of Cubism and Expressionism to an extent unrivaled by any other American painter of his day. *(Cat. 67, 73)*

William Stanley Haseltine (1835–1900)

Born in Philadelphia, William Stanley Haseltine learned to paint under Paul Weber, whom he followed to Düsseldorf after graduating from Harvard in 1854. In Germany Haseltine was introduced to three prominent American artists—Emanuel Leutze, Worthington Whittredge, and Albert Bierstadt. The three journeyed down the Rhine River to Switzerland and to Rome in 1856. From these sojourns Haseltine developed the love of river imagery that would occupy his landscapes throughout his career. In 1858 he moved back to the United States, where he took a studio in 51 West Tenth Street in New York. In America Haseltine continued to develop his repertory. Often making excursions to paint the Delaware River, he developed a raw impressionist style that some critics characterized as "unfinished and too vigorous."

Haseltine also was one of the original founders of the American Academy in Rome. In 1893 he participated on the Art Committee for the World's Columbian Exposition in Chicago, one of the critical events in the history of American design. *(Cat. 51)*

Childe Hassam (1859–1935)

A relative of William Morris Hunt and Nathaniel Hawthorne, Childe Hassam grew up just outside of Boston as the son of a hardware merchant. Apprenticed to a wood engraver in 1876, he soon found work as a freelance illustrator for *Harper's Weekly*, *Scribner's Monthly*, and other Boston-based periodicals. He took art classes at night, studying for a time with William Rimmer and exposed to the Barbizon School by William Morris Hunt. A trip to Paris in 1886 to attend classes at the Académie Julian profoundly affected him. There he encountered the latest developments in Impressionism, the style he would practice after his return to America in 1889. He settled in New York City, where he perfected his dashing brushstroke and use of glaring light. A co-founder with John Henry Twachtman and Julian Alden Weir of the Ten American Painters group in 1898, he helped to convince a circle of artists, whose ranks included Edmund C. Tarbell, William Merritt Chase, and Thomas Dewing, to secede from the Society of American Artists. By the turn of the century, Hassam was one of the leading impressionist painters in America, producing numerous street scenes and a well-known series of American flag paintings. *(Cat. 70)*

Martin Johnson Heade (1819–1904)

The breadth and volume of work produced by Heade is perhaps unrivaled by any artist of nineteenth-century America. At various times Heade was intensely interested in portraiture,

still life, and landscape. Despite such interests, he was little known during his lifetime, probably because he ignored fashion. Heade grew up in Pennsylvania and briefly received instruction from Edward Hicks before seeking further study in Europe. By 1859 he had settled in New York where he developed a close friendship with Frederic Church, who encouraged him to travel to South America. Heade became fascinated by the rich wildlife of South America and produced somewhat active still lifes of these exotic plants and birds. He is often best remembered for his elegant paintings of the New England and mid-Atlantic coast, his exploration of light and atmosphere exemplifying Luminism, a branch of Hudson River School painting that sought a visual equivalent to Transcendentalism. *(Cat. 24, 31)*

Robert Henri (1865–1929)

Robert Henri began his career by studying at the Pennsylvania Academy of the Fine Arts, trained in the curriculum designed by Thomas Eakins and followed by Thomas Anshutz. From these artists he inherited a willingness to engage directly with the ugliness and imperfection of the modern world. After a trip to Paris, Henri began to incorporate the visual effects of Impressionism into his images, which resulted in a highly original form of painting that embodied the vitality and roughness of the early twentieth-century urban environment. He was more interested in celebrating his perceived truths of modern life, rather than traditional notions of beauty. Henri's boldness soon attracted a group of young followers known as The Eight, dubbed the Ashcan School because of their gritty style, whose ranks included John Sloan, William Glackens, George Luks, and Everett Shinn. Although they exhibited collectively at the Macbeth Gallery in

New York City, their divergent styles and stress on artistic freedom would never allow The Eight to coalesce into an actual school of art. Nevertheless Henri and the others launched a vibrant strand of Modernism based on realism instead of abstraction. *(Cat. 69)*

Edward Hicks (1780–1849)

Although he is now best remembered as the proverbial father of American folk painting, Edward Hicks was best known in his day as an esteemed Quaker orator. His only formal training was that of a coach maker, though he mainly earned his living as a painter of shop signs. Hicks did not paint his first fine-art painting until he began working in that tradition at forty years of age. He then took to the practice with zeal, producing over sixty versions of the painting known as *Peaceable Kingdom*. Based upon a biblical passage, Isaiah 11, this image of peace among wild animals was his metaphor for the ideal society. Despite his lack of formal training, Hicks knew something of the art of his day. Many of his versions of *Peaceable Kingdom*, including the one in the M.H. de Young Memorial Museum collection, actually feature background miniatures of the Benjamin West painting *Penn's Treaty with the Indians*. This insertion makes it clear that the tranquility among the animals is a metaphor for political harmony between the European colonists and Native Americans. *(Cat. 12)*

Winslow Homer (1836–1910)

Homer began his career as an apprentice to a lithographer in Boston, a position that he hated and likened to slavery. As an illustrator in the Civil War, he came into his own as an artist, gradually shifting to painting by the war's end. Aside from images of the war, he specialized in depictions of genteel American life: croquet games,

beachfront resorts, fly fishermen, and children at play. In 1881 Homer's career reached another turning point when he visited the English fishing village of Culler Coats, still a popular destination for British maritime painters. Although the reasons are not entirely clear, he then eschewed the genre paintings of his earlier career, instead focusing on larger scenes that often featured the struggle of individuals against nature, especially the sea. Homer then moved to his family property in the quiet resort town of Prout's Neck, Maine, where he set up a studio. Here he would produce his paintings of the rugged New England coast, perhaps the most celebrated examples of late nineteenth-century American painting. Reduced in narrative content, these paintings instead highlighted Homer's thick and choppy application of paint, leading many critics to see his style as a reflection of the harsh realities he depicts. *(Cat. 26)*

Thomas Hovenden (1840–1895)

Born in Ireland, Thomas Hovenden came to New York City at the age of twenty-three, attending night classes at the National Academy of Design. His determination to paint was solidified when he went to Paris in 1874 for six years of study at the Ecole des Beaux-Arts, studying for a time under Alexandre Cabanel. Upon returning to the United States, Hovenden produced many of his paintings at the Plymouth Meeting House, a Quaker meeting house in rural Pennsylvania that was an important stop in the underground railroad. His work differed from that of other genre painters in that he wanted to advance social causes, particularly regarding the lives of people of African descent in America. Other paintings by Hovenden explore the role of the family in American culture and the effects of industrialization on what was formerly an agrarian community.

Hovenden died at the age of fifty-five and was buried next to the Quaker meeting house in which he worked. Despite the fact that his early death cut short his artistic production, his painting of *The Last Moments of John Brown* was referred to in the *New York Times* in 1884 as "the most significant and striking historical work of art ever executed in the republic." *(Cat. 43)*

William Morris Hunt (1824–1879)

The brother of Richard Morris Hunt, the renowned Victorian architect, William Morris Hunt played a crucial role in bringing the French painting of the Barbizon style to America. This offered American landscape painters an alternative to the Hudson River School by encouraging them to loosen their brushstroke and focus more on atmosphere than solid form. Like his French counterparts, Jean-François Millet and Jean-Baptiste-Camille Corot, Hunt preferred to paint outside in nature rather than within the bounds of the traditional studio. Like Millet and Corot, Hunt also championed the heroic depiction of rural farmers and humble peasants instead of traditional historical or classical figures. As a young man at Harvard, Hunt began to realize his artistic talent, traveling to Rome to train as a sculptor, but studying painting for five years in Paris under Thomas Couture. Eventually he also convinced important American art patrons, such as Martin Brimmer, to form collections of French painting from the Barbizon school. *(Cat. 35)*

George Inness (1825–1894)

Studying first with Regis Gignoux, George Inness' earliest paintings were made in the style of the Hudson River School. On a trip to France in 1853 he was exposed to the works of the Barbizon painters, who worked in and around Fontainebleau. From these painters, Inness inherited a

looser brushstroke and the use of softer tonal qualities. He soon exchanged the attention to precise detail learned from the Hudson River School for the atmospheric effects that dominated his mature work. In 1863 Inness left the urban environment of New York City for the quiet of an artist's colony in Eagelswood, New Jersey. Once there, he developed a close friendship with the painter William Page. Page introduced him to the spiritualist writings of Emanuel Swendenborg, who stressed the idea that our visual world was simply a metaphor for a higher metaphysical reality. This influence became apparent as Inness rendered mystical landscapes that were more an extension of emotional rather than visual reality. *(Cat. 33)*

Eastman Johnson (1824–1906)

In his own time Eastman Johnson's reputation rivaled that of his younger contemporary, Winslow Homer. Unlike Homer, Johnson derived much of his income from portraiture, supposedly beginning his career by drawing portraits of the family of Henry Wadsworth Longfellow. Moving from Maine to Washington, D.C., in the mid-1840s, Johnson accomplished much of his early work in a make-shift studio that he set up in a Senate Committee meeting room. This unique arrangement, probably made possible by the political connections of the artist's father, helped Johnson to attain numerous important commissions. In 1849 he went to Europe for six years to perfect his craft, spending time in Düsseldorf and The Hague before briefly studying with Thomas Couture in Paris. Johnson became particularly well known for his anecdotal depictions of rural life and children at play, and today is remembered as the foremost genre painter of late nineteenth-century America, and as a specialist in scenes of everyday life. After the turmoil of the Civil War, Johnson's clear and highly legible narratives offered a world view that accommodated the Victorian need for stability and certainty. *(Cat. 27, 29, 32)*

Joshua Johnson (active 1796–1824)

As the first American artist of African descent to achieve public notoriety, Johnson probably began life as a slave of West Indian ancestry before starting to paint portraits as a free man in 1790's Baltimore. Little is known about his early professional training. Although he likely learned from the work of Charles Willson Peale, perhaps as a studio assistant or hired hand, Johnson claimed to be a "self-taught genius, deriving from nature and industry his knowledge of art." While the precise reason for Johnson's claim is unknown, it is possible that he needed to portray himself as a natural genius in order to find patronage among the white upper class. On the other hand, many of his paintings do exhibit a two-dimensional flatness of perspective, often associated with sign painting or vernacular portraiture. The employment of this style was probably a conscious choice made by the artist, as it would have been part of the familiar visual experience of his patrons. Whether trained or self-taught, Johnson's portraits embody the aspirations of wealthy eighteenth- and early nineteenth-century Americans. As commissioned portraiture was still not broadly available in America, Johnson's painting helped to communicate and solidify the upper-class status of his patrons. *(Cat. 6)*

William Keith (1839–1911)

Keith was among the first generation of landscape painters to import to California the kind of grand-manner landscape painting developed by the members of the Hudson River School. He was born in Scotland, emigrating

to New York with his parents. After a brief stint at a law firm, the publishing company Harper Brothers sent Keith to San Francisco in 1859 to work as an engraver. In his spare time he began to paint for pleasure, producing advertising pictures for the Northern-Pacific Railway and eventually attracting the patronage and friendship of the great naturalist John Muir. Like Bierstadt, Keith's east-coast contemporary, Keith then went to Düsseldorf to receive training. Upon returning to San Francisco he enjoyed a successful career until the great earthquake and fire of 1906 ravaged his Berkeley studios. Despite the loss of over a thousand paintings and drawings, Keith continued to paint. He maintained a long friendship with George Inness, who introduced him to the muted atmospheric effects of Tonalism. *(Cat. 53)*

John Frederick Kensett (1816–1872)

The son of a British engraver who had emigrated to Connecticut, Kensett himself first worked as an engraver in Albany, New Haven, and New York City before beginning to paint seriously. He finally submitted his first landscape painting to the National Academy in 1838 and before long became associated with the Hudson River School. Kensett next traveled to Europe in 1840, journeying to many countries with his fellow artists John Casilear and Asher Durand. Seven years later, Kensett returned to the United States and was almost immediately well received, becoming a full member of the National Academy within two years. He made prodigious images of the Catskills and Adirondacks and would later make several trips to the American West. Even before Thomas Moran, Kensett is credited with being among the first American painters to emphasize light as much as solid form in American landscape painting. *(Cat. 21)*

Rockwell Kent (1882–1971)

Rockwell Kent was a man of varied education and multiple careers. After a tour of the art and architecture of Europe at the age of thirteen, he studied at the summer school of William Merritt Chase. His talent immediately recognized, he was offered a full scholarship to continue. At the urging of his mother, Kent instead studied architecture at Columbia University before finally accepting Chase's offer nearly four years later. At different times Kent would also study under Robert Henri, Kenneth Hayes Miller, and Abbot Thayer. During his life he worked as a dairy farmer, ship's carpenter, and lobsterman, though he made a lasting mark in the art world as an illustrator and printmaker. Kent set new standards with his simplified modern design advertisements for General Electric and Rolls Royce and earned popular acclaim for his illustrations of *Moby Dick* in 1930. With his oil painting, Kent was able to focus on his lifelong love of the sea. He reached the height of his popularity in the 1930s, but his political affiliation with the Socialist party cost him his passport and most of his artistic supporters during the 1950s. He willed his own collection of over 80 paintings and nearly 800 graphic works to the Soviet Union. *(Cat. 65)*

George Luks (1867–1933)

After brief periods of study at the Pennsylvania Academy of the Fine Arts and the Düsseldorf Academy, George Luks traveled around Europe, learning from the dark palette and loose brushstrokes of Rembrandt and Franz Hals. Settling again in the United States in 1894, he joined the staff of the *Philadelphia Press*, where he worked as an illustrator. After moving into a studio apartment with his colleague, Everett Shinn, he soon became acquainted with John Sloan, William Glackens, and Robert Henri.

Luks then served as a correspondent in Cuba during the Spanish-American War, eventually drawing for "The Yellow Kid," arguably the first newspaper comic to measurably boost a paper's circulation. Shortly after the turn of the century, Luks gave up his career as an illustrator to focus almost exclusively on painting. He continued his association with Shinn, Sloan, Glackens, and Henri and became one of the core members of the Ashcan School. A rambunctious man and heavy drinker, Luks was found dead on the streets of New York in 1933 after a barroom brawl. *(Cat. 72)*

Reginald Marsh (1898–1954)

The son of successful painters, Reginald Marsh studied art at Yale University before moving to New York City to illustrate for the *New Yorker* and other notable publications. After additional instruction at the Art Students' League with Luks and Sloan, his art became a vehicle for social commentary. By the middle of the 1930s, Marsh was firmly associated with a genre of painting known as Social Realism, which looked at the harsh reality of urban life in America during the Great Depression. Unlike many contemporaries he often favored tempera instead of traditional oil paint, which roughened the surface of his paintings and captured the frenetic movement of urban experience. Despite his associations with other urban scene realists, Marsh's depictions of the urban dwellers of Coney Island and the New York subway border on caricature. *(Cat. 80)*

William McCloskey (1859–1941)

Born in Philadelphia, William McCloskey and his wife Alberta would be among the first round of American artists to bring the sophistication of east coast painting to southern California. McCloskey was trained at the Pennsylvania Academy of the Fine Arts under Thomas Eakins, from whom he no doubt acquired his love of empirical detail. McCloskey and his wife had established a picture studio in the Child's Grand Opera House in Los Angeles by 1884, which they opened one day a week to the public. Today, McCloskey is best remembered for his still-life paintings of California fruit, prompting art historian William Gerdts to term him the "Master of Wrapped Citrus." Many of his paintings do indeed convey a fascination with layers and concealment, suggesting that McCloskey may have understood the artist as an arbiter of what is seen and unseen. The painting of wrapped oranges in the M.H. de Young Memorial Museum collection may link California as the promised land to the painters of its riches. *(Cat. 52)*

Louis Remy Mignot (1831–1970)

The son of a wealthy French confectioner, Louis Remy Mignot was born in Charlestown, South Carolina. By the age of twenty, he traveled to The Hague to advance his artistic training, collaborating there on a number of paintings with Eastman Johnson. In 1855 Mignot returned to the United States and settled into the Tenth Street Studio in New York. There he met the famed landscape painter Frederic Church, with whom he traveled to Ecuador in 1857. The material from this trip lasted for years, giving him a reputation during his lifetime nearly equal to Church's. With the outbreak of the Civil War, Mignot fled New York in 1862 and settled in Brighton, England, where he lived until his death in 1870. His work was well received in the United Kingdom and he participated in many exhibitions at the Royal Academy. Despite this success, Mignot's prominence faded shortly after his death and art historians are only now beginning to rediscover his work. *(Cat. 22)*

Thomas Moran (1837–1926)

Born in England and raised in Philadelphia, Thomas Moran was almost entirely self-taught as an artist, with the exception of the brief time he spent as a wood-engraver's apprentice. Producing romantic landscapes in the tradition of Cole and Bierstadt, his career reached a turning point in 1871 when the director of the United States Geological Survey, Ferdinand Hayden, invited him to join an expedition to what would become Yellowstone Park. Moran was fascinated by the geysers and geothermal activity of Yellowstone and the trip marked one of the most productive periods of his life. Later in his career he was less concerned with the details of the particular scenes he was painting and more interested in the formal qualities of painting. Inspired from an early age by the works of J.M.W. Turner, Moran experimented with color, light, and form, setting the tradition of American panoramic landscape on a trajectory that foreshadowed the rise of modernist painting. *(Cat. 64)*

Charles Christian Nahl (1818–1878)

Born into a family of artists dating to the seventeenth century, Charles Christian Nahl lived and studied in Germany until financial ruin forced his family to flee to Paris in 1846. In Paris Nahl exhibited at the Salon and was reportedly a student of both Horace Vernet and Paul Delaroche. In the wake of the 1848 uprising that established the Second Empire in France, the Nahls again had to move, this time heading for New York. Once in the United States, Nahl became excited by the promise of gold in California. He and his brother Arthur, also an artist, booked passage on a steamer to Central America, crossed the Isthmus of Panama, and then boarded another steamer to San Francisco. After a few months of unsuccessful gold panning near Sacramento, he again turned to the fine arts, making engravings for a local newspaper and painting the portraits of local miners. In 1852 a fire in his Sacramento studio forced Nahl to move to San Francisco. He then resumed his career as an artist, painting commissions from Leland Stanford and paintings of California history for Charles Crocker. *(Cat. 15)*

Georgia O'Keeffe (1887–1986)

Born near Sun Prairie, Wisconsin, O'Keeffe began her training at the Art Institute of Chicago before studying with Kenyon Cox and William Merritt Chase in New York City in 1907. After about four years of work as a commercial artist, she spent a brief time as a teacher in Texas before returning to New York to study with Arthur Wesley Dow at Columbia University. By 1915 she began to develop a thoroughly modern style that focused on close-up images of flowers and other objects, bordering on abstraction. O'Keeffe had her first one-person show in 1917 at the famed 291 Gallery of Alfred Stieglitz, whom she would later marry. In 1929 she made her first trip to New Mexico and almost immediately became enamored by the light of the Southwest and what she called the "wonderful emptiness." O'Keeffe visited the Southwest every summer until she moved there permanently in 1946 following the death of Stieglitz. Although O'Keeffe always commented on the formal qualities of her art, many viewers and critics have perceived sexual metaphors. No matter what the symbolic interpretation, she was able to render each form she painted as though it alone were a universal microcosm. *(Cat. 76)*

Charles Willson Peale (1741–1827)

Like Benjamin Franklin and Thomas Jefferson, Peale's wide range of ability and interests were stimulated by the

needs of the new American nation. In his youth, Peale worked as a clock-smith, silversmith, and saddle-maker before becoming a painter. In the mid-1760s, he made a new saddle for the painter John Hesselius in exchange for lessons on painting. He then traveled north to Boston to receive further instruction from John Singleton Copley. Still not satisfied, Peale then left his native Baltimore for two years of study with Benjamin West at the Royal Academy in London. After returning to America, Peale embarked on a prolific career that would change the course of American art. Aside from his success as a portraitist, whose commissions include numerous paintings of George Washington, he also founded the nation's first public museum in the top floor of Independence Hall in Philadelphia. More than simply a painter, Peale was also an avid naturalist who used his museum to exhibit numerous specimens and arti-facts, including the skeleton of a giant mastodon that he had excavated. He is the founder of one of America's most notable families of accomplished painters, including his brother, James Peale *(fig. 23)*, and his son, Raphaelle Peale *(fig. 24)*.*(Cat. 4, 9)*

Agnes Pelton (1881–1961)

Born to American parents in Germany, Pelton and her mother returned to Brooklyn in 1890 after the death of the artist's father. Trained by her mother to play the piano at an early age, Pelton began to study the visual arts in her late teens. After earning a cer-tificate from the Pratt Institute, she studied for a time with Arthur Wesley Dow, who introduced her to both mod-ernist landscape painting and Japanese prints. In 1919 Pelton first visited the Southwest as a guest of Mabel Dodge Luhan in Taos, New Mexico. She was immediately enamored of both the topography and climate of the South-west and by the group of modern painters, the Transcendental Painting Group, who clustered around Luhan. She became heavily interested in theosophy and Agni Yoga, which emphasizes fire as a spiritual symbol. In 1931 Pelton settled in Cathedral City, California, where she painted surrealistic scenes of desert imagery. Although there is no evidence that she ever returned to New Mexico, Pelton did continue to share ideas though her correspondences with Raymond Johnson and other artists from Taos. *(Cat. 85)*

John Frederick Peto (1854–1907)

For most of the twentieth century, relatively little was known about the life of John Peto and for a time his work was even attributed to William Harnett. In 1878 he was enrolled in the Pennsylvania Academy of the Fine Arts at the same time as Harnett, who may have served informally as his teacher. Trompe-l'oeil painters, who sought to "fool the eye," were associ-ated with the trickster and the con man, putting them at odds with the artistic and moral establishment of the nineteenth century. Nonetheless, Peto's images of personal memorabilia and old-fashioned letter racks are today recognized as fine intellectual accomplishments. Each of his images of worn photographs, dog-eared books, and tattered letters function as enig-matic repositories of memory. His work may be viewed as a comment on the futility of making memory perma-nent through material form. Virtually every object included in his work would have been old and dated at the time of his painting. With the passing of time, the objects in his work appear even more deteriorated, suggesting a relationship between the erosion of the material world and the erosion of memory. *(Cat. 54, 60)*

Horace Pippin (1888–1946)

Born the grandchild of slaves, Horace Pippin spent almost his entire life in the town of his birth, West Chester, Pennsylvania. He served in World War I but was severely crippled by a gunshot wound to the arm. Pippin had previously worked as a craftsman but was unable to do manual labor after his combat wound, and so began painting. Almost entirely self-taught, Pippin worked obsessively out of a small, dark room in his home. His painted images of Abraham Lincoln and John Brown evince his particular interest in historical scenes that were of great importance to Americans of African descent. His work is rich in a psychological complexity and can at times border on the uncanny, as he had the ability to make familiar scenes of the home and other everyday subjects seem unfamiliar. He was exposed to the latest trends in Modernism through his frequent visits to the nearby collection of legendary art collector Dr. Albert Barnes. Perhaps instructed by these visits, Pippin began to incorporate modernist techniques into his work, such as decorative pattering and flattened perspectives. *(Cat. 86)*

Alexander Pope (1849–1924)

Pope grew up working in his family's lumber business in Dorchester, Massachusetts. There he made his earliest artistic creations, carving small wooden animals. He briefly took lessons in painting and sculpture from William Rimmer, but soon, primarily self-taught, he independently earned a living as an artist. By the 1880s, Pope decided to follow the market and focus almost exclusively on painting. He reportedly was a gregarious man who had a successful career and enjoyed the gentlemen's clubs of Bostonian society. Often using live or stuffed animals as models, he rose to the top of the Boston artistic establishment through his detailed images of hunting and fishing. He produced traditional still-life paintings, portraits of horses, and other animals and trompe-l'oeil paintings that were of a similar quality to those of William Harnett. Pope's work provides the viewer with a snapshot of the genteel brand of masculinity that pervaded middleclass and upper-middleclass society in late nineteenth-century America. *(Cat. 62)*

Maurice Prendergast (1859–1924)

Introduced to Robert Henri and The Eight by William Glackens, Maurice Prendergast joined their circle of artists without becoming an Ashcan painter. Although Prendergast was also interested in the hustle and bustle of the modern city, especially the crowds of urban parks and beaches, unlike the other members of this group he retained a bright palette. Born in Newfoundland, Prendergast came to America with his family at the age of ten. After settling for a time in Boston he left America to study at the Académie Julian in Paris. Once in Europe, Prendergast was exposed to the myriad art movements and styles of the beginning of the twentieth century, though he was most influenced by the post-Impressionist tendency to juxtapose well-regulated strokes and blotches of vibrant color. Returning to America, Prendergast settled in New York City, where he perfected his production of kaleidoscopic images of city life. Aside from his own work as an artist, he played an important role in organizing the 1913 Armory Show, the first exhibition in America to broadly exhibit the latest advances in European art. *(Cat. 66)*

Albert Pinkham Ryder (1847–1917)

Perhaps the most erratic and eccentric artist in the pantheon of American painters, Albert Pinkham Ryder bridged the nineteenth and twentieth

centuries. He moved from Massachu-setts to New York City in 1870, where he mainly painted seascapes and other images that lent themselves to mystical association. Unlike most of his contem-poraries, Ryder cared very little for the replication of nature or actual visual experience. Instead, his paintings reveal an inner vision fraught with psychological turmoil and metaphysi-cal concern. He employed a thickly impastoed brushstroke, mixing wax and other ingredients with his paints. As a result, Ryder's paintings have a rich and multi-layered material presence that at times border on abstraction. This made Ryder a hero to the first generation of American Modernists, who welcomed him into the famed Armory Show of 1913. As time went on Ryder became increas-ingly reclusive and absorbed in his art, yet he still served as a mentor to Marsden Hartley and other painters who visited him in his cluttered studio in Greenwich Village. *(Cat. 42)*

Robert Salmon (1775–1848/1851)

Having already received training as an artist, Salmon moved from Liverpool to Boston in 1828. Once there, he worked in a lithography studio with Fitz Hugh Lane, another artist who would become a master of maritime painting. A reportedly eccentric and solitary man, Salmon lived for years in a small dwelling on one of Boston's many wharves. His paintings reflect the Dutch tradition of maritime paint-ing, featuring a low horizon line and clarity of light. Among the more pecu-liar aspects of his paintings are the repetition of waves, which often seem choppy and artificial. His paintings are also almost always rich in miniature detail, many containing tiny figures going about their daily business on shore or on board a ship. In this way Salmon chronicled the economic life that was vital to Boston and other nineteenth-century port cities on the east coast of America. It is possible that his almost obsessive attention to empirical detail was fostered by the materially focused values of mercantile Boston. *(Cat. 8)*

John Singer Sargent (1856–1925)

The son of wealthy expatriates, Sargent was born in Florence and did not come to the United States before the age of twenty. Throughout his childhood, the Sargent family trav-eled from place to place in Europe in search of cures to his mother's per-ceived illnesses. These travels became an extraordinary learning opportunity for Sargent, as he and his mother would see art collections in each of the cities they visited. At the age of eighteen Sargent became one of the youngest students in the atelier of the famed Parisian society painter, Charles Carolus-Duran. Under Duran's direc-tion, Sargent developed the loose and flowing brushstroke that became his hallmark. His sensual style appealed to the European and American social elite and he quickly became a fashion-able member of the art world of nineteenth-century Paris. Sargent's reputation was seriously threatened when, in 1884, he produced a scan-dalous portrait of a prominent French socialite, Madame Gautreau. Critics were shocked by his depiction of her bare shoulder, although the painting is now considered a pinnacle of late nineteenth-century elegance. Sargent resumed his career in London where he associated with the members of the Aesthetic movement, although by 1900 he was frustrated with the taste and expectations of his clientele and largely gave up portraiture in favor of landscape painting. *(Cat. 44, 45, 71)*

Ben Shahn (1898–1969)

Ben Shahn was born into an orthodox Jewish family in Lithuania in 1898.

After moving with his family to Brooklyn early in life, Shahn obtained an apprenticeship with a lithographer, taking night classes at New York University and the National Academy of Design. By 1929, he shared a studio with photographer Walker Evans, who may have helped foster Shahn's interest in Social Realism and issues of social justice. These themes brought Shahn briefly to North Africa and Europe, until he returned to the United Sates in 1930. After assisting Diego Rivera with his murals in Rockefeller Center, Shahn produced numerous photographs for the Farm Security Administration and undertook his own mural projects for the WPA. He also worked as an illustrator, producing images for *Time* magazine and World War II posters. In the wake of the Holocaust, Shahn renewed his interest in Jewish subject matter and developed a surrealistic style in which he depicted stories from the Old Testament and Jewish folklore. *(Cat. 87)*

Charles Sheeler (1883–1965)

Charles Sheeler was initially trained as a traditional turn-of-the-century portrait painter, studying with William Merritt Chase at the Pennsylvania Academy of the Fine Arts. After visiting Italy and France in 1909, he became interested in the work of Paul Cézanne and the European old masters. Soon after returning to Philadelphia, Sheeler began to experiment with Fauvism until financial need pushed him to take up photography in 1912. His experimentation with this technologically based medium signaled a profound shift in his work. With Charles Demuth and other artists who were part of the avant-garde circle of Alfred Stieglitz, Sheeler developed an artistic style based on the underlying geometrical structure of the material environment. This style, Precisionism,

emphasized regularity, planar surfaces, and the machine-like application of paint. Many of Sheeler's paintings depict the industrial landscape with an almost hygienic clarity, while much of his other work celebrates the simplicity and austerity of early American domestic interiors. While present-day images of industrialization refer to pollution or urban decay, Sheeler's images of factories and machines optimistically regard the industrial life of early twentieth-century America. *(Cat. 77, 84)*

Everett Shinn (1876–1953)

Born in rural Woodstown, New Jersey, Everett Shinn first studied engineering and industrial design at the Spring Gardens Institute in Philadelphia. He took his first job designing fixtures for gas lighting, but soon became bored. He then enrolled at the Pennsylvania Academy of the Fine Arts, where he studied painting and drawing under Thomas Anshutz. After rooming with George Luks, a fellow illustrator for the *Philadelphia Press*, Shinn eventually became a founding member of the Ashcan School. While Shinn, like other Ashcan painters, continued to paint the underbelly of urban life, he also became fascinated by the rarefied world of the theater, often depicting actresses and dancers in a manner reminiscent of Edward Degas, and later designing sets for the theater. In 1949 he was elected to the National Academy of Design. *(Cat. 68)*

Edmund Tarbell (1862–1938)

Edmund Tarbell was one of the most acclaimed artists of Boston at the turn of the century. Raised in West Groton, Massachusetts, his artistic talent was recognized when he enrolled as an art student at the School of the Museum of Fine Arts under Otto Grundmann, whom he succeeded as the head of painting in the Museum School at the

age of 27. After completing his study in Boston and spending a brief time in Paris, Tarbell adopted an impressionist style and participated in the nation's most prestigious expositions. By the 1890s, a master of plein-air figurative style, Tarbell became a founding member of The Ten, a group of artists from Boston and New York at the forefront of American Impressionism. As the twentieth century began, he shifted his attention to interior scenes that he rendered in muted tones and suffused light. Along with Frank Benson and other Boston artists, Tarbell developed a refined style that combined the pretenses of Aestheticism with a value system consistent with the upper middle class. *(Cat. 58)*

John Vanderlyn (1775–1852)

John Vanderlyn was among the first generation of artists who attempted to raise the standards of American art to the level of European painting, then considered superior to any homespun achievements. After briefly learning the rudiments of painting from Gilbert Stuart, Vanderlyn spent nineteen years studying in Europe. In particular, he assiduously studied ancient statuary and the old masters, as well as the contemporary work of Jacques-Louis David and other neoclassical masters. Returning to America in 1815, Vanderlyn met with limited success. In New York City, he set up a small studio based on the designs of a classical temple. Here he displayed his own paintings in the neoclassical style, which, aside from their subject matter, have been interpreted as allegories of the American Republic. In the rotunda of his studio he also exhibited a panorama of the palace of Versailles. Despite such attempts at publicity, portraiture dominated the art market in early nineteenth-century America and there was little demand for the kind of grand-manner history painting that

Vanderlyn aspired to produce. In 1837 he finally was commissioned to produce a large history painting, *The Landing of Columbus*, which can still be seen today in the rotunda of the United States Capitol. *(Cat. 7)*

Elihu Vedder (1836–1923)

Living most of his adult life in Italy, Elihu Vedder was a painter of mystical imagery. He grew up in Schenectady, New York, leaving to study art in Paris in 1856. After a short while abroad, Vedder decided to move to Florence, realizing that he had much to learn from the Italian Renaissance. He returned to the United States at the beginning of the Civil War and briefly made a living as a commercial artist for *Vanity Fair* and other periodicals. Not too long after, Vedder made Rome his permanent home, only returning for brief periods to the United States. Vedder loved mystical literature, painting subjects that included sphinxes, angels, and biblical figures. He was particularly interested in *The Rubiayat of Omar Khayyam*, a book of poetry by a Persian mathematician written about 1120 A.D. For this book he produced over fifty images, setting a new standard in book illustration not seen since William Blake. Despite his fascination with the supernatural, Vedder retained an academic style throughout his career. *(Cat. 38)*

Irving Ramsay Wiles (1861–1948)

The son of a successful landscape painter, Wiles first learned to paint in the New York Washington Square studio of his father, Lemuel Maynard Wiles. Although Wiles devoted much of his youth to the study of the violin, he shifted his focus to painting after enrolling at the Art Students' League, where he studied under William Merritt Chase, from whom he inherited a loose and painterly brushstroke. Wiles next went to Paris to perfect his

portrait style under the instruction of Jules-Joseph Lefebvre and Charles Carolus-Duran, who also taught John Singer Sargent. Upon his return to America in 1883, Wiles first earned his living as an illustrator for *Harper's* and *Scribner's* before establishing his reputation as a painting instructor by the 1890s. The recipient of prestigious awards both in New York and Paris, Wiles became an admired portraitist and occasional landscape painter. Aside from his work as a teacher and society artist, he was selected by the National Art Committee along with only eight other artists to paint the history of World War I. *(Cat. 50)*

Worthington Whittredge (1820–1910)
The son of a New England farmer who migrated to Ohio while it was still a wilderness, Worthington Whittredge grew up as a young hunter and trapper until he found steady employment as a house and sign painter with his brother-in-law. Inspired by the invention of the daguerreotype, an early and popular form of the photograph, Whittredge tried unsuccessfully to become both a photographer and traditional portrait painter. By 1843 he was determined to make his mark as a landscape painter and was encouraged early on by the praise of Asher B. Durand, then president of the National Academy of Design. Whittredge traveled abroad for a brief period of study in Düsseldorf, where he served as one of the models for Washington in Emanuel Leutze's *Washington Crossing the Delaware.* Whittredge also spent five years in Rome, becoming part of a creative circle that included Frederic Church and Nathaniel Hawthorne. In 1859, Whittredge returned to America where he took up a studio in the fabled Tenth Street Building in New York. After three trips through the Great Plains to the Rocky Mountains, he established himself as one of the nation's leading landscape painters. *(Cat. 34)*

Joseph Wright (1756–1793)
Born in New Jersey, Joseph Wright would go on to become the nation's preeminent clay and wax modeler. He traveled to England with his mother in 1772 where he studied briefly under Benjamin West and John Hoppner, producing a portrait of the future King George IV during his time at the Royal Academy. He next went to Paris, honing his skills by painting French society portraits under the patronage of Benjamin Franklin. Wright returned to America, almost penniless after a shipwreck off the Spanish Coast. He settled for a time in Boston and became acquainted with William Dunlap, who may have helped Wright secure his first commissions. Wright would eventually go on to produce several celebrated portraits of George Washington, who sat for him near Princeton in 1783. Because of Wright's superb skill as a modeler, Washington appointed him as the first draftsman of the U.S. Mint, and he designed many of the first medals and coins for America. Wright and his wife died of yellow fever during an epidemic in Philadelphia in 1793. *(Cat. 5)*

Selected Bibliography of Visual Culture Studies

Berger, John. *Ways of Seeing*. London and Middlesex: British Broadcasting Corporation and Penguin Books, 1972.

Bryson, Norman, et al. *Visual Culture: Images and Interpretations*. Hanover and London: Wesleyan University Press, 1994.

_____. *Visual Theory: Painting and Interpretation*. New York: Harper Collins, 1991.

Chave, Anna. "O'Keeffe and the Masculine Gaze." In *Reading American Art*, ed. Marianne Doezema and Elizabeth Milroy, 350 – 352. New Haven: Yale University Press, 1998.

Corn, Wanda. "Coming of Age: Historical Scholarship in American Art," *Art Bulletin* 70 (June 1988): 188 – 207.

Dabakis, Melissa. "Douglas Tilden's Mechanics Fountain: Labor and the 'Crisis of Masculinity' in the 1890s." *American Quarterly* 47 (June 1995): 204 – 235.

Evans, Jessica, and Stuart Hall, eds. *Visual Culture: The Reader*. London, Thousand Oaks, New Delhi: Sage Publications, in association with The Open University, 1999.

Miller, David C., ed. *American Iconology: New Approaches to Nineteenth-Century Art and Literature*. New Haven and London: Yale University Press, 1993.

Mitchell, W. J. T. *Iconology: Image, Text and Ideology*. London and Chicago. University of Chicago Press, 1986.

Mulvey, Laura. *Visual and Other Pleasures: Theories of Representation and Difference*. Bloomington: Indiana University Press, 1989.

Nemerov, Alex. *"Doing the 'Old America':* The Image of the American West, 1880 – 1920." In *The West as America: Reinterpreting Images of the Frontier, 1820 – 1920*, ed. William H. Truettner. 285 – 343. Washington, D.C.: Smithsonian Institution Press, 1991.

Panofsky. *Studies in Iconology: Humanistic Themes in the Art of the Renaissance*. London: Oxford University Press, 1939; New York: Harper and Row, reprint, 1967.

Staniszewski, Anne. *Believing is Seeing: Creating the Culture of Art*. New York and London: Penguin Books, 1995.

Williams, Linda, ed. *Viewing Positions: Ways of Seeing Film*. New Brunswick, N.J.: Rutgers University Press, 1994.

Wolf, Bryan J. "History as Ideology: Or, 'What You Don't See Can't Hurt You, Mr. Bingham.'" In *Redefining American History Painting*, eds. Patricia M. Burnham and Lucretia Hoover Giese, 242–262. London: Cambridge University Press, 1995.

Index

Numbers in boldface indicate illustrations

Accents 8, 9, 101–103; American 8; linguistic 8; visual 8; varied, of America 101, 103

Academies, National Academy of Design (New York) 11, 29; Art Students' League (New York City) 55; Pennsylvania Academy of the Fine Arts 40, 43, 106, 107; European 62, Académie Julian 106, and Ecole des Beaux-Arts 107; and Düsseldorf Academy 112; and see also Salon

Adams, Henry 51, 108

Addison, Joseph 16; *Cato* 16, 105

Aelst, Willem van 91; *Flowers in a Silver Vase* 91, **91**

Aeschylus 66; *Prometheus Unbound* 66

African Americans 58, 60, 78, 83, 110, Diaspora and middle-passage 58, 110; and equal status for 81; and American Indians 83; Civil War, casualties to 111; Harlem Renaissance 58, 109, and John Hope Franklin 109, and Alain Locke and *The New Negro: An Interpretation* 58; heritage 58, 60; negrophilia 58; and slavery 58, 60, 77, 81, 110; role of 78, 81, 83; as army teamsters 81; and muleteers 81, 83; promise, religious and utopian 60; racism 81

After the Hunt (Harnett) cat. 46, 93, 122, **122**

Afternoon on the Sea, Monhegan (Kent) cat. 65, 95, 127, **127**

American Indians 83–86, and seen as "savage bloodhounds" 112; Andrew Jackson 83, and as "Indian killer 112; black slaves of 83; in Civil War, causalities to 111, and vs. U.S. government 111; Cherokee nation 84, 112; horses and buffalo, 86, 87; paternalism 83; slave-labor economy 83; The Trail of Tears 83, 112; tribal, rights, and attack on 84, and removal of 84; as "vanishing race" 83

Anshutz, Thomas Pollock 43, 45, 46, 57, 102, 106, 107, 108, 132; *The Ironworkers' Noontime* cat.

41, 43–46, **44**, 57, 102, 107, 108, 121, frontispiece

Antiquity 16, 17, 42; 70; art, Greek and Roman 60; 39; and sculpture, Greek 45; Roman 16, 45; the body 45, 66, 68; classical 39; and scenario 65; classicism 39; Clio (Muse) 42; frieze 45, 86, and *Horseman* (Parthenon) and *Battle of Greeks and Amazons* (Mausoleum at Halicarnasssus) 112; genres 11; Greek and Roman 60; heroic athlete 65, 86; Jupiter, god 66, the star 69; mythology 86; the nude 86; Roman, empire 16, and as empire of iron 16; republic 16; works, Euclid and *Geometry* 35; Plutarch and *Lives* 64; Egyptian, art 60; Anubis, god 64

Aspiration (Douglas) cat. 82, 58, **59**, 130

Ault, George; *Highland Light* cat. 78, 53, 129, **129**, 132

Bard, James; *The Steamship "Syracuse"* cat. 17, 36, 117, **117**, 132–133

Baroque 21, 91; conventions of, in Gainsborough *Jonathan Buttal* 17; high, of European old masters 12, 55; portraiture 16, 17; realist 42, and José deRibera 42; and Thomas Eakins 43, 107

Bath, The (Gérôme) 82, **82**

Beaux, Cecilia; *Little Lamerche* cat. 58, 26, 65, 125, **125**

Beham, Barthel 45; *The Rape of Helen* 45, **45**

Bellah, Robert N. 33

Bermuda Window in a Semi-Tropic Character, A (Hartley) cat. 73, 96, 129, **129**

Bierstadt, Albert 84, 86, 89, 90, 112, 113, 133; *California Spring* cat. 36, **88**, 89, 121; *Indians Hunting Buffalo* cat. 48, 84–87, **85**, 90, 123; *The Last of the Buffalo* **84**, 86; *Roman Fish Market, Arch of Octavius* cat. 18, 90, 117, **117**; *Sunlight and Shadow* cat. 23, 113, 118, **118**

Bingham, George Caleb 36, 38, 39, 40, 133; *Boatman on the Missouri* cat. 11, 36–40, **37**, 115; *Country Politician* cat. 14, 38, 116, **116**

Blackberries (R. Peale) 93, 94, **94**

Blue Veil, The (Tarbell) cat. 58, 26, 125, **125**

Boatman on the Missouri (Bingham) cat. 11, 36–40, **37**, 115, back cover

Bohemian, A (Bunker) cat. 47, 35, 122, **122**

Bouguereau, William-Adolphe 106

Bradford, William 76, 134; *Scene in the Artic* cat. 40, 76, 121, **121**

Bright Side, The (Homer) cat. 26, 79–82, **80**, 118

British Merchantman in the River Mersey Off Liverpool (Salmon) cat. 8, 115, **115**

Brown Family, The (E. Johnson) cat. 32, 18–22, **19**, 125

Brown, John George 134; *On the Hudson* cat. 30, 71, 119, **119**

Bunker, Dennis Miller 134; *A Bohemian* cat. 47, 35, 122, **122**

Burchfield, Charles E. 134–135; *Spring Flood* cat. 79, 55, 130, **130**

Burr, Aaron 64, 65, 110; and relationship to Harman Blennerhassett, Alexander Hamilton, and James Wilkinson 64

Caius Marius Amid the Ruins of Carthage (Vanderlyn) cat. 7, 62–66, **63**, 68, 82, 104, 110

California Spring (Bierstadt) cat. 36, **88**, 89, 121

Caroline de Bassano, Marquise d'Espeuilles (Sargent) cat. 44, 22, 26–29, **27**, 122

Cassatt, Mary 24, 26, 106, 135; *The Child's Bath* 24, **24**, 26; *Mrs. Robert S. Cassatt, The Artist's Mother (Katherine Kelso Johnston Cassatt)* cat. 49, 24–26, **25**, 35, 123

Cello Player, The (Dickinson) cat. 75, 95, 129, **129**

Central Park 47, 49, 50; "Greensward" plan of Frederick Law Olmsted and Calvert Vaux 47, 49

Central Park South, New York (Wackernagel) 47, **47**

Challenge (Pelton) cat. 85, 96, 131, **131**

Chase, William Merritt 135; *A Corner of My Studio* cat. 55, 124, **124**

Church, Frederic Edwin 74, 76, 77, 89, 135–136, and Cole's *Prometheus Bound* 74, 111; *Rainy Season in the Tropics* 76, **77**, 111; *Twilight* cat. 19, 74–76, **75**, 89, 111, 117

Child's Bath, The (Cassatt) 24, **24**, 26

Civil War (U.S.) 18, 20, 38, 76–79, 81–84, 89; and industrial nature of 82; Confederacy ideology of 78; pre-Constitutional Articles of Confederation 78; military forces and General James Carlton 84; Union 36, and ideology of 78; and vocabulary of equality and solidarity 78; Missouri Compromise and 36, 78; and the "Mason Dixon line" 78; vocabulary of alliance and separation 84; Matthew Brady 79, and Timothy H. O'Sullivan and *Field Where General Reynolds Fell, Gettysburg* 79, **79**; Constitution (U.S.) 78

Class 15, 40, 45, 47, 102; bourgeois morality 22; capitalism and 36, 40, 51, 57, 66; and Friedrich Engels 107; and Karl Marx 39, 107; *Das Capital* 39; clothing, as a sign of 29; domesticity, notions of 102; ownership 51; status 15, 16, 28, 31, 40, 62, and colonial status 66; and equal status for 81; social position 17; Dutch, bourgeois society 18, and merchant classes 21; middle class (bourgeoisie), emerging 24, 49, and ethics 28; and entitlement 21, and American ethic of prosperity vs. European ethic of birth 21; ownership

classes 51; social elites 82; work and leisure in relation to 35, 36, and communities of leisure 49

Classical, see Antiquity

Cole, Thomas 66, 68–70, 74, 77, 89, 110, 111, 136; *Peace at Sunset (Evening in the White Mountains)* cat. 10, 71, 89, 115, *115*; *Prometheus Bound* cat. 13, 66–70, *67*, 74, 111, 116; Theodore (son) 111

Community 11, 33, 38, 39, 40, 47, 51, 55, 57, 58, 60, 61, 83, 95, 103; gendered ordering in 20; social order in 20, 34, 38, 82, 83, and values 32

Concert, The (Vermeer) 18, *18*

Copley, John Singleton 110, 136–137; *Mary Turner Sargent (Mrs. Daniel Sargent)* cat. 2, 17, 114, *114*; *William Vassall and His Son Leonard* cat. 3, 18, 114, *114*

Corner of My Studio, A (Chase) cat. 55, 124, *124*

Country Politician (Bingham) cat. 14, 38, 116, *116*

Courbet, Gustave 24, 82

Courtship (The) (Eakins) cat. 37, 40–43, *41*, 121

Crèvecoeur, Hector St. John de 71, 72, 111; *Letters From an American Farmer* 71, 111; and "middle landscape" 71, 72, 74

Culture 87, 102; contemporary 9; context 8; discourse and 10; experience and 10; hegemony in 81; human 54; see also Indigenous; institution 9; language 66; multiculturalism 61; negotiation 11, 33, 101, 102; norms 65; of retreat 90; sensibility 22; themes 11; with visual 10, and historians 10; and language 38, 49, 50, 55, 60, 66, 72, 96, 100, 101; and vocabularies 32, 55, 58, 61, 65, 66, 70, 96, 100–103

Cup We All Race 4, The (Peto) cat. 60, 91–95, *92*, 125

Curry, John Steuart 137; *Self-Portrait* cat. 83, 55, 131, *131*

Danto, Arthur 9, 10, 104

David, Jacques-Louis 16, 105, 110; *The Death of Socrates* 16, *16*

Death of Socrates, The (David) cat. 16, *16*

Death on a Pale Horse (West) 62, *62*

Demuth, Charles 53, 54, 55, 57, 109, 137; *From the Garden of the Château* cat. 74, *52*, 52–55, 96, 129, front cover

Dewing, Thomas Wilmer 137–139; *Elizabeth Platt Jencks* cat. 56, 26, 125, *125*

Dickinson, Edwin 139; *The Cello Player* cat. 75, 95, 129, *129*

Dinner Table at Night, A (The Glass of Claret) (Sargent) cat. 45, 22–24, *23*, 122

Douglas, Aaron 58, 60, 138; *Aspiration* cat. 82, 58, *59*, 130; "Hall of Negro Life" 58

Drawing (Picasso) 96, *96*

Duchamp, Marcel 53, 109; *Fountain* 53, *53*, 109, 110, and readymades 53, 109; *Nude Descending a Staircase, No. 2* 53, *53*, 86

Durand, Asher Brown 70–72, 74, 76, 89, 138–139, and study of Claude 111; Letter 111; *A River Landscape* cat. 20, 72, *72*, 74, 89, 117

Durrie, George Henry 139; *Winter in the Country* cat. 16, 40, 116, *116*

Duveneck, Frank 139; *Study for Guard of the Harem* cat. 39, 121, *121*

Dyck, Anthony van 16, 21, 105; and sitters for 18; *Marie Claire de Croy, Duchesse d'Havré and Child* 18, *18*, "van Dyck dress" 18, 21, 105

Eakins, Thomas 40, 42, 43, 45, 51, 82, 107, 139–140; *The Courtship* cat. 37, 40–43, *41*, 121; *Female Model* (formally, *Negress*) cat. 28, 82, 119, *119*; *Frank Jay St. John* cat. 61, 40, 126, *126*; *Professor William Woolsey Johnson* cat. 57, 40, 125, *125*

Edison, Thomas A. 51

Elizabeth Platt Jencks (Dewing) cat. 56, 26, 125, *125*

Enlightenment 8, 87; political theory 16; philosophy 17; Emmanuel Kant 8, 9, 104; and *Critique of Judgment* 8; John Locke 71, and *Essay Concerning Human Understanding* 111; and William Blackstone 71, and *Commentaries on the Law* 111; and Jean-Jacques Rousseau 87, 104, and "noble savage" 87, and romantic philosophy 86; law, common-sense 74; of God 69, 71; natural law 69, 71

Evening at Medfield, Massachusetts (Inness) cat. 33, 71, 120, *120*

Exposition, 1913 Armory Show 53, same as International Exhibition of Modern Art 109; and Arthur B. Davies 106, 109; and J.F. Griswold and *The Rude Descending the Staircase (Rush Hour at the Subway)* 109; Impressionism, see also Painting; 1908 New York exhibition 29, and see also Painting; Paris Exposition, in 1889 112, and in 1900 51; 1876 Philadelphia Centennial Exhibition 40, 47, 108; 1936 Texas Centennial Exposition 58; Universal Exposition in Paris 82; 1893 World's Columbian Exposition (Chicago) 90, and with Jackson Park (Chicago) 108

Family 11, 33, 61, 83, 103; association with 32; associations in painting 32; childhood, as visual metaphor 12; "courtship" 40; familial bond 26; image of 28

Female Model (formally, *Negress*) (Eakins) cat. 28, 82, 119, *199*

Field Where General Reynolds Fell, Gettysburg (O'Sullivan) 79, *79*

Flowers in a Silver Vase (van Aelst) 91, *91*

Fountain (Duchamp) 53, *53*

Freake-Gibbs Painter 12, 32, 140; *The Mason Children: David, Joanna, and Abigail* cat. 1, 12, *13*, 15, 101, 114

Freud, Sigmund, see Sexuality

From the Garden of the Château (Demuth) cat. 74, *52*, 52–55, 96, 129, front cover

Gainsborough, Thomas 17, 18, 105; *Jonathan Buttal (The Blue Boy)* 17, *17*, 21, 105

Georgia O'Keeffe (Stieglitz) 96, 97, *97*

Gérôme, Jean-Léon 82; atelier of 107; *The Bath* 82, *82*

Gifford, Sanford Robinson 140; *A View from the Berkshire Hills, near Pittsfield, Massachusetts* cat. 25, 71, 118, *118*

Gilded Age (American) 18, 20, 21, 40; parlors in 18, 20; and revival style, Greek- and French Renaissance- 20; Léon Marcotte 21

Glackens, William J. 47, 48, 49, 50, 106, 108, 140–141; *May Day, Central Park* cat. 63, 47–50, *48*, 126

Glory of the Heavens, The (Keith) cat. 53, 90, 124, *124*

Governor's Creek, Florida (Hunt) cat. 35, 76, 120, *120*

Grand Canyon of the Yellowstone, Wyoming (Moran) cat. 64, 76, 111, 126, *126*

Great Swamp, The (Heade) cat. 31, 71, 120, *120*

Grosz, George 141; *Lower Manhattan* cat. 81, 55, 130, *130*

Harlem Renaissance 58, 109

Harnett, William Michael 93, 141; *After the Hunt* cat. 46, 93, 122, *122*

Hartley, Marsden, 113, 141–142; *A Bermuda Window in a Semi-Tropic Character* cat. 73, 96, 129, *129*; *The Summer Camp, Blue Mountain* cat. 67, 96, 127, *127*

Haseltine, William Stanley 142; *Ruins of the Roman Theatre at Taormina, Sicily* cat. 51, 69, 123, *123*

Hassam, (Frederick) Childe 142; *Seaweed and Surf, Appledore, at Sunset* cat. 70, 49, 128, *128*

Heade, Martin Johnson 142–143; *The Great Swamp* ca. 31, 71, 120, *120*; *Twilight, Singing Beach* cat. 24, 71, 118, *118*

Henri, Robert 28, 29, 31, 32, 106, 143; *O in Black with Scarf (Marjorie Organ Henri)* 29–31, *30*, and Organ as odalisque 106

Hicks, Edward 143; *The Peaceable Kingdom* cat. 12, 87, *115*, 116

Highland Light (Ault) cat. 78, 53, 129, *129*

Holiday, The (Prendergast) cat. 66, 49, 127, *127*

Homer, Winslow 79–82, 111, 143–144; *The Bright Side* cat. 26, 79–82, *80*, 118; and war correspondence for *Harper's* (Homer) 79

Hovenden, Thomas, 106, 144; *The Last Moments of John Brown* cat. 43, 82, 122, *122*

Hunt, William Morris 76, 145; *Governor's Creek, Florida* cat. 35, 76, 120, *120*

Illustrations, *McClure Magazine* 49; *New York Journal* 29; *New York World* 29, 49; Philadelphia Press 106; and illustrators for 106, and John Sloan 106

Independence, Declaration of 77; rhetoric of 12; vs. dependencies 12; Benjamin Franklin 12, and relationship to Joseph Wright 15; George III (king of England) 61; Thomas Jefferson 16, 64

Indians, see American Indians

Indians Hunting Buffalo (Bierstadt) cat. 48, 84, *85*, 86, 87, 90, 123

Indigenous, language 61, 66; people and culture 72; subject matter 71

Individualism 17, 18, 33, 45, 51, 61, 78, 81, 90; American 38; possessions as sign of 91; professionalism and career of 33; individuals 51, 71, and identity of 91, 94

Industrialism 40, 43, 47, 51, 72; industrialization 43, 46, 57, 70, and dislocation 40; vs. preindustrial 40, 43, 51; industrial progress 45; electricity in 51, 53, 54, 56; iron in 53, and foundry 45, 46, and ironworkers 16, 17, 46, 47, and production 53, and skyscraper 53; puddlers and 46; railroad

46, 47, 57, and 1877 strike 46, 47, 51, 108; steel in 53; mechanism of industry 45; modern machine age 54, and vs. individuals 45; labor vs. capital 108; see also Labor

Inness, George 144–145; *Evening at Medfield, Massachusetts* cat. 33, 71, 120, *120*

Innocence (Luks) cat. 72 128, *128*

Ironworkers' Noontime, The (Anshutz) cat. 41, 43, *44*, 45, 46, 57, 102, 107, 108, 121, frontispiece

Job Lot Cheap (Peto) cat. 54, 91, 124, *124*

John Coats Browne (Wright) cat. 5, *14*, 15, 16, 17, 18, 21, 114

John Jay St. John (Eakins) cat. 61, 40, 126, *126*

Johnson, Eastman 18, 20, 21, 22, 145; *The Brown Family* cat. 32, 18, *19*, 20, 125; *The Pension Claim Agent* cat. 29, 119, *119*; *Sugaring Off* cat. 27, 35, 119, *119*

Johnson, Joshua 145; *Letitia Grace McCurdy* cat. 6, 114, *114*

Jonathan Buttal (The Blue Boy) (Gainsborough) 17, *17*, 21, 105

Keith, William 145–146; *The Glory of the Heavens* cat. 53, 90, 124, *124*

Kensett, John Frederick 146; *Sunrise Among the Rocks of Paradise at Newport* cat. 21, 70, 117, *117*

Kent, Rockwell 146; *Afternoon on the Sea, Monhegan* cat. 65, 95, 127, *127*

Kitchen, Williamsburg (Sheeler) cat. 84, 53, 131, *131*

Labor, American Federation of Labor (AFL) 108; Continental Congress of the Working Class 51; Industrial Workers of the World (IWW) (Wobblies) 51, 108; Great Depression 55, 60, and stock market crash 110, and Herbert Hoover 55; May Day 50; mercantilism 36; paid employment 36; and common laborers 39; labor and capital 39; wage labor 39, 77, bourgeois ideology of 39; socialism 45; see also Industrialism

Language, of abstraction, with symbolic vocabulary 96; of deception 94; of nature 71; of objective observation 91; of the still life 91; symbolic 78; visual 8, 62, 66; of warfare 78; see also Indigenous

Last Moments of John Brown, The (Hovenden) cat. 43, 82, 122 *122*

Last of the Buffalo, The (Bierstadt) *84*, 86

Letitia Grace McCurdy (J. Johnson) cat. 6, 114, *114*

Limited, The (Marsh) cat. 80, *56*, 57, 130

Little Lamerche (Beaux) cat. 59, 65,125, *125*

Lone Scout, The (Ryder) cat. 42, 122, *122*

Lorrain, Claude 72, 111; *View of Tivoli at Sunset* 72, *72*

Lower Manhattan (Grosz) cat. 81, 55, 130, *130*

Luks, George, 106, 146–147; *Innocence* cat. 72, 128, *128*

Luncheon of the Boating Party, The (Renoir) 24, *24*

Maria Teresa, Infanta of Spain (Velázquez) 42, *42*

Marie Claire de Croy, Duchesse d'Havré and Child (van Dyck) 18, *18*

Marriage of Cana (Veronese) *10*, 11

Marsh, Reginald 55, 57, 147, and relationship to Kenneth Hays Miller 109, and Art Student League (Fourteenth Street School) 109; *The Limited* cat. 80, *56*, 57, 130

Marx, Karl, see Class

Mary Turner Sargent (Mrs. Daniel Sargent) (Copley) cat. 2, 17, 114, *114*

Mason Children: David, Joanna, and Abigail, The (Freake-Gibbs Painter) cat. 1, 12, *13*, 15, 101, 114

Masterwork (or Masterpiece) 8, 9, 10, 11, 101, 102, 104; and cultural discourse 10; genius in 8, 9, 10, 104, and Friedrich Hegel 104, transcendental formulation of 104

May Day, Central Park (Glackens) cat. 63, 47, *48*, 49, 50, 126

McCloskey, William J. 147; *Oranges in Tissue Paper* cat. 52, 91, 123, *123*

Mignot, Louis Remy 147; *Sunset on White Mountains* cat. 22, 70, 117, *117*

Mitchell, M.J.T. 102, 113; postructuralist 102

Modernity 39, 40, 43, 45, and condition of 95, and Charles Baudelaire 107; American 101; Modernism 54, 60; avantgarde modernism 60; and abstraction 55; and avantgarde 55; City Beautiful movement 49, and transcendentalism 108; Progressive movement 49, 50, 51; transcendentalism 79, 101, 108, and belief 47, and philosophy 38, and transcendentalists 68, 69

Moran, Thomas 76, 111, 147–148; *Grand Canyon of the Yellowstone, Wyoming* cat. 64, 76, 111, 126, *126*

Mordecai Gist (C.W. Peale) cat. 4, 33, *34*, 35, 114

Motte, Charles Etienne Pierre 9; *Napoleonic War Series III: Installation du Gouvernement Consulaire aux Tuileries* 9, *9*

Mrs. Robert S. Cassatt, The Artist's Mother (Katherine Kelso Johnston Cassatt) cat. 49, 24, *25*, 26, 35, 123

Museums 11, 101; as cultural institution 9, and role in contemporary culture 9; revolutionary appropriation (pillage) 9; Louvre 9, 104, and appropriation of 109, and Bertrand Barère 9

Nahl, Charles Christian 148; *Peter Quivey and the Mountain Lion* cat. 15, 38, 116, *116*

Napoleonic War Series III: Installation du Gouvernement Consulaire aux Tuileries (Motte) 9, *9*

Nation 9, 11, 12, 35, 36, 61, 65, 69, 70, 76, 82, 83, 96, 103; discourse and 89; empire and 87, and of America 86; expansion 89, 90; expansionist policy 90; English 12; expanding 66;

identity 76, 77, 83, 99, 100, 101; independent 18; of Israel 87; modern 71; nationalism 76; pride 78; ship of state 35; spiritual (Christian Church) 87; and Reformation and typology 87; unity affirmed 77

Nature 47, 74, 87; middle landscape 74, 76; natural landscape 77, 78; pastoral 74, 76, 78, 89; the buffalo 84–87, and slaughter of 112; the horse and prairie 86, 87; mules 81

Nude Descending a Staircase (Duchamp) 53, *53*, 86

O in Black with Scarf (Marjorie Organ Henri) cat. 69, 29, *30*, 31, 106, 127

Ohio Magic (Shahn) cat. 87, 96, 131, *131*

O'Keeffe, Georgia 96, 97, 99, 100, 101, 113, 148; *Petunias* cat. 76, 96, 97, *98*, 99, 100, 101, 129; and relationship to Arthur Wesley Dow 96

On the Cache la Poudre River, Colorado (Whittredge) cat. 34, 71, 120, *120*

On the Hudson (Brown) cat. 30, 71, 119, *119*

Oranges in Tissue Paper (McCloskey) cat. 52, 91, 123, *123*

Outdoor Stage, France (Shinn) cat. 68, 35, 127, *127*

Painting 33, and encounter with the landscape 72; School, Ashcan ("The Eight") 29, 31, 43, 45, 46, 49, 55; and of Paris (abstract movement) 53; 1908 New York exhibition 29, and Ernest Lawson, and John Sloan 106; American 8, 9, 11, 101, and historical 101; avant-garde 22, 24, 53, 58, 60, 95, and avant-garde abstraction 53, 60, 96, and of symbolist abstraction 60; and modern abstraction 96, 113; baroque realist 107, and Spanish baroque 42; Cubism 54; Dutch baroque 91, and genre 18, 22, and realist and bourgeois society 106; Grand Manner 62; historical landscape 70; history 45, 62, 65, 66, 68, 79, 82, 83, 96; Hudson River School 70, 74, 76, 77; and in Düsseldorf

89, 112; Impressionism 22, 24, 26, 28, 49; Impressionist 22, 24, 29, 31, and exhibitions 22, 24, 106; and the "new painting" 24, 26; and sensibility 22, and Edgar Degas 24, 49, 106, and Edouard Manet 24, 49, 82, and Claude Monet 106, and Berthe Morisot 49, 106; Italian Renaissance 16; landscape 68, 74, 79, 97, 100, 101, and American 111; limners 12; modernist vocabulary 58; neoclassical 62, 68; neomedieval 12; the nude 66–68; old master 12, 104, and see also Masterwork; Precisionism (precisionist) 53, 54, 55, 57, 109; and Immaculates, New Classicists, and Cubist-Realists 109; and Preston Dickinson, Elsie Driggs, and Niles Spencer 109; Regionalism 109, and Thomas Hart Benton 109; pre-Renaissance 12; Renaissance 55, 97, and rejection of 54; realist 42, 53; Romantic 39; romanticism 39, 68; and Eugène Delacroix 109; still life 91, 93, 94, 97, 100, 102, and Dutch 113; trompe-l'oeil 91, 93, 94; Tudor 12; western genre scene 38

Panofsky, Erwin 101; iconography 101; iconology 101, 102

Peace at Sunset (Evening in the White Mountains) (Cole) cat. 10, 71, 89, 115, *115*

Peaceable Kingdom, The (Hicks) cat. 12, 87, *115*, 116

Peale, Charles Willson 33, 35, , 107, 113, 148–149; *Mordecai Gist* cat. 4, 33, *34*, 35, 114; *Self-Portrait* cat. 9, 35, 115, *115*; *The Staircase Group: Raphaelle and Titian Ramsay Peale I* 113

Peale, James 93; *Still Life with Fruit* 93, *93*

Peale, Raphaelle 93, 94, 113; *Blackberries* 93, 94, *94*; *Venus Rising from the Sea—A Deception* [also called *After the Bath*] 113

Pelton, Agnes 149; *Challenge* cat. 85, 96, 131, *131*

Pension Claim Agent, The (E. Johnson) cat. 29, 119, *119*

Peter Quivey and the Mountain

Lion (Nahl) cat. 15, 38, 116, *116*

Peto, John Frederick 91, 93, 94, 95, 149; *The Cup We All Race 4* cat. 60, 91, *92*, 93, 94, 95, 125; *Job Lot Cheap* cat. 54, 91, 124, *124*

Petunias (O'Keeffe) cat. 76, 96, 97, *98*, 99, 100, 101, 129

Photography 22, 79, 82; and documentary 109; and glass-plate 81; and descriptive truth 81; and language of 82; and realistic techniques 81; New Deal agency, of Franklin Roosevelt 109; and Walter Evans and James Agee 109

Picasso, Pablo 96; *Drawing* 96, *96*

Pippin, Horace 149–150; *The Trial of John Brown* cat. 86, 82, 131, *131*

Pope, Alexander 150; *The Trumpeter Swan* cat. 62, 91, 126, *126*

Portrait of Joris de Caulerij (Rembrandt) 12, *12*

Portrait of a Lady (Anon.) 12, *12*

Portraiture 33; American 28; baroque 17; baroque English court 16; "conversation piece" 18, 20, 22, 105; English 18, 35; grand manner 15, 17, 18, 28, 35, 105; naturalism 12; neoclassical 15, 18; neomedieval 12; society 15, 28, 29; still lifes as 91; Peter Paul Rubens 16, 109

Prendergast, Maurice 106, 150; *The Holiday* cat. 66, 49, 127, *127*

Professor William Woolsey Johnson (Eakins) cat. 57, 40, 125, *125*

Prometheus Bound (Cole) cat. 13, 66, *67*, 68, 69, 70, 111, 116

Rainy Season in the Tropics (Church) 76, *77*, 111

Rape of Helen, The (Beham) 45, *45*

Realism 22, 24, 29, 40, 42, 45, 46, 49, 53, 57, 91, 104; reality 94, 95; realist, convention 95; illustration 29, 50; social 55, 57, 58; technique 28, 79; tradition 22, 31; vocabulary 29, 43, 45, 55, 82, 91, 97; and reality 95, and vs. illusion and ability

to deceive 94–96, and image of deception 95

Reed, Luman 71

Religion, calling, 35, 39, 60, and mercantile 33; Puritan 15, 33, 60, 101; "city on a hill" 60; and John Winthrop 89, 112; and Massachusetts Bay Colony 89

Rembrandt Harmensz. van Rijn 12, 109; *Portrait of Joris de Caulerij* 12, *12*

Renoir, Pierre-Auguste 24, 106; *The Luncheon of the Boating Party* 24, *24*

Republic, American 16; political ideology 18, Roman 16

Revolution 16; American 15, 61, 71, 78; French 9, 11, 16, 62, 64, 104, and Napoleon Bonaparte 9, 10, 11, 62, 110; industrial 20, 36, 39, 43, and Arnold Toynbee 107; and machines 36

River Landscape, A (Durand) cat. 20, 72, *72*, 74, 89, 117

River system, boatman 36, 38; flatboat 38; steamboat 36, 38, and John Fitch, inventor of 107, and Robert Fulton 36, 107, 110; rivers 38; Mississippi River 36, 84, and Missouri River 36, 86

Roman Fish Market, Arch of Octavius (Bierstadt) cat. 18, 90, 117 *117*

Royal Academy 62, 64, 105; London Academy 35; Schools 15; Mather Brown 110, and other American artists at 110; Sir Joshua Reynolds 17, 35, 62, 105

Ruins of the Roman Theatre at Taormina, Sicily (Haseltine) cat. 51, 69, 123, *123*

Ryder, Albert Pinkham 150–151; *The Lone Scout* cat. 42, 122, *122*

Salmon, Robert 151; *British Merchantman in the River Mersey Off Liverpool* cat. 8, 115, *115*

Salon 11, 62; Unofficial (New York) Walter and Louise Arensberg, Mable Dodge, and Stieglitz 104; Jean-Léon Gérôme 82; Tony Robert-Fleury 106; and François-André Vincent 64;

European 68; French 24; Paris, in 1802 62, 66, and in 1808 104; Atelier 64, of Gérôme 107; Galleries (New York), and Stieglitz's 291 gallery 53, 96, 109; The Bourgeois Galleries 53; The Daniel Gallery 53, 109; The Downtown Gallery 53; and see also Academies

Sargent, John Singer 22, 24, 26, 28, 29, 106, 151; *Caroline de Bassano, Marquise d'Espeuilles*, cat. 44, 26, **27**, 28, 29, 122; *A Dinner Table at Night (The Glass of Claret)* cat. 45, 22, **23**, 24, 122; *Trout Stream in the Tyrol* cat. 71, 22, 128, **128**

Scene in the Artic (Bradford) cat. 40, 76, 121, **121**

Seaweed and Surf, Appledore, at Sunset (Hassam) cat. 70, 49, 128 **128**

Self-Portrait (Curry) cat. 83, 55, 131, **131**

Self-Portrait (C.W. Peale) cat. 9. 35, 115, **115**

Sexuality 31, 97, 99, 106; domesticity 102; femme fatale 31, and Charles Swinburne and Walter Pater 106; 106; and sexual purity, Victorian 28, 46, 107; flowers, sexual associations in 97, 99, and petunias 100; traditional woman vs. feminist 30; and creative talent 26; gender 102; and gender roles 42, 43, and reorganization of 99; and gendered division 99, and gendered identity 66; gendered spheres, in the Gilded Age 105; and female body 29, 106, and male gaze 106; Symbolist 31; and odalisque, see Robert Henri; masculinity 46, 65; and femininity 31, 46; and spinning 43; the exotic 31, 97; and Sigmund Freud 106; Freudian models of desire 31; *Studies in Hysteria* 106; Reform Dress Movement 29, and National Women's Party and Equal Rights Amendment 99

Shahn, Ben 151–152; *Ohio Magic* cat. 87, 86,131, **131**

Sheeler, Charles, 109, 152; *Kitchen, Williamsburg* cat. 84, 53, 131, **131**; *Still Life* 53, 96

Shinn, Everett, 106, 152; *Outdoor Stage, France* cat. 68, 35, 127, **127**

Signing of the Declaration of Independence (Trumbull) 70

Sonata, The (Wiles) cat. 50, 35, 99, 123, **123**

Sphinx of the Seashore, The (Vedder) cat. 38, 31, 121, **121**

Spring Flood (Burchfield) cat. 79, 55, 130, **130**

Staircase Group: Raphaelle and Titian Ramsay Peale I, The (C.W. Peale) 113

Steamship "Syracuse," The (Bard) cat. 17, 36, 117, **117**

Stieglitz, Alfred 53, 96, 97, 99, 109, 113, and 291 (gallery) 96; *Camera Work* (journal) 96; *Georgia O'Keeffe* 96, 97, **97**; Salon 104; and relationship to Arthur B. Carles, Arthur Dove, John Marin, Alfred Maurer, Edward Steichen, and Max Weber 113

Still Life (Sheeler) cat. 77, 53, 96, 129, **129**

Still Life with Fruit (J. Peale) 93, **93**

Study for Guard of the Harem (Duveneck) cat. 39, 121, **121**

Sublime 68, 69, 70, 74, 76, 78; as the experience of a nation 74; and Edmund Burke 68, 70; *Philosophical Inquiry into the Origins of Our Ideas of the Sublime and Beautiful* 68

Sugaring Off (E. Johnson) cat. 27, 35, 119, **119**

Summer Camp, Blue Mountain, The (Hartley) cat. 67, 96, 127, **127**

Sunlight and Shadow (Bierstadt) cat. 23, 113

Sunrise Among the Rocks of Paradise at Newport (Kensett) cat. 21, 70, 117, **117**

Sunset on White Mountains (Mignot) cat. 22, 70, 117, **117**

Tarbell, Edmund C. 152–153; *The Blue Veil* cat. 58 26, 125, **125**

Trial of John Brown, The (Pippin) cat. 86, 82, 131, **131**

Trout Stream in the Tyrol (Sargent) cat. 71, 22, 128, **128**

Trumbull, John 70, 110; *Signing of the Declaration of Independence* 70

Trumpeter Swan, The (Pope) cat. 62, 91, 126, **126**

Twain, Mark 18, 38; *The Adventures of Huckleberry Finn* 38; and relationship to Charles Dudley Warner 18; and satiric lampoon 18

Twilight, Singing Beach (Heade) cat. 24, 71, 118, **118**

Twilight (Church) cat. 19, 74, **75**, 76, 89, 111, 117

Vanderlyn, John 62, 64, 65, 66, 68, 82, 104, 110, 153; *Cauis Marius Amid the Ruins of Carthage* cat. 7, 62, **63**, 64, 65, 68, 82, 104, 110, 115

Vedder, Elihu 153; *The Sphinx of the Seashore* cat. 38, 31, 121, **121**

Velázquez, Diego 42 in the Prado Museum 107; *Las Hilanderas* 107; *Maria Teresa, Infanta of Spain* 42, **42**

Venus Rising from the Sea—A Deception [also called *After the Bath*] (R. Peale) 113

Vermeer, Johannes 18; *The Concert* 18, **18**

Veronese (Paolo Caliari) 10; *Marriage of Cana* **10**, 11

Vickers, Albert 22, 24, 26; Edith (Lady Gibbs) 22, **23**, 24, 26

View from the Berkshire Hills, near Pittsfield, Massachusetts, A (Gifford) cat. 25, 71, 118, **118**

View of Tivoli at Sunset (Lorrain) 72, **72**

West, frontier 36, 38, 87, 89–91, and as new territories 70; and settlers 38; and western states 38; and the West 86, 89, 90; exploration of 76, 77; and language of 74; and wilderness 74, 86, 90, and sublime experience in 70; Manifest Destiny 39, 86, 100, and empire 86, 90, and American 87; exploration and conquest 74; and westward

expansion and settlement 86; will to conquer 87; as Promised Land 87, 89, 90; gold 84, 89, 90; and discovery of 84, 89, 90, and California golden promise 89; expansion of the U.S. 77, 89, 90; Louisiana Purchase 36; and Territory 64; James Monroe 77; and the Monroe Doctrine 77; retreat from civilization 90; Frederick Jackson Turner 90, 112, and "fatalist discourse" 113; "The Significance of the Frontier in American Life" 90; New Historians 112

West, Benjamin 35, 62, 110; *Death on a Pale Horse* 62, **62**

Whittredge, Worthington 154; *On the Cache la Poudre River, Colorado* cat. 34, 71, 120, **120**

Wiles, Irving Ramsay 153–154; *The Sonata* cat. 50, 35, 99, 123, **123**

William Vassall and His Son Leonard (Copley) cat. 3, 18, 114, **114**

Winter in the Country (Durrie) cat. 16, 40, 116, **116**

World War I 51, 54, 99, 109

Wright, Joseph 15, 17, 18, 21, 104, 105, 110, 154; *John Coats Browne* cat. 5, **14**, 15, 16, 17, 18, 21, 114; Patience Lovell (mother) 15